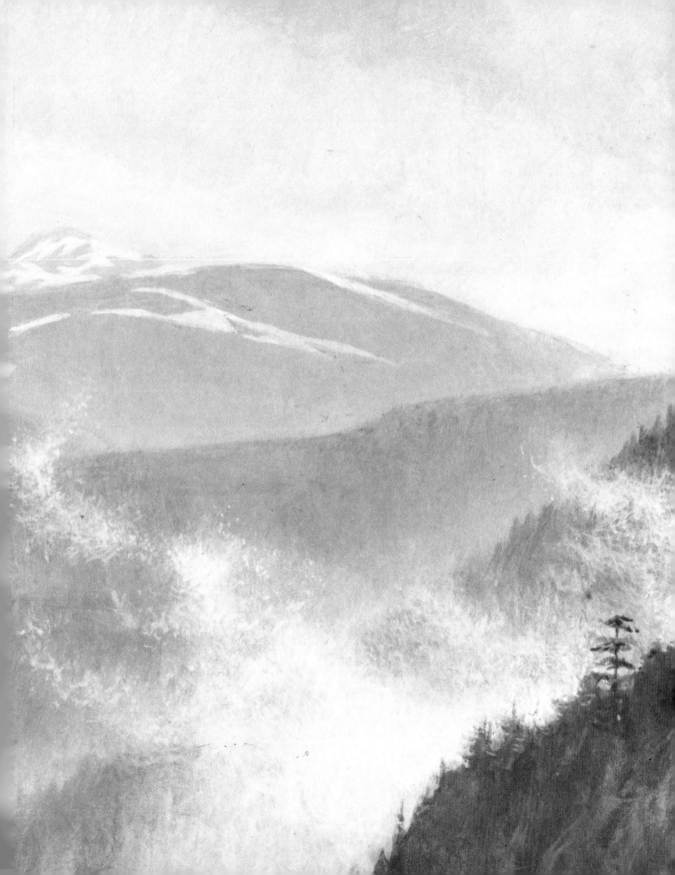

LIFE SKETCHES

A MEMOIR

SIMON & SCHUSTER

NEW YORK LONDON TORONTO SYDNEY NEW DELHI

Simon & Schuster Canada
A Division of Simon & Schuster, Inc.
166 King Street East, Suite 300
Toronto, Ontario
M5A 1J3

This Simon & Schuster Canada edition November 2015

For information about special discounts for bulk purchases,
please contact Simon & Schuster Special Sales at 1-800-268-3216
or CustomerService@simonandschuster.ca

Manufactured in the United States of America

1 3 5 7 9 10 8 6 4 2

Library and Archives Canada Cataloguing in Publication
Bateman, Robert, 1930–, author
Life sketches / Robert Bateman.
Issued in print and electronic formats.
1. Bateman, Robert, 1930–. 2. Painters–Canada—Biography.
3. Wildlife artists–Canada–Biography. 4. Naturalists–Canada—Biography.
5. Animals in art. 6. Nature in art. 7. Wildlife conservation. I. Title.
ND249.B3175A2 2015 759.11
C2015-903852-9 C2015-903853-7

Cover design by PGB
Interior design by Sharon Kish / www.sharonkish.com

ISBN 978-1-4767-8297-3
ISBN 978-1-4767-8302-4 (ebook)

GRATITUDE TO THOSE

WHO HAVE POSITIVELY INFLUENCED MY WORLD,

NONE MORE DEEPLY THAN BIRGIT.

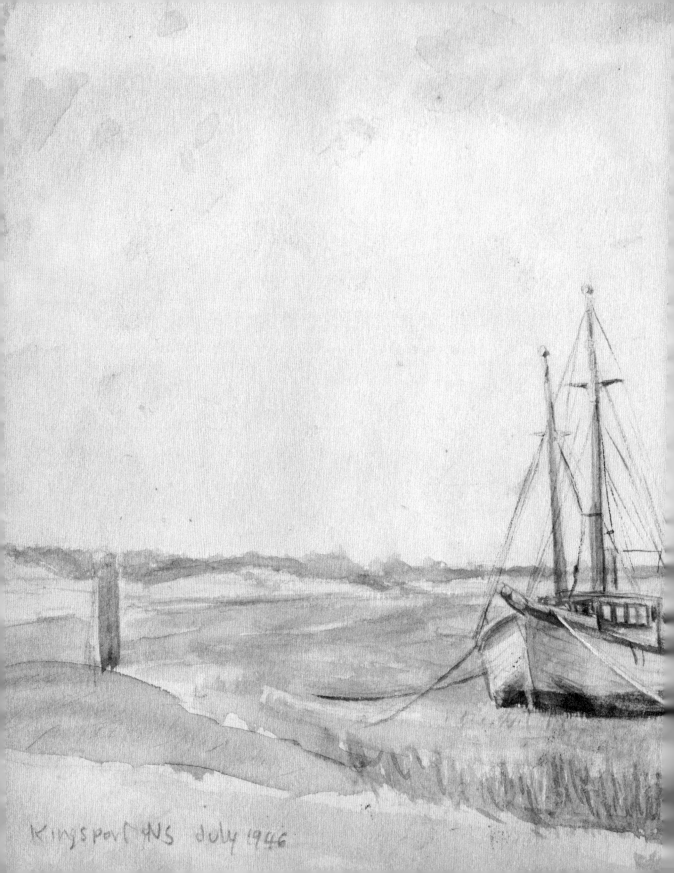

Kingsport NS July 1946

CONTENTS

LIFE SKETCHES

I : THE RAVINE

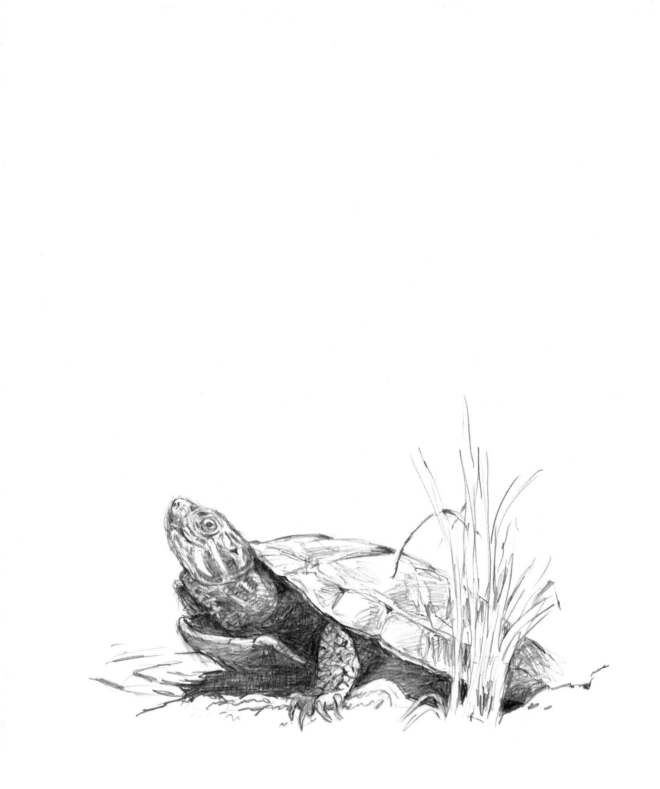

As a painter, I rank green as one of my least favourite colours. But as a naturalist, I view green as soothing to the eye, especially that chlorophyll-laced green of the first leaves in spring. I liken this luminous lime-yellow colour, which the French call chartreuse, to a warm bath for the soul. And when I see that shade of green, I think of the ravine behind our Toronto house on Chaplin Crescent, in what was then the village of Forest Hill. The first forest I came to know, my own private woodland, my own *The Wind in the Willows* world.

Would I have become a painter and a naturalist had I not lived where I did as a boy? Hard to say, but that ravine enchanted me and drew me in from the time I could walk.

Imagine a day in May of 1940, when ten-year-old Bobbie Bateman descends the wooden steps at the back door of his family's modest red-brick Georgian home, set on a regular city lot. He heads purposefully across the backyard, down the slanted lawn, past the rockery to a white picket fence and a rose arbour, and through his dad's vegetable garden.

He comes to a rudimentary wire fence, easily cleared over, fixed to a log retaining wall. Maybe the railroad company had constructed it to shore up the banks, protecting the rail line that runs down the centre of the ravine. Twice a day, a black steam engine chugs past with its freight-car loads of coal and ice and building supplies. The Belt Line Railway, as it was originally called at the end of the nineteenth century, was meant to link the old town of Toronto with the villages and communities sprouting on farmland to the north. Yet young Bob can imagine an Indian hunting party quietly stalking through these woods; the ecosystem remains much as it has been for centuries.

On the north side of the rail bed is a creek that massively overflows every spring, creating a body of water sizable enough to justify the building of a raft. The creek is home to water bugs and minnows, crayfish, pollywogs, frogs and painted turtles; the ravine, to foxes and skunks, raccoons and mice. There is the smell of damp earth, the ambrosia of composting leaves and pine needles, plus the fragrance of the blossoms of the plum tree that grows by a favourite solitary perch. The boy takes it all in. He can hear willows rustling in the breeze, insects stirring in the brush, the sound of water coursing. And the birds.

As a child, I regarded the birds as my neighbours and I was eager to learn their names. Before I was twelve, my parents had given me several bird books, including Roger Tory Peterson's *A Field Guide to the Birds of Eastern and Central North America* and *Birds of America*, illustrated by Louis Agassiz Fuertes. I knew the calls, the colours and the place in the canopy preferred by particular predators and songbirds. In that ravine of mine (or so I considered it to be) were warblers, thrushes, flycatchers, Blue Jays and Baltimore Orioles, and at dawn, I would hear the squawk of pheasants. Especially in spring, when migration was in full swing, the ravine was a chorus of birds. I loved, and still love, that symphony.

The other book that I read and reread as a young boy was Ernest Thompson Seton's *Two Little Savages*, whose subtitle says it all: *Being*

the Adventures of Two Boys Who Lived as Indians, and What They Learned. Very early in the book, the narrator, a boy named Yan, describes his frequent visits to a nearby taxidermist's shop. The boy gazes "spellbound" at the window display of some fifty birds, twelve of which are labelled. "Osprey. Kingfisher. Blue Jay. Rose-breasted Grosbeak. Wood Thrush. Scarlet Tanager. Partridge or Ruffed Grouse. Bittern. Highholder. Saw-whet Owl. Oriole."

The boy thought it important to know the birds, their names and identifiers, and he saw that the taxidermist had erred in his labelling. The alleged Woodthrush was actually a Hermit Thrush. Furthermore, "The last bird of the list was a long-tailed, brownish bird with a white breast. The label was placed so that Yan could not read it from outside, and one of his daily occupations was to see if the label had been turned so that he could read it. But it never was, so he never learned the bird's name."

To Yan, it was sacrilegious not to know the names of the flora and fauna in his neck of the woods. My ten-year-old self shared that notion, though I had only a vague understanding of the concept of *sacrilegious* and certainly could not spell the word. I considered it my sacred duty to know, simply by the shape of the tail—rounded or square— whether the hawk circling overhead was a Sharp-shinned Hawk or a Cooper's Hawk or a Red-tailed Hawk. To me, that detail, that particularity, mattered a great deal. And just like Ernest Thompson Seton, I capitalized each species of bird when I identified it, and still do.

MOST KIDS START DRAWING mammals and birds at three and quit before they're ten. I never stopped. The habit of sketching the wildlife I was observing took hold when I was very young, and I remember having smallish brushes always at hand. Mom, in particular, saw my passion, and she actively encouraged me. One year, I presented her with a painting of a dignified Elk for Christmas. I had, of course, never seen a real Elk, but the pages of *National Geographic* offered a model, and

Some rough sketches of my pet Screech Owls. The oily stain on the left is from a critter I was stuffing.

for the landscape there were multiple sources: our own ravine, trees from a golf course, a photograph of a mountain for the background.

The focus of my art was most often the menagerie of pets in the household. There was a black cat called Shadow, so named because she was always following us around. If someone asked, we called our canine pets "mongrels." There was a dog the same colour as a yellow lab we called Wink, and later, a Canadian farm collie cross called Ruff because of a shank of soft hair at the back of her neck.

Those were just the domesticated pets. I also had a pet crow (who went unnamed), a turtle called Buck, a raccoon known as Cooney, and two Screech Owls named Blink and Rombus. Owls, I knew even then, raise several young, but there's usually a runt that gets sat upon and hen-pecked, and often there is not enough food for it. I found a nest containing four young, and I took the two smallest, telling myself that this was a rescue of sorts. I fed them mostly pieces of liver. I would hold one of the birds to my chest facing away from me, then force the lower beak open and use a toothpick to stuff a morsel of meat down its throat. I'd close its beak so it had no choice but to swallow the food. Later, I started mousetrapping and feeding whole mice to the owls. I knew that Screech Owls require bones and fur for calcium. Soon I was cutting up mice, frogs and grasshoppers as food for Blink and Rombus, and each time I fed them, I whistled in order to imprint on them the feeding like Pavlov's dog. Eventually, they were on their own but came back to be fed for a few weeks when I whistled.

Years later, my friend Bristol Foster and I rescued another runt, a Short-eared Owl we named Howland, who was the object of many of my sketches. He lived in the basement of the Foster residence, a rather grand house, where Bristol's parents looked after him for years. His mother was a dignified lady with a spark of mischief, and she would go to the top of the stairs and utter the scratchy owl call that Howland had come to recognize as the dinner bell. Howland would hop up the stairs and happily receive the mice she had for him. During dinner parties, the Fosters would set him on the fireplace mantel, next to the

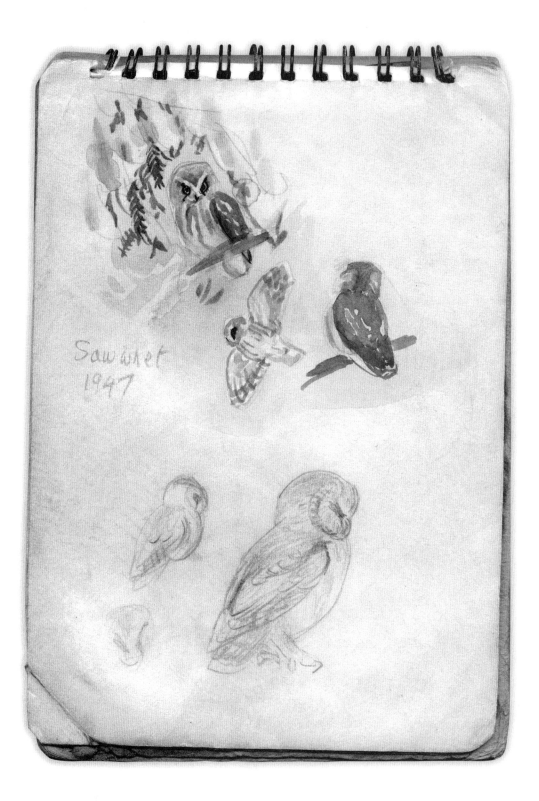

Sawwhet
1947

chinaware pheasant. More than one glass of sherry was spilled down a dress when someone spotted the owl, perfectly still to this point, rotating his head almost 360 degrees. Eventually, Howland was handed over to Toronto's Riverdale Zoo, where he lived to a ripe old age.

We were free-range kids, virtually unsupervised. Across the tracks and up on the hill were the homes of the wealthy of Forest Hill, but their backyards held garden pools or smallish lawns that ended in fences. And where the fences stood guard, our world began. When the trees, bushes and shrubbery were in full foliage, the canopy was too dense on either side of the ravine to see through. Feral boys—Al Gordon, my younger brothers, Jack and Ross, and I—did what feral boys are wont to do. We made bonfires, roasted potatoes and jumped over the embers. On one occasion, when I was taking a run at the fire pit to make my leap, I caught my toes in an old page wire fence hidden in the leaves. I fell hands-first into the glowing coals. I remember my mother put my hands in cold water, then cold towels, and still the blisters rose like so much tapioca on the palms of both hands. Badges of honour.

BETWEEN 1939 AND 1945, from the time I was nine until my fifteenth birthday, the war shaped our play. My family listened to CBC Radio, and I remember hearing Lorne Greene, "The Voice of Doom," as he came to be called for his rich baritone, delivering details of the disaster that was the Dieppe raid in 1942. Before that, on December 7, 1941, we had heard the Edgar Bergen/Charlie McCarthy radio show interrupted by news of the attack on Pearl Harbor. Fortunately, the horrors of the war never touched my close family, and we boys innocently incorporated its drama into our make-believe ravine battles.

We built forts, and not just because of the war. We had a legendary, almost mythical "enemy"—a group of boys called the Gilgorm Gang for the street they lived on to the north of us. They were a rough-and-tumble counter to our bunch. We were budding birders and

My buddies and I used to go looking for Saw-whet Owls, which are quite tame. You can grab them if you sneak up just right. This page from my sketchbook dates back to 1947, when I was seventeen.

naturalists who played at soldiers but were pacifists at heart. Down the rail track was a dump that we plundered for building material such as plywood to make a roof for our ground fort. We dug into the hillside and loaded up on "ammo"—old shoes from the dump, plus paper bags full of the fine powdery ash from our fire pit. These were mortars to be launched at imaginary foes. Boys love an enemy, for enemies bring excitement and dopamine. We never imagined that the Gilgorm Gang would actually attack. One day, we heard angry voices approaching along the tracks, but we hoped the boys would pass us by or not see us. Nothing was said, by them or by us, when the Gilgorm Gang spotted our fort, demolished it, and then went back the way they had come. We, of course, could not handle a violent encounter, so we sat passively to one side and watched. They thankfully ignored us.

A SINGLE EVENT IN CHILDHOOD can shape a life, and that was the case with an episode that affected all three Bateman brothers, especially the youngest, Ross. I was perhaps twelve, Jack nine and Ross six when a young House Sparrow landed on the lawn behind the house. What Ross remembers is that Al Gordon and I had been downgrading sparrows and starlings as invasive pests, which might have precipitated what happened. As many kids in those days, we owned a BB gun, the classic Red Ryder model that had long been advertised on the back pages of comic books. My parents had set down certain rules about the gun: Use it for target practice only and engage common sense.

Never imagining that he would actually hit the bird, Ross took a shot and struck the poor creature in the eye with one of the round brass pellets. I remember telling my brother, "Ross, finish it!" There were tears flowing down his cheeks when he finally did end the bird's suffering. My mother got involved, and she, too, was horrified. Looking back, I can see that, as the older brother, I should have taken matters into my own hands, but I did not relish the prospect of killing the bird either. We were all traumatized by what we witnessed.

The Walt Disney film *Bambi* had come out that year, 1942, and we had gone to see it as a family. There is a scene in the film in which the animals flee in terror, and when all is quiet and safe once more, Bambi asks his mother why they had run. She replies, "Man was in the forest." Ross, just six, looked on in horror, uttered an "Oh no!" under his breath and fled the theatre, with my mother chasing after him.

Ross was utterly changed by that incident with the young bird and by seeing that film. He would grow up to become an ardent conservationist and social activist, fighting to protect Carolinian trees, natural habitat and heritage buildings, among many other things. He has always felt that "man in the forest" creates problems.

Bambi and its creator, Walt Disney, also had a huge impact on me as I continued to paint. Disney's artists were incredibly skilled at capturing the way animals move, and that impressed me. Beyond that, however, the characters of this animated drama—Bambi, Thumper, Flower and the rest—entered the public consciousness. By the time I was sixteen, I was almost mass-producing 6"x 6" paintings of these characters for the baby rooms of my mother's friends. A popular rendering was Thumper by a pool, looking over Bambi's shoulder, with mushrooms at his feet.

But I was a typical jaundiced teen, and I would surreptitiously insert an evil eye into one of the toadstools or show a Grim Reaper figure reflected in the pool. No mother ever complained, and no baby was ever frightened, as far as I'm aware. Now and again, at a book signing or an exhibition, a grey-haired lady will introduce herself as an old friend of Annie Bateman, and from her bag she will pluck one of my paintings of Bambi or Thumper or Flower. I cringe, but a part of me is at peace with my sentimental past.

IF THE RAVINE WAS CENTRAL to my childhood, so, too, was a little cottage some 200 kilometres northeast of Toronto, to which the Bateman family travelled every summer starting in 1938. Al Gordon's parents knew Lake Boshkung (an Iroquois word that means, depending on which source you believe, "place of grassy narrows," "meeting of the waters" or "place of rest") and had recommended it. There, in the Haliburton Highlands, a second, very different landscape entered my consciousness.

The ravine behind our house in the city seemed to me wild and tangled and completely ours. The banks were steep, and in some places the giant willows in high summer were almost impenetrable. This ravine connected with others in the city, a ribbon of nature that led to the Don and Humber River valleys, promising almost limitless possibilities. But the truth was that an athlete with a good arm could throw a baseball from our backyard on Chaplin Crescent and hit one of the imposing Forest Hill houses on the other side, the area was that narrow and confined.

The land around the cottage, in contrast, offered wide open play space. The first year, we occupied a little hilltop cottage called Wildwood, but the next we rented a newly built unit, one of three closer to the lake. When I think of the early days at Boshkung Lake, this is the cottage I recall. Adjacent to it was a working farm with several hundred acres of pasture and all the animals then common

on mixed farms: horses (plough horses named King and Queen), a cow, sheep, pigs, geese and a flock of black and white chickens. The Bateman brothers, pals Al Gordon, Don Smith, and Jack and Don Lowery, whose parents rented cottages alongside ours, had the run of the place. That farm had a deep influence on me.

I remember watching the farmer milk a cow by hand, aiming a squirt of warm milk into a cat's mouth. I remember seeing chickens slaughtered, hanging by their feet and bled from the throat with a small but very sharp penknife. We watched the sheep being sheared and, when their time came, bled with a small butcher knife. The highlight of the summer was haying time, when we were encouraged to ride on the horse-drawn wagon and help the hired hands —or at least to try to stay out of the way. In the barn, ropes hung from the rafters, and we would swing like pirates and drop into the loose hay piled thickly below.

That barn, the surrounding pastures, the lovely sandy bay on Boshkung Lake, ringed by aspen, spruce and the odd white pine (then and still my favourite tree), was our playground. There were very few cottages on the lake, which lent it a pristine quality. The water was clear and pure, and we often watched as loons and Mergansers paraded past the dock with their young. And just as we did in the ravine, we built forts— first of bracken and then out of fallen logs. We played cowboys and Indians and commandos, and raided one another's bastions. We made balsam beds in the style prescribed by Ernest Thompson Seton, and sometimes even slept in them. Because there was no electricity on the farm or in the cottage, there was no noise other than the sounds of animals, both domestic and wild. And the birds, of course.

In the evenings, my mother read us bedtime stories by the light of a coal-oil lamp. Often the selection was from Ivan T. Sanderson, a Scottish biologist who produced such classics of nature writing as *Animal Treasure* (an account of his expedition into the jungles of West Africa) and my favourite, *Living Treasure* (about similar treks in Jamaica, British Honduras and the Yucatan).

The landowner, Clayton Rogers, who would later become reeve of the township, had built several cottages on the bay and called his little enterprise Moorefield Acres, after the original owner of the property. It wasn't just that Mr. Rogers possessed an entrepreneurial bent, though he did. It was more the case that by itself, farming in the Haliburton Highlands offered too meagre a return to support a family. He was then the virtual laird of this land, owning the entire south shore of Boshkung Lake and the hills beyond. You'd think he'd have been pleased when, many years later, I did my honours geography thesis at the University of Toronto on the future of the township (then called Stanhope, now called Algonquin Highlands). My conclusion was that the future of the township lay in tourism, but Mr. Rogers was none too pleased to hear this, for he thought the place deserved a grander fate, perhaps a more industrial one.

Every July during 1938 to 1945, when we lived at the cottage, we were in heaven. There was gas rationing in those days, and Dad had just enough fuel to drive up Highway 35, then a dirt road, and drop us off before returning to Toronto and his job at Canadian General Electric. Commuting was out of the question. Groceries meant a major walk or a row through Little Boshkung and Twelve Mile Lake to Mr. Rogers' General Store in Carnarvon, though I remember an itinerant truck with red wooden panels driving up to the barn with supplies. When the truck didn't stop by with bread, my mom or her sisters or her mother would bake it. And if we boys gathered small pails of wild raspberries, we got a pie out of the deal. "Go up over the hills," Mom would say, for that's where the berries were.

The conveniences at the cottage were few—except for a coal-oil lamp—but that only made the place feel more exotic. Instead of a flushing toilet, there was an outhouse behind the cottage. We hauled drinking water a pail at a time, using a hand pump located over a well near the farmhouse. An ice house at Mr. Rogers' barn contained blocks of ice cut from Boshkung Lake the winter before. Getting ice meant making a trip to the ice house, digging a block out of the

insulating wood chips, grabbing tongs, hoisting the
heavy block into a wheelbarrow, conveying it to
the lake to wash off any remaining sawdust,
and hauling it to the cottage, where two boys
or Dad would lift it onto the veranda and
drop it into the icebox.

All those raspberry pies made by my mom,
my maternal grandmother or my aunts were
baked in the wood stove. Towels and linens were
vigorously scrubbed over a glass washboard, hung
on the line to dry and then pressed, using irons heated
on the same wood stove. The only phone was a crank-up unit
at the farmhouse. And with only coal-oil lamps for light, we tended to
rise at dawn with the sun and slide into bed not long after sunset. We
would drift off to sleep to the sound of the waves lapping the shore,
or the haunting call of a loon or a Whip-poor-will.

In 1946, Dad bought the cottage next door, the one that the Lowery
family had rented since 1930, and we set about making it our own.
Ross remembers being conscripted for that project. For a local his-
tory published years later, he wrote, "We gathered flagstones from the
woods and lake bottom and built a rustic fireplace. 'Grab aholt,' Dad
intoned, as we dragged old pine logs from the lake and cut them into
firewood with a Swede saw; Jack and I did this, I should specify, or
a cousin or two. Bob was off in the woods or over the hills, painting."

The bay, the pastures, the forests—all seemed alive with wildlife.
There were water snakes, hognosed snakes and five-lined skinks at
Blueberry Hill. (For a while we called it Lizard-Up-the-Pant-Leg-Point,
after one was observed running up into my brother Jack's pants.)
There were many chipmunks; one year our cat Shadow caught one,
and only by tossing both predator and prey into the lake was the cat
convinced to release her victim. It worked out well for the chipmunk.
Bluebirds nested in boxes on the cedar rail fence behind the cottage,
and one year I found a Whip-poor-will's nest and a Nighthawk's nest

on Blueberry Hill, the only two members of the nightjar family found in eastern Canada.

We all felt an allegiance to the place, in no small part because of the many comforting rituals that arose out of being there for so many summers. When, for example, our dad would return to the cottage and stay for the last two weeks of July, we would take out a flat-bottomed rowboat and troll for lake trout. Dad liked to fish; me not so much. In those days, you fished not for sport but in expectation of breakfast. It would be slow trolling with a copper line and a spinner.

But there were reasons other than fishing to man the oars. The family would pile into that rowboat and follow the west shore of the diamond-shaped lake until, after almost an hour of rowing, we stopped at the mouth of the Boshkung River. A walk upriver took us

to a place where the rocks were flat: the Buck Slides rapids and falls, named after one Daniel S. Buck, who had built a log mill on that spot in 1862 (long ago burnt down), as well as a wooden flume to enable logs to move from Kushog Lake down to the mill. This mecca, where the water drops about 120 feet over a 100-foot stretch from Kushog Lake into Boshkung Lake, became our familiar picnic spot.

The water rushed down the falls at a wicked pace, but there was a spot at the bottom of the falls where a swimmer could safely sit in the water, with his back to the current, while the turbulent foam tumbled over his head and shoulders and offered the most pleasant massage.

For many decades, that landscape offered refuge. It was to become part of my family's future.

I LIKEWISE FELT A SENSE OF REFUGE in the unheated, glassed-in sunroom at the back of our house on Chaplin Crescent, a space that became my studio spring through fall. That's where I liked to be, with my friends and brothers chirping at me while I painted. My brothers, both self-taught painters, also took up art, but neither had the single-minded drive to paint that I did. Jack was dragged along to my woodcarving classes in the 1940s, and he still has a few bird carvings that he pronounces "decent," but as for painting, he says, "I started in 1945 and stopped in 1945." For some thirty-four years, Ross made his living in commercial art as illustrator, designer and art director of an educational publishing company. Then he became head of a high school art department. His particular skill is gesture caricature. He has also done paintings of the scenery at his home and cottage that sell in the limited edition market. He's very good, but he paints only one piece every few years. "It's too hard," as he puts it now.

Many years ago, and long after the rail line ceased to function as such, the city offered homeowners the right to buy the pieces of land that extended from their backyards into the ravine—indeed, smack dab into the middle of the ravine. Had that plan gone ahead, the

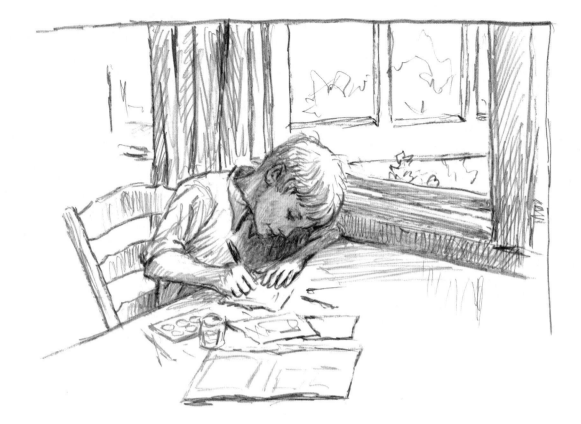

ravine would have been lost altogether. A public space would have been cut up into so many private domains. But an activist named Kay Gardner got a petition going and saved enough of the ravine to create a crushed gravel path atop the old rail bed for walkers, joggers and cyclists. My mom helped get signatures for that petition.

Two doors down from our old house is the Robert Bateman Parkette, set in the right of way that people use to access the ravine. There are benches here, and plaques declaring the Kay Gardner Beltline Trail. Another plaque, dated 2010, honours the tenth anniversary of the creation of the park, and carries some reproductions of my early paintings. I was fourteen when I made those, in that old sunroom with my pals looking on.

Me drawing in the sunroom of our house on Chaplin Crescent.

II : CHAPLIN CRESCENT

My father, Joseph Wilberforce Bateman, grew up on a farm near Tweed (Cookston was the closest village), in Hastings County in Southeastern Ontario. The family had come from Ulster, a province in Ireland, in the 1840s. Both sides of the family can be described as Ulster-English. When I was a boy, Dad would tell me stories about "being a small boy on a big farm," so rural life was deeply imbedded in my consciousness from the time I could fathom language.

My time as a child spent on the farm at the cottage in Haliburton taught me to value the bucolic. A traditional farm, where the land and humankind coexist, where the touch of *Homo sapiens* is light, has always been an ideal for me. I lived in the city of Toronto for some thirty years and tolerated it well enough, but I have spent the other fifty-four years of my life so far on various country properties in Ontario and British Columbia. I am a champion of the countryside.

Chaplin Crescent Winter, 1948. A Brown's bread wagon on delivery to my house.

I arrived in the maternity ward of Toronto General Hospital on the 24th of May, Queen Victoria's birthday. (The timing makes a kind of sense, for I have been an ardent monarchist all my life.) When she bore me, my mother was thirty years old, considered late for child-birth in that era. My parents lived in a modest house at the corner of Craighurst Avenue and Duplex Avenue, and we stayed in that house until I was six. My mother's mother and sisters, Agnes and Elsie, the latter as cheerful as the former was serious, lived just a few blocks away, so there was much visiting back and forth between the two houses—for Sunday dinners, for Thanksgiving, for Christmas and Easter and birthdays. We also had a "mother's helper," a woman named Marguerite, who helped Mom with child care. As I recall, we had two Ednas and one Pauline, who played similar roles throughout the early years. All these women in my life. I must have thrived in their care, for childhood seemed blissful to me.

Dad was a taciturn, gentle man, often with his nose inside a news-paper or a book. He had come from a long line of farmers in eastern Ontario; the men in that line said little and the women did all the talking. He had graduated from the University of Toronto with a de-gree in electrical engineering and was later employed by Canadian General Electric, first at its plant in Peterborough and then as head of the lighting service department at the Toronto facility. If you wanted professional advice on lighting your stadium, school or church, you went to my father. He met Mom when they both lived in the same Toronto rooming house, one floor apart.

My mother, Annie Maria McLellan, was born in Windsor, Nova Scotia. The McLellans, like the Batemans, were from Ulster, but my mother's family had originated in Kirkcudbright, Scotland. The fam-ily seat is McLellan Castle (now a ruin), which was also the early home of John Paul Jones, the best-known American revolutionary naval fighter. The McLellans arrived in Kings County, Nova Scotia, in 1775. Coincidentally, both the Bateman and McLellan Irish roots are in Derry.

My paternal grandfather, Joseph L. Bateman.

My maternal grandfather, Clemens DeBryers McLellan.

My mother's paternal grandfather, Ebenezer Cox, built thirty tall ships in tiny Kingsport, Nova Scotia. Those ships sailed the world, and their number included *Canada*, the largest wind ship ever built in this country. My Cox ancestors arrived in Massachusetts at the very beginning of the seventeenth century. My great-great-great-great-grandfather, Captain John Cox, was born in 1719 and moved with his parents to Falmouth, Mass., at the age of ten. He later met and married Sarah Proctor, whose grandfather had been executed for witchcraft in Salem in 1692.

As Loyalists, John Cox and his family were persecuted, yet they still raised the old flag. Then in 1782, under the threat of death from an American mob, the family piled into a boat one night and safely made it to Nova Scotia. Family lore has it that John Cox founded the village of Kingsport. His gravestone stands in Habitant Cemetery.

The family built ships in Spencer's Island, Nova Scotia, across the Minas Channel from Kingsport. We have a treasured picture of Mom from 1916, a girl of sixteen christening a sailing ship for the lumber trade, *The Minas Princess*. Spencer's Island is where my ancestors built and sailed the famous ghost ship the *Mary Celeste*, which was found adrift in the south Atlantic with all its accoutrements, even heaped dinner plates, undisturbed and no one aboard. No passengers were ever found.

Riverine waterpower, tidal shores, plentiful oak, tall timbers and special skills ruled both the shipbuilding industry and the waves. When coal-driven, ocean-going steamships could rival the speed of tall ships under canvas, the supremacy of Nova Scotia and its small but worldly ports came to an end.

My grandfather, a ship's carpenter, moved his family to where the coal was—Spring Hill, Nova Scotia, where he designed and built schools and churches. One of the latter still stands in Windsor, where Mom was born during construction. Mom travelled as a girl by horse-drawn carriages and cutters. Then her father bought the first car in Spring Hill, a Gray-Dort.

Eventually most of that side of my family drifted to Upper Canada (as they called it).

An impressive member of the bunch was my mother's brother Frank. At the age of sixteen, he went to sea on a commercial sailing ship; during the First World War he flew a biplane in the Turkish theatre. He described how he would sight a target below, reach to his feet to retrieve a bomb, and then drop it over the side of the plane. He was a successful dog-fighter against enemy aircraft, and was awarded the Distinguished Flying Cross of the British Empire. His medal and other regalia were loaned to a private museum in Oshawa. When it closed (unknown to the McLellans), all the items were auctioned off and lost to the family.

Uncle Frank, my mother's brother, who built our house on Chaplin Crescent.

Uncle Frank trained as a chiropractor, but that proved a poor choice for Spring Hill. He hung out his shingle and waited and waited for clients to appear, but none did—except one, who was referred to him in error. The story of that career was fodder for family mirth for decades.

Between 1934 and 1935, Uncle Frank built our house at 287 Chaplin Crescent. By then, his brothers and sisters and widowed mother had all gathered in the environs of Toronto and Oshawa. His maritime family had all responded to his note home: "The future," he had counselled, "is here!"

My Aunt Agnes lived with Grandma McLellan a few blocks away; Aunt Elsie, for a time, lived just a few doors up, on Russell Hill Road. Aunt Agnes eventually married Charlie Browne, a George Burns type whose observations on the news or modern times would have even youngsters laughing. Uncle Charlie earned the ire of Grandma; it was the poor fellow's luck to live in the same house with a teetotalling mother-in-law who pestered him. He was a connoisseur of fine tobaccos and renowned sherries, unlike our grandma.

My mother's other brothers were Newman, who sold building products in Saint John, New Brunswick; and Cyril, who retired to Huntsville, Ontario. Victor, the youngest, was a garage mechanic. Another brother, Jack, was killed while serving in the army during the First World War. He was killed not in combat but during a baseball game, when a line drive struck him in the heart.

The genealogy of my parents' families did not reveal much in the way of artistic ambition or accomplishment; when I looked into it, all I could uncover was an aunt who liked to paint pansies on tin plates. This made Aunt Elsie's husband, Bill Sennett, an especially welcome addition to the family. Soft-spoken with an English accent, sensitive and cultured, Uncle Bill was a top watercolourist in the advertising department of the Eaton's store, where he produced tasteful renderings of dining room suites and bedroom furnishings for newspaper and magazine ads.

He would play classical music recordings to entertain us, but insisted that the piece be listened to with respect for the music and the composer. If the room broke into chatter, he would lift the stylus off the record. When someone asked, "What happened to the music?" he would say, "Oh, I thought you weren't interested." Then he would delicately drop the stylus back down. But the minute conversation resumed and the music became background, not foreground, he would repeat the manoeuvre. (It was a technique I would later adapt to good effect in the classroom and at the podium.)

IN 1946, THE BATEMAN FAMILY embarked on a trek "down home," as my mother called it. Gas rationing had made such a trip impossible during the war years, and my mother was aching to get back to Kingsport and Spencer's Island, places on the Bay of Fundy that she once called home. I was the principal driver on that mission; I was allowed to drive most of the way as a "learner" as long as Mom was in the car. (I eventually got my licence on the third try, after being done in first by nerves, then by a missed stop sign.) We rented a cottage overlooking Minas Basin on the Bay of Fundy and spent the summer there. For me, it was a rare summer of idleness—playing poker for matchsticks with my cousins and not doing much of anything.

My only accomplishments were some sketches I made of relatives and their homes, and a watercolour of a fishing vessel anchored on a great expanse of beach at low tide (see art on contents page). I sketched the latter *en plein air* that July, and later made the sketch into an oil painting that still hangs in my brother Jack's house.

MY FATHER WAS QUIET and steady and level. He sometimes liked to wrestle and roughhouse with his young boys, but it wasn't until the grandchildren came later in life that one might have described him as playful. My mother, on the other hand, was bright and light all her

life, and unlike my more withdrawn father, she was a political animal who had opinions on everything.

She believed herself lucky and often said so: She felt blessed to have married into the Bateman clan, blessed to have given birth to three sons. She had attended finishing school at Acadia University in Wolfville, Nova Scotia, then secretarial school, and was working in an office when she met and married my father. Once I arrived on the scene, my mother became a full-time homemaker. My brothers, Jack and Ross, were born precisely three years and six years later.

As young boys, we cherished our mother's cooking, which was not always haute cuisine. The entire family went to church on Sunday morning, and Mom would put a roast in the oven beforehand. We'd have the major meal of the day after church. Then we'd be out of doors, on a hike through the ravine or a place nearby we called Woodland Glen; three kilometres to the east was Sherwood Park, at Lawrence and Yonge. Fall through spring, we would hike in these places, returning in the late afternoon to make a fire in the fireplace and haul out card tables and white tablecloths. Then came the treat: Velveeta cheese mixed with mayonnaise on white bread, broiled with bacon strips and topped with a slice of tomato. From time to time, Mom made what we called Grandma's brown bread. It contained cornmeal and molasses and glutinous flour. Moist and slightly chewy, it was always a treat, and a must with homemade baked beans.

Mom was the innovator in the family, always with a project in mind. The Protestant work ethic had a firm grip on her, and she frowned on indolence and lying about. She led by example rather than talk. Even in her later years, she was always doing something, whether at home or on a visit—reupholstering the couches at the cottage, cleaning the kitchen stove at my house. She rarely sat down. That instinct was passed on to me, as my children and adult friends would discover; I conscript them for work detail much as my mother conscripted her offspring. She was always pressing Dad, who seldom wanted to spend money, for one home improvement or another. If her

family could not fulfill my mom's plans—at least the ones requiring funding—the plans were stalemated.

In the house on Chaplin Crescent, we prized ritual, and never more so than at Christmas. Dad would hang little red wreaths in five windows of the house, including one in my bedroom, and one of my most cherished memories is of falling asleep while staring at the red glow from a single bulb at the base of the wreath. Another tradition was the front yard rink Dad made. Trees eliminated the possibility of hockey, but the three Bateman boys would skate there, circling the trees as we went.

On Christmas morning, we would assemble at the top of the stairs and sing a special song, one that perhaps my mother had brought with her from the Maritimes. It went,

> *"We just jumped out of our warm little beds,*
> *We come with a loud hoorah hoorah.*
> *We feel so happy we could stand on our heads,*
> *Hoorah hoorah hoorah rah rah."*

Then we would all march down the stairs to the living room to our stockings, hung by the chimney, and the sled or bike or surprise present that was set up there. Our dad, we were pretty sure, was behind the gifts, but the fact that we had left out food for Santa and that it was gone by morning seemed to point to Mr. Claus' existence. And the gifts under the tree would be opened one at a time, so they could be properly appreciated—not just by us but also by Aunts Elsie and Agnes and Uncle Charlie, who always came over on Christmas Day.

Thanks to my brother Ross, who transferred Uncle Bill's old 8mm films onto a DVD, I can look back at scenes from Christmas on Chaplin Crescent: Mom and Dad dressed to the nines, her playfully sitting on his lap and giving him a peck on the cheek. "That scene," opines my brother Ross, "looked like a cross between a Norman Rockwell

painting and a life insurance ad." The blond Bateman brothers, likewise dressed formally, can be seen admiring their new toboggan or manoeuvring a wheelbarrow. All of us gathered around the piano while Mom, looking radiant and joyful, played and led us in song.

Our church—St. James-Bond United, built in the Norman-Gothic style and set on Avenue Road—had an impact on my life, but not in the way one might think. When I was young, the congregation was segregated on Sunday morning—adults upstairs in the church, children downstairs for Sunday school, with the girls in one room and the boys in another. The thinking was that children would be bored with the sermons meant for adults, though I never was. Most of the adults, ironically, had little interest in religion. Church was more about making social connections among the bourgeoisie, including the Bateman family.

When I was in my late teens, I taught Sunday school to ten-year-old boys. What a great age that is, when the mind is alert and curiosity is infinite. I had to engage those impatient minds, and I remember using *Life* magazine, which had done a major feature on evolution, as a teaching tool. I had been spending my summers with wildlife biologists, so I attempted to marry what I had learned from them about evolution to the biblical version of creation. I told the kids that the Bible offered a lovely allegory about the evolution of humankind, and that allegory and fact were not so different from each other—except that one took place over the course of 24 hours and the other over the course of 24 million years.

Fast-forward a decade or so, after I returned from a round-the-world adventure with my friend Bristol Foster. I was twenty-nine years old, with no wife and not even a girlfriend, although I had been searching for the right girl for a decade. My mother never hesitated to make suggestions about anything.

"You should join the Young People's Club," she suggested, meaning the church group to which many of the sons and daughters of her friends then belonged.

"They're a different species from me," I told her. "I prefer the company of wildlife biologists."

"So," my mother came back. "You don't like my friends?"

"They're not like me," I explained. "I went to Africa and I learned to respect the pygmies too. But they're not my tribe."

"You compare my friends to pygmies?" my mother said, aghast.

This was a pivotal moment, one that reminded me that, while it seemed I was a member of a certain tribe—the United Church, for example, or my north Toronto neighbours—I actually felt quite removed from them. And yet I felt and still feel a kinship with that tribe, and those roots.

WILBUR AND ANNIE BATEMAN possessed inquiring minds, especially my mother. As my knowledge of the natural world expanded in my early teenage years, she was keen to hear and retain. It became apparent that I was born to be a teacher, an explainer, and my most attentive listener, always, was my own mother. She and I had much in common, not least the inclination to share enthusiastically the things we had learned or discovered since our last chat or visit. Her brother Newman was like that too, keenly interested to learn from, and share with, others. He was somewhat similar in appearance to the movie actor Keenan Wynn. His suit coat inner pocket was invariably full of interesting newspaper clippings. I remember his smile and that hint of cigar as he entered the back door after years of absence. I am like him in that regard (minus the cigar smell): I am always harvesting newspaper or magazine pieces in anticipation of pressing them into the hands of potentially interested relatives or friends.

What my mother taught me was the importance of generosity. For many years she would cook an extra chicken or turkey at Christmas and hand deliver a complete meal to a woman and her daughter who lived in a less genteel part of the city. My mother had been put in touch with this family through the church, and one year when I was

in my late teens she took me with her on this errand of mercy. Her charity was genuine.

Nonetheless, my mom had come to believe—and I would as well—that each of us is in charge of his or her own destiny. She believed passionately in self-improvement. She introduced us to Norman Vincent Peale and his book *The Power of Positive Thinking*, along with William James' nineteenth-century classic, *The Will to Believe*, which argued for the importance of faith in something (religious or otherwise) as a way of boosting individual confidence. My mom would quote Gandhi: "The best way to find yourself is to lose yourself in the service of others." And I took to heart her lesson about the futility of worry. I did a lot of fretting in my teenage years, when exams and girls were sources of high anxiety. "A hundred years from now," Annie Bateman would tell me, "you will neither know nor care about this."

The Bateman brothers were, and still are, very close. Jack would grow up to become the even-keeled one, the level-headed skeptic who years later would playfully mock my passion for healthy food, dubbing it "Bob's quest for immortality." Jack was quieter than Ross and I and preferred the company of small groups, though he rose to a leadership position as Ontario Fire Marshal from 1977 to 1990. Ross was the most sensitive, the one who wore his heart on his sleeve and was quick to rally to worthy and important causes. We were both high school art teachers. Although Ross had complaints about that career, I'm sure he was a very good teacher and absolutely a memorable one for his students.

Mine, as I said, was a happy childhood, but I was the ringleader of the three, and sometimes I would do things that didn't set the best example. Corporal punishment ("Spare the rod, spoil the child") was part of parenting then, but I remember only a few occasions when my father lost his temper. More to be feared was my mother's anger. She was the ever-cheerful one, and to lose that constant beam of warmth was cause for greater concern than to experience my father's rare outbursts.

The railway track in the ravine was where some of my mischief played out. Down the tracks was a trestle that spanned a creek, and neighbourhood kids would dare one another to sit under there while a train passed overhead. I wasn't normally a risk-taker, but one day when I was about ten, I decided to up the stakes by sitting on the end of a railway tie as the train passed by, the great wheels and pistons just inches from my head. My father lost his temper when he heard about that.

Another time, when I was fourteen, I sat in church with a friend of mine, and we got the giggles—while my parents sat in the pew behind us and did a slow burn. Once more, my father lost his temper when we got home.

III : THE BRODIE ROOM

The Brodie Room, on the restricted fourth floor of the Royal Ontario Museum in Toronto, stamped me early on as a birder and as a naturalist. In 1942, when I was twelve, my mother took me to the ROM, where I signed up with the Junior Field Naturalists' Club. Once again, Al Gordon's parents were influential. His father told my folks about the club, and his endorsement of it changed my life.

The inner sanctum of the museum became my home away from home. The ROM's first three floors, filled with galleries and exhibitions, were open to the public; the fourth floor was not. Members only, as it were. To be admitted to the fourth floor was to be a part of something exclusive. My only reason for being there was that initially this was where the bird-carving group met, and later it was the meeting place for the Intermediate Naturalists.

It's telling that the topic of my first public speaking assignment, delivered in grade 8, was birds. My knees were rubber, and I thought I'd faint as I gave a talk on how birds' names sometimes miss their mark. "What's in a Name?"

My fascination with mice is evident in this sketch. The scientific name of this mouse is Phenacomys ungava, *but the common name is* Ungava phenacomys. *It is a very rare subarctic vole.*

was the title of my speech, which remarked on the fact that the Bald Eagle is not bald, the Ruby-throated Hummingbird does not hum, and the English Sparrow is neither English nor a sparrow, but a weaver finch that originated in Africa.

The Junior Field Naturalists met once a month on Saturday morning, and over the course of two years I rarely missed a gathering. The morning was divided into two parts. First came a general meeting in the museum theatre, with a speaker on some topic to do with nature. Then we split into groups for specialized activities. The one I chose was bird carving, in the Brodie Room.

The Brodie Room was named after William Brodie, a dentist who had made so many contributions to the study of the natural world that he was eventually named provincial biologist. Born in Scotland in 1831, he grew up in a log house, on a farm in what is now Markham, and was home-schooled by his mother. A commemorative poem written after Brodie's death in 1909 paints a picture of the man—untamed hair and beard, high forehead, shaggy brow and deep-set eyes.

I was drawn to Brodie's story. He taught school for five years, then practised dentistry in Toronto for thirty-three years. But in his spare time he walked up and down the Don Valley ravines, much as I had done as a boy. Except that in the nineteenth century, those lands would have been near pristine. An amateur entomologist, he published forty-two scientific papers and accumulated a staggering collection of specimens: 68,000 insects, reptiles, plants and seeds. His collection would form the foundation for the Provincial Museum, forerunner of the ROM.

The Brodie Room was a small, plain space with long, narrow tables arranged in an L-shape. This meant that someone at the far end of one table could not see his counterpart at the far end of the other. For that reason, guest speakers and anyone chairing a meeting sat at the corner of the L. On the wall over the chairperson's head was a painting of Brodie himself, examining a specimen.

Our instructor in the Brodie Room was Frank Smith, a gentle,

grey-haired man who was patient with us children, mostly boys. He made a living as a pipe fitter but his passion was bird carving. He would start with a block of balsa, an extremely soft, lightweight but durable wood that he told us was used as a prime building material in the incredibly fast Mosquito bombers deployed in the war then raging in Europe and North Africa.

Using his band saw at home, he would cut out a bird's silhouette. These were generic patterns—sparrow, say, or thrush or chickadee shapes. Students in the class took over the carving, using these silhouettes as starting points; our tools were extremely sharp knives with egg-shaped handles. But sometimes the balsa had streaks of hardness in it, and one day, when I was trying to create a notch between the wing and the tail of my carving, I cut deeply into my left thumb, leaving a wound more than two inches long.

In those days, one didn't rush off to hospital emergency departments for stitches. I was whisked down to the basement, where my thumb was heavily bandaged, and I was given a cup of sweet tea to counter my pallor and offset the shock. I remember feeling that I was being well looked after by adults who knew what they were doing, but nowadays a wound like that would require stitches.

The basement of the Royal Ontario Museum was the domain of a man named Cliff Hope, then in his early thirties and chief preparator in the division of ornithology. Cliff had personally acquired many of the birds, nests, eggs, insects and mammals in the museum's collection, and he also presided over the museum's dermestid beetles (also known as skin beetles), which fed on skin and dried flesh and were used to tidy up the skeletons of mammals. These little larvae could get into the nasal passages of mice, for example, and clean them handily. At one point, there was a full lion carcass down there—food for the beetles. It was all part of the fascination of the place.

Cliff's tea worked its magic, and the feeling of shock subsided. I kept those bandages on for the longest time. Eventually the wound healed, but to this day the movement of that crooked thumb is restricted.

I continued with the carving classes for another five years. By the age of fourteen, my bird carvings were acknowledged as better than anything being produced in the class, including the carvings of Frank Smith himself. I was able to capture the birds' faces in a way that others could not. When I was twenty, I carved a Screech Owl for my mother as a Christmas present.

What with the Elk when I was twelve and the Screech Owl eight years later, I was starting to use my art as gifts, which I still do to this day. Bird carving contributed to my later development as a bird artist, for it offered insight into the three-dimensional world. For decades, before modern photography and computer imaging, I made Plasticine models to test poses and help me capture the three-dimensional forms of creatures. Bird carving was the forerunner of that practice, exacting work that also demanded precision in observation and in execution.

The most memorable and exciting part of those Saturday mornings was the hours after the club meeting, when a few of us would prowl around the museum. Because we were naturalists, the third floor, with its stuffed specimens and enchanting dioramas, became our paradise. Between the cases were paintings by Arthur Heming. The title of one of his books, published in 1921, says all you need to know about him—*The Drama of the Forests: Romance and Adventure.*

Heming produced dramatic and realistic oils in grey, black, white and yellow. (I later learned he was colour-blind.) The subject matter was the Canadian north, with its wild animals, native hunters and coureurs de bois, irresistible to a young boy's imagination. By this time I was reading avidly, not only Arthur Heming and Ernest Thompson Seton but also Sir Charles G.D. Roberts and Jack London. Every two weeks I would hop on my bike and ride the almost three kilometres to St. Clements Public Library, at the corner of St. Clements and Yonge St., and come back with my carrier full of books.

I reread most of Roberts' and Seton's tomes every year. As I got older and as my mom's self-improvement streak rubbed off on me, I

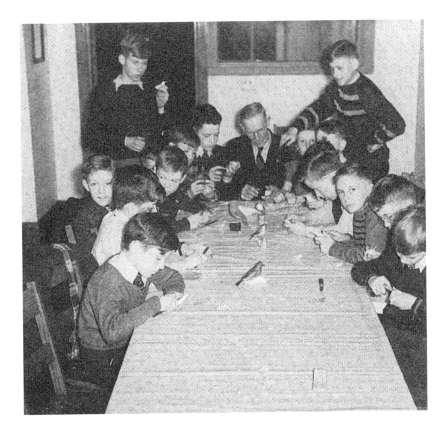

would search out books in the library that I thought would be instructive. Sometimes I sought books mentioned on CBC Radio interviews I had heard. In my late teens or early twenties, I tackled the heavy-duty *Seven Pillars of Wisdom* by T.E. Lawrence and Ernest Hemingway's mighty work on bullfighting, *Death in the Afternoon*. About the same time, I devoured a book encapsulating the work of famous philosophers through the centuries.

One philosopher whose ideas stick with me today is Baruch Spinoza, who lived in Holland in the seventeenth century. He held that resentment was bad for one's constitution, so he refused to resent anything or anyone. Often his friends would tell him, "So-and-so is using you and doing you a disservice." He would say in reply, "I

don't want to hear it, and I don't want to think about it. The sun is in the sky, God is in His Heaven and all is right with the world. Dwelling on somebody using me would not be helpful." That seemed to me an admirable attitude. My philosophy is: I'd rather be "used" than useless.

MANY OF THE GREAT PAINTERS of the world were self-taught, and I maintain that it's a viable alternative to formal schooling in art. I did teach myself a great deal when I was young (and still do so), but it's also true that I had some very good teachers along the way.

In my late teens, I won a scholarship from the Junior League of Toronto (my mother belonged to this benevolent charitable organization). That fund allowed me to go every weekend for several years to the Arts and Letters Club on Elm Street, where I was taught by Gordon Eastcott Payne. He was quiet, gentlemanly and inexpressive, but he was also a man of great depth and background. He was what's called an academic painter, one who painted landscapes and still lifes before the Impressionist revolution came along. Payne knew how to create shadows and atmosphere. From him, I learned how to lay on linseed oil (I use walnut oil now) in order to meld yesterday's work with today's. The oil allowed day-old paint to bond nicely with the fresh stuff.

My brain was full of myriad invaluable lessons Payne taught in those intimate classes of two or three students. One of the books we used was *Cézanne's Composition* by Erle Loran. From that work we learned that in painting we were not reproducing a world but creating a new one, and that we were free to break rules and play with its elements.

As I MOVED THROUGH my teenage years, the Brodie Room continued to exert a powerful influence on my life and that of many others. Constant was our interest in nature, fuelled by a steady stream of

guests, some of them professors at the University of Toronto, who either gave talks or led us on field expeditions. My fellow naturalists became my closest friends, and it's astonishing to consider how the Brodie Room led these people into related professions. Bristol Foster went on to become a prominent scientist; Al Gordon, a forest ecologist; Don Smith, a professor of zoology.

After the war, a number of returning veterans entered the Brodie Room circle, and one of them, a naturalist named Yorke Edwards, taught me how to skin and stuff mice specimens. While working at summer jobs during my university years, and during travels afterwards while in my twenties, I collected small mammals to donate as specimens to museums. I sometimes say that if I go down in history, it will be through my mice and bats and shrews. I note with pride that I have specimens in the Royal Ontario Museum, the National Museums of Canada, the American Museum of Natural History in New York, Chicago's Field Museum of Natural History and the Natural History Museum in London. You can go to the mammal departments in these museums and pull out a drawer, and there will be a specimen that might say, for example, "Robert Bateman, 1953."

One year, I was a field assistant with the Geological Survey of Canada, accompanying a party of geologists in western Newfoundland, near the community of Burnt Pond. On a clear night early in the trip, I ventured out with about three dozen mousetraps and my usual bait of oatmeal and peanut butter.

"What have you got there?" one geologist asked me.

"Mousetraps," I said, a little embarrassed.

"Do we have a problem with mice?" he asked, sounding alarmed.

"No," I told him. "I'm collecting specimens for the Royal Ontario Museum."

Several sketches from that summer illustrate the two convergent impulses that drove me. One sketch, a life-sized painting of a bat, reflected my interest in biology. Like my friends, I saw myself as a budding scientist, but a scientist who was also an artist, carrying on his

walks a clean and empty mayonnaise jar to gather plant specimens, à la Darwin. Another sketch, a watercolour, depicts one of those gathered specimens—a shinleaf plant, *Pyrola grandiflora* (see colour insert). After many years of experimenting with other styles of art, in my mature art I combined both interests.

When members of the Junior Field Naturalists turned sixteen, they were considered too old for the ranks. As teenagers, we viewed the senior field naturalists, who were middle-aged or older, as a bunch of old fuddy-duddies, "little old ladies in tennis shoes," and we didn't feel we belonged with them either. (Now, of course, little old ladies

I sketched this from a fresh-caught Least Chipmunk specimen. I would prop them into lifelike poses as shown. This little critter—along with countless others—may very well be RIP in the ROM.

in tennis shoes are among my favourite people.) I couldn't bear the thought of putting the club behind me, and so I asked if I could come back as an instructor. And so, in our late teens we decided to create a club. We called ourselves the Intermediate Naturalists (forerunners to the Ontario Field Biologists), and thus was I able to maintain my connection with the ROM.

In a way, I was following the advice of someone who had impressed me at a high school assembly. The guest speaker on one occasion was a world traveller who had spent time in Africa and made a name for himself stalking lions. He gave advice on growing up and becoming who you wanted to be. "Be whatever you want to be," he told us, "and associate with like-minded people. If you want to be a garage mechanic, hang out with mechanics. If you want to be a millionaire, hang out with rich folks." I thought there was wisdom in that. Perhaps his advice simply buttressed what I was already doing: I was a naturalist who sought the company of other naturalists.

In those days, museum staff worked on Saturday mornings, and so a few of us were able to become museum groupies in the afternoon, lingering behind the scenes in two different departments, Ornithology and Exhibits. One of our teachers was Jim Baillie, then the best-known birder in Toronto thanks to his weekly column in *The Toronto Telegram*, a feature that ran for almost forty years. He was a lanky, red-haired, amiable man who resembled Gary Cooper. Jim was quiet and soft-spoken, just like the actor, and everyone loved him. At the time, he was the curator of collections at the ROM, where he was employed for almost fifty years, and he generously treated us almost as peers. But Jim possessed no postgraduate degree or formal training in ornithology. Sadly, he was eased out of the museum as it increasingly turned to the expertise of young PhDs.

The other important person to me at the ROM was Terence Shortt, whom we were encouraged to call Terry. Then considered the dean of Canadian wildlife artists, he was the brilliant head of Exhibits at the museum and had created some spectacular dioramas. My favourite

was the Passenger Pigeon display, formally called the Passenger Pigeon Habitat Group. I would stand for long minutes, contemplating the scene of an early spring hardwood forest in pioneer times, when the flocks of these birds were so abundant.

The display was unveiled in January of 1935. The last Passenger Pigeon had died in 1914 at the Cincinnati Zoo. Only thirty years before that, Passenger Pigeon flocks darkened the skies, sometimes for days, as they passed overhead. The Atlantic cod fishery disappeared in the twentieth century and the Great Plains Bison during the century before. We live in a disappearing world, and the Passenger Pigeon diorama was my first lesson in species extinction by human hands.

Terry Shortt worked at the museum for some forty-five years. He was a warm human being who knew more about nature than I ever will. During a summer trip one year, I chanced across an unfamiliar feather and slipped it into my Peterson Field Guide. When I got back to Toronto in the fall, I showed it to Terry.

"Can you help me identify this feather?" I asked him.

"I'm not sure," he said. "It looks like the third or fourth primary feather from the left wing of an immature female Goshawk," he said. Then we went to the museum skins drawers, which gave off a powerful whiff of moth repellent whenever one was opened. The bank of drawers—each some three feet wide and three feet deep and arranged in a floor-to-ceiling fixture—were set off in a room behind a sturdy steel door as protection against moths. Terry took from one drawer a stuffed immature female Goshawk. The feather matched. Third primary. Left wing.

A sketch of mine—a White-throated Sparrow dated July 3, 1947—always reminds me of Terry. One of us had caught the creature in a mousetrap; perhaps the bird was going for the bait or landed there by mistake. The sketch shows the bird in two poses, one with the beak open, the other closed. Terry urged us to make careful renderings of the soft parts of the anatomy, the mouth and beak, because they are the first to atrophy.

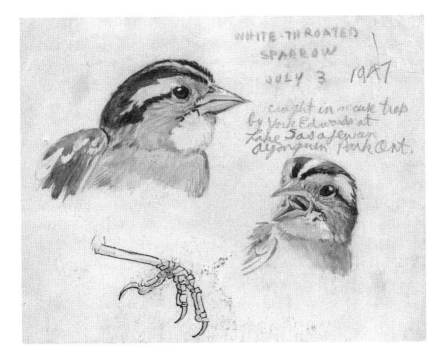

WHITE-THROATED
SPARROW

JULY 3 1947

caught in mouse trap
by York Edwards at
Lake Sasajewan
Algonquin Park Ont.

One of the many satisfying aspects of my summers at Lake Sasajewun's Algonquin Wildlife Research Station was doing the bird census. This is a White-throated Sparrow I sketched in 1947.

Several years ago, I went back to the Royal Ontario Museum and was horrified on two counts. First, the dioramas were all gone.

"Where are they?" I asked.

"In storage in Oakville," I was told. I seriously doubted that the dioramas could have been moved without irrevocable damage. I also saw for the first time the external addition to the museum, a crystal configuration designed by architect Daniel Libeskind and built in 2007. I agreed with legendary architect Arthur Erickson, who remarked, "It looks like something I would take down after Christmas." To me the addition is a waste of money and a desecration of heritage.

BY THE TIME I WAS IN HIGH SCHOOL, the drawing and painting habit had fully taken hold. In every class, it seems, there is a class clown and a class jock; I was the class artist. And eventually at Forest Hill

Collegiate, I was seen as the school artist. I did drawings for the yearbook and was especially busy during one year when I had to repeat French and chemistry (but only French and chemistry) after coming up with failing grades in both subjects. That year, I spent more than half my time working for the yearbook as co-editor.

One of my yearbook drawings was of Miss Robinson, the teacher who had failed me in French (she would insist that she had not failed me, but rather that I had failed myself—which is true). I portrayed her in the yearbook as a swish fashion model, with her hair in a flip and an impossibly thin waist. I did posters to advertise football games and dances. I painted sets for school plays and took the role of Dick Deadeye in the school's production of Gilbert and Sullivan's *HMS Pinafore*. (I still love the music of Gilbert and Sullivan, which is much under-rated and often dismissed.) And I made my first art sale when the science teacher at Forest Hill, Hiles Carter, asked for my little painting of a cardinal. I was happy just to give it to him, but he insisted on paying. "No," he said. "I want to pay for it so I can claim to be the first to buy a Bob Bateman." I charged him a dollar.

As I had done since the age of twelve, I continued to paint in the sunroom studio on Chaplin Crescent. Thanks to the Bateman family diary, hard-bound and lined journals where my family recorded the minutiae of our lives, I know that on April 5, 1947, as recorded by Jack, I won $75 in an art contest sponsored by Robin Hood flour. Then, on May 24 of that year, a bunch of us went to a woodlot in Woodbridge and climbed a tree to view a Red-tailed Hawk's nest. A sketch, with the date clearly visible, records the find. (I should add this caution: do not do what I did as a teenager. One should not disturb birds' nests.)

Here is Ross' entry in the diary for November 20, 1948: "We just got back from Buffalo. We went there Saturday morning and stayed at Hotel Buffalo Saturday night. We saw television and then went to a show. Today we went to the zoo, the art gallery, and the museum where Bob has some bird paintings on exhibit—they are going on a

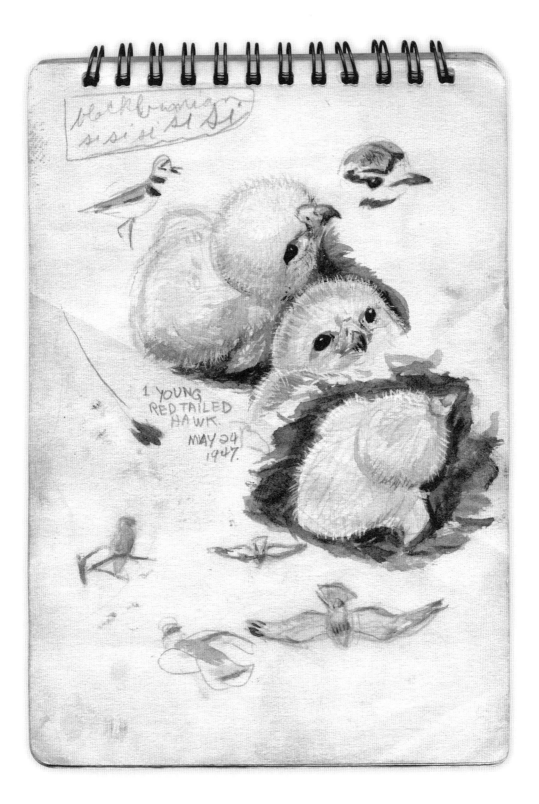

black browngrrrr
si si si si si Si

1 YOUNG
REDTAILED
HAWK.
MAY 24
1947.

tour of the United States." These years were marked by steady encouragement, though I didn't take it too seriously.

My graduation yearbook featured a photograph of me that seemed to capture the height of my dorkiness: blazer, polka dot tie, forced smile. Above my name were three words, "Old Master Painter," and below, the notation "Always Says:Yawn!" a reference to a time I famously fell asleep in class. "Ambition: To replace Norman Rockwell, Milton Caniff (he drew the *Terry and the Pirates* comic strip), Tom Thompson [sic], Picasso, Walt Disney, Salvador Dali, and Burl Ives"—a nod to my singing and guitar strumming. Under "Future Fate," it predicted "Sidewalk Portraits."

After graduating from high school in 1950, I went to the University of Toronto's Victoria College, where I studied geography, in no small part because it meant field trips to remote locations where I could continue to sketch and photograph and paint in natural settings. Part of me wished I could pursue a degree in biology, but I lacked math facility, so that was never really an option.

At first, my plan was to take what was called "pass arts," the equivalent of today's three-year B.A. But then I decided to pursue a four-year degree, convinced that the Honour year would serve me better. Had I opted to skip the odd class, my absence would have been surely noticed; my fourth-year honour geography class comprised just seven students, five men and two women. But in fact, I never skipped class. It didn't appeal to me to hang out with those playing bridge in the common room.

While at the university, I took life drawing with Carl Schaefer, a distinguished painter who introduced me to Kimon Nicolaïdes and his book, *The Natural Way to Draw*, first published in 1941. Nikolaïdes was a Greek American who had served in the First World War as a camouflage artist. He distinguished between contour drawing, which essentially captures the outline of what you intend to draw, and gesture

drawing, which captures the essence of the subject in a few bold and rapid strokes. With practice, anyone can do the former; being good at the latter is a gift you are born with. You either have the ability to draw with economy of line and dynamic energy or you don't.

Carl Schaefer had been commissioned by the Royal Canadian Air Force as an official war artist, and the Canadian War Museum holds his collection of more than 200 wartime watercolours, sketches and diaries. "Some of my best friends died in the war," he once said. "When you see that much death and you are away from your native land, it colours your whole life. When you come back to normal life, you are changed. You can't explain why, any more than you can explain the taste of sugar." A black-and-white photograph taken of Schaefer in his forties—his age when he taught me—shows him wearing a great-coat, a tartan scarf and a somewhat hangdog expression. His nose is strong and his thick hair is jet black, matched by a trim, full mous-tache. There's a strong resemblance to George Orwell.

Schaefer was well aware that some students were more interested in ogling nude females than in learning to draw. This was the early 1950s, when even the strippers on Spadina Avenue wore tassels and bikini bottoms, or so I was told. Schaefer weeded out the gawkers by making sure that the first four classes in September were devoted to drawing pumpkins and corn.

He was an expressionist, post–Group of Seven. "If you can't paint it with the back end of a broom," he would say, "it's not worth paint-ing." His most damning critique of a work was to call it "precious."

I remember classes in which he would give us precisely three sec-onds to capture the gesture of the nude model—bending forward, be-seeching, pointing. "Change pose," he would instruct the model, and we'd have three more seconds to convey this new frame. Then he'd say to us, "Finish it in ten seconds." Then we'd be given three more minutes. Then twenty. The key was that we were to be self-critical, and if we hadn't caught the spirit of the pose in those first few strokes, we had to correct and correct again.

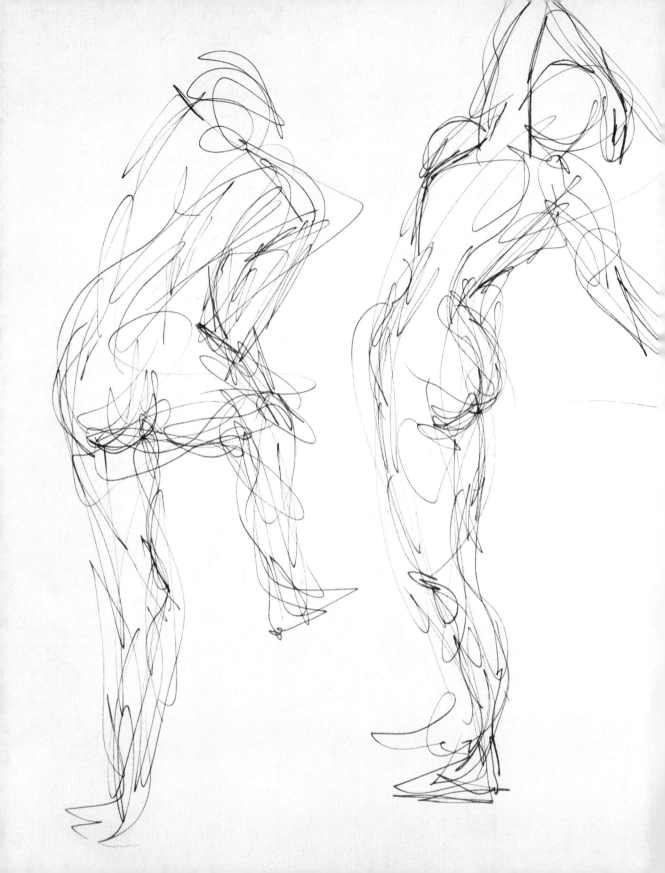

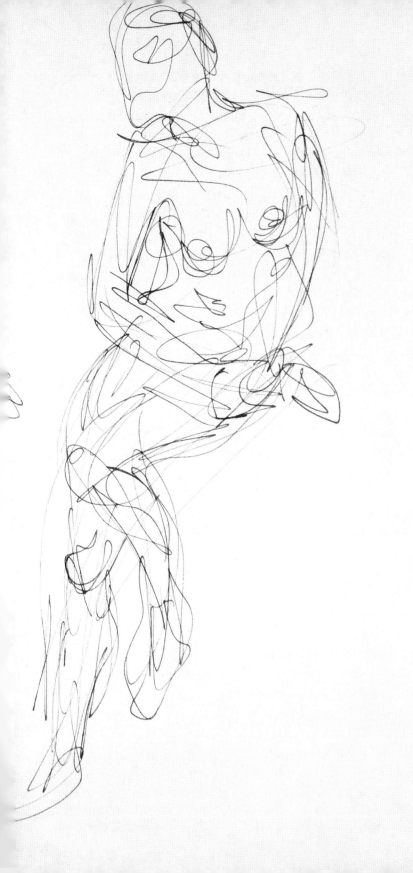

Some of my life drawings from Carl Schaefer's class using Kimon Nicolaïdes' The Natural Way to Draw.

I had sketched since I was a boy, but Schaefer taught me to draw with speed, always aiming to catch the essence of my subject in a few strokes. I would apply that knowledge when I wanted to portray a Killdeer doing its broken-wing act, or the way a Red-winged Blackbird holds its wings or the way water cascades down a waterfall. Just as method actors immerse themselves in their roles by virtually becoming their character, I approach sketching in the same way. I try to put myself inside that bird or that waterfall. If you think it, it will come.

John Singer Sargent (1856–1925) was my hero in this regard. Sargent would think ten minutes before making a particular stroke, then execute it in three seconds. Tom Thomson, who profoundly influenced the Group of Seven members who came after him, worked in the same way. The strokes are a record, a moment in time before the painter presses on. With the great academic painters such as Sargent and the Spaniard Joaquín Sorolla, you could see the paint if you got close to their work. But when you stepped back, you felt like you were staring at a photograph.

A writer once told me about her approach to her craft, how she wrote quickly and almost instinctively during a first draft but then went back at it, cutting and subtracting, fine-tuning, first on the screen of her computer and then with a pencil on hard copy. "That's it exactly," I told her. "You rewrite and rewrite. I draw and redraw, constantly correcting. That's the story of my life. I try to apply it to my own behaviour and I certainly apply it to my art."

Carl Schaefer was a bit of a curmudgeon, but I became his class monitor. I got to class early and paid the model, I tidied when the students had left. After class, he'd give me a lift almost to my house, dropping me off at Eglinton and Avenue Road, granting us time for long chats. Sometimes he talked about living in London during the war, and trying to find his way home during blackouts. Each flat, he said, had its own coal fireplace, so that soot plus pea soup fog, coupled with covered windows, meant he had to practically find the route by

touch. Even the headlights of passing cars were taped, with thin slits emitting the only light he had to navigate by. One night, he finally got to what he thought was his flat and inserted the key. It was the wrong flat, and back he went to his voyage in the dark.

Years later, a former teaching colleague told me about a conversation he'd had with Schaefer. Carl had seen a book of mine and pronounced, "Robert Bateman has gone way down. He's gone all precious." There was an element of truth to that, and it pained me slightly to hear it spoken. My style was not as loose as it had been. I still had in me those earlier influences—Impressionist, abstract, expressionist, cubist—but apparently not enough to satisfy my old teacher.

WHEN I LOOK BACK ON MY LIFE I can see that a great deal of luck came my way. In 1947, that good fortune brought me to the Algonquin Wildlife Research Station in south-central Ontario, some 300 kilometres north of Toronto. My time there was a life-changing experience, a case of being in the right place at the right time.

A fellow student at Forest Hill Collegiate was Bob Crosby, whose father held a senior position in what was then called the Department of Lands and Forests. Bob was not exactly a close friend, but I knew him well enough. In any case, he got a job working at the research station, not a posting he particularly wanted. Bob thought he was being tossed into the briar patch and he complained to his father, "I won't know anyone up there." To which his father replied, "Find a friend to go with you." Bob picked me. I had been born in the briar patch, and I saw this assignment as a plum job.

The research station was located at Lake Sasajewun, actually a swelling of the Madawaska River. The area had been logged many years before and was now a wilderness—virtually sacrosanct—where graduate students could do their work in biology. The year 1947 marked the camp's second year of operation and the first of three happy summers I would spend there.

Accommodation was rustic. Set up on wooden platforms were tents made of white duck cloth with a fly overtop as added protection against the rain. My job was grunt work: making road repairs, digging garbage pits and helping with dishes. Our cook, a happy-go-lucky Frenchman named Jacques Pigeon, didn't believe in washing dishes in the traditional way. He would simply drop all the plates, utensils and pots into a huge galvanized tub, sprinkle in soap flakes, add boiling water and stir. My job was to dry, but owing to Jacques' unorthodox methods, I would end up having to use the dishtowel to clean egg-encrusted forks.

The great bonus of the job was that I got to do the bird census. I would walk up and down the grid lines in the forest and either listen for or watch for species. The male Scarlet Tanager, for example, is a gorgeous bird with a blood-red body in high contrast to its black wings and tail. But because these birds prefer the high canopy, they are hard to spot, so I would have to listen for the call—like that of a Robin with a sore throat. The Rose-breasted Grosbeak, another gorgeous bird with flashes of black, white and red, sounds like a drunken Robin. And the Red-eyed Vireo, an olive green and white songbird and one of the most common birds of the eastern woodlands, also has a distinctive call. This bird sounds like it's in conversation with itself. "Where are you?" the first half goes, followed by "Here I am!"

Sometimes I would help with autopsies of mammals, mostly deer that had been struck on the highway, but on one occasion a bear. One fellow at the camp was skilled at throwing a knife; he could toss it end over end and it would land with a shudder in the trunk of a tree. The highways department had dropped off a dead bear at the camp, and we would need a skilled knife tosser. By the time we got to the bear, gases had built up inside its abdomen. The belly was swollen and taut like a drum. From a distance, in order to avoid the worst of the nauseating smell, the man tossed the knife and out poured the gasses.

I was soon up to my elbows in blood and guts. It wasn't pleasant, but I could handle it. We were looking for parasites by sifting every

bit of the bear's intestinal contents through a sieve with a bucket of water. We found that bears that frequented garbage dumps had no parasites. We also discovered in their stomachs much that didn't belong there, such as cigarette packages and dishcloths.

Deer, on the other hand, were often thick with parasites. Bot flies, pernicious creepy insects, would lay their larvae in the nasal passages of the poor deer. The flies would dive-bomb their ears and nostrils, and soon the deer's sinuses were full of maggots. I remember that sound so well: deer in the forest trying to get rid of maggots and sounding like so many dogs sneezing.

My other task was to gather scientific data, and that meant attending to the trap lines set out to capture small mammal specimens for the Royal Ontario Museum. There was enough of the cold-blooded biologist in me that I never felt bad about ending the lives of these mice and shrews. On the contrary, walking that line to see what lay in the traps was for me like opening gifts on Christmas Day. Sometimes I would live-trap the little mammals and I'd clip their toes with nail-clippers so we could identify them if we caught them again. Clearly, I was no bleeding heart.

One creature I did feel sorry to see in a trap one summer day was a flying squirrel. One foot had been caught and it had died of shock. Looking at its soft, luxurious fur, I thought it one of the most beautiful creatures I had ever seen. I still have that stuffed flying squirrel in my possession, and I remember with clarity every encounter I have ever had with a flying squirrel. One time I was in a forest at Hogg's Hollow in what was then

north Toronto and I knocked on a dead tree, hoping to flush a Flicker or an owl. Out popped the endearing faces of four curious baby flying squirrels. Living under canvas at the research station, I looked forward to hearing a local flying squirrel that was in the habit of using our tent roof as its own personal trampoline

Another creature I very much admired was the Jumping Mouse, or *Napaeozapus insignis*. One of the most striking mice in the world, it is pure snowy white below, with strong clear orange sides and a grey-brown back. A tail three times the length of its body and extra-long hind feet give the mouse its great jumping ability. It was a thrill for me to see one, even one that had perished in my trap.

In the main, and even then in my late teens, I was not inclined to mourn the loss of individual members of a species. I did admire their beauty and I did pick up their bodies with reverence. But I was more concerned with the overall health of a species, especially if particular bird or animal populations were threatened. Years later, I would ponder the different approaches of two naturalists in Africa, Joy Adamson and Jane Goodall. The former was able to raise a great deal of money, which she would use to rescue and rehabilitate a wounded jackal, for instance. I was more worried about the state of the elephant population, even more so today when an elephant dies at the hands of poachers every fifteen minutes on that continent. Jane Goodall, the primate specialist and someone I count as a friend, certainly cared for individual members of the primates she got close to, but she, too, takes the view that preserving habitat and healthy populations outweighs the fortunes of individual creatures.

In the same vein, I accept that, unless the species are being depleted, hunters can actually be beneficial for an animal population. I'm more worried about farmers using pesticides and cutting down hedgerows than I am about hunters. And, of course, agri-business is the worst.

So I did not say a prayer at the research camp when I came across a dead deer mouse or a short-tailed shrew in a trap. More often than

not, I would skin the animal and stuff it, and offer it to the museum as a specimen. My inspiration in this was taxidermist and wildlife artist extraordinaire Allan Cyril Brooks (1869–1946). He was born in India and served in the Canadian Army as a major during the First World War. The son of an ornithologist, and indeed named after an ornithologist friend of his father's in India, Brooks started out as a game hunter and specimen collector. But he soon turned to illustration, and in time *National Geographic* was accepting his work. He became one of the foremost realistic bird painters of the early twentieth century, and he illustrated several books, including *Birds of Canada* when it was first published in 1934. The ROM regularly displayed his paintings in its rotunda.

Stuffing a bird so the creature looks natural is hard to do; I always did museum study skins which are stereotyped to fit into storage places. Brooks did the same thing and his specimens were works of grace. In his paintings of birds, however, he tended to glamorize his subjects, making them look fluffy and chubby. By sixteen, I had painted every hawk and owl of North America. I still have that series of small pieces in a scrapbook. Each painting was based on many reference sources, just as my paintings are today. My style imitated that of Allan Brooks because I liked the fluffed-up way he depicted his birds.

He employed gouache and was an opaque painter; that is, one who lets the paint itself create the brightness. A transparent watercolourist, on the other hand, allows the paper to transfer brightness. I have been pretty well opaque in my art ever since experiencing Brooks' work.

Every chance I got at the research station, I would paint *en plein air*, in homage to, and in imitation of, the Group of Seven. Dad had built me a painter's box, with compartments for my palette and Masonite panels. Of course my work did not measure up to that of my heroes, though I shared their suffering from black flies. The ones that didn't bite me perished after flinging themselves at the gooey paint.

At the age of eighteen, I joined an informal group of folk singers. Several of them were attending the Ontario College of Art. Among them was Chris Adeney, who was twenty and therefore much more sophisticated and mature than me. He liked my little bird paintings but said they were not real art. For real art, he said, you need a big brush and you slap on the paint in a bold manner. Remember, this was 1948. The Impressionists, the Post-Impressionists and the Group of Seven were becoming mainstream for those who were interested in art.

I never expected to make a living at art, as a very few artists then did. It was impossible to generalize, but I knew that most artists had either patrons or day jobs. On the other hand, I knew that I would always be an artist. And wanting to be *au courant* as an artist, I abandoned the small brushes and became an Impressionist.

I would head out into the bush after supper and a pick a spot to paint and work until it was too dark to see. In the darkness one particular night, I opted to take a shortcut back to the camp and became hopelessly lost. There was no moon to guide me, only stars. The sensible thing would have been to retrace my steps, follow the stream back to the road and walk to the camp from there. But I pushed ahead,

unknowingly veering ever to the left. The knee-high bracken concealed hollows; I would drop into them and bang my shins on deadfalls. I finally came to a rise that gave me a glimpse of Lake Sasajewun. Then I had my bearings and could find my way home. In that fading light of the night, I had been applying paint that I thought was black. In the next morning's light it was revealed as alizarin—a cool, crimson red.

I CANNOT OVERSTATE THE IMPORTANCE of those summers at the research station to my life as a naturalist, to my development as a painter, even to my capacity for critical thinking. Every Friday afternoon, on the slope leading down to the lake, in a grove of spruce trees, the grad students would take turns delivering progress reports on the research they were doing. A lectern had been set up there, and the budding scientist would outline his findings before his fellows.

Some of the audience members were senior biologists, and some were veterans who had served in the war. Their critique might go something like this: "So you're sampling rough grouse populations by counting droppings in a square metre every sixty-six feet, and you're changing directions every week. What makes you think that's a random sample?" Not an attack, but a polite challenge meant to help the student improve his thinking. Kindness was not the issue; malice was not the intent. It was all done with thoughtfulness and generosity of spirit. What an eye-opener this was, teaching me to welcome constructive criticism whenever it was offered.

One of my companions at the station was a brilliant young ecologist named Bob MacArthur. He was my age but already a university student and far ahead of me intellectually. Around the campfire, he could thoughtfully discuss the ideas of Charles Darwin or Immanuel Kant, then pick up a guitar and sing the folk songs of Pete Seeger or Woody Guthrie. (My joke is that I started playing guitar in 1947 and my skill plateaued in 1948. Even today I can play any camp song—as

long as it's in the key of D.) Robert Helmer MacArthur would go on to become a world-famous ecologist and one of the founders of evolutionary ecology.

All this seemed very far removed from north Toronto. At a research station in the wilderness, I was encountering a new tribe—men in blue jeans and plaid shirts who could sharpen an axe and find their way in the woods. They were rugged but refined, intellectual but also capable of zaniness. At lunch we would have poetry readings, perhaps from the works of T.S. Eliot, or we'd read from Arthur Conan Doyle's *White Company*, a somewhat lighthearted look at King Arthur and his roundtable. The more senior grad students took on the noblemen roles, while I, the most junior, was Acting Serf Without Pay.

I realized then that, unlike so many of the north Toronto tribe into which I'd been born, I would never work in an office.

IV : AROUND THE WORLD IN
FOURTEEN MONTHS

In the spring of 1957, when I was barely two years into my first full-time job after university, my friend Bristol Foster asked me this question: "How would you like to go around the world with me in a Land Rover?"

At first, this seemed to me an outrageous idea. He was talking about a year-long trip, maybe more; I'd have to quit my job, dip into my savings. Bristol said he would give me a week to come up with five better reasons why I shouldn't go. In the end, I couldn't come up with any. We pulled out an atlas one Sunday afternoon and plotted our course. For both of us, the guiding principle was to go where the wild animals were, and that made Africa, Asia and Australia prime destinations.

The whole trip, we thought, could be chronicled and partially underwritten by a series of dispatches, "letters home," that *The Toronto Telegram* might agree to publish. My sketches would accompany the letters so that readers could enjoy an intimate sense of our journey and the sights along the way.

Bristol and I pose in the Grizzly Torque before setting out on an epic journey.

That was one purpose for the sketches and drawings I would make, but not the sole incentive. Visual record keeping was my equivalent of the daily diary. My sketches were invariably dated and identified, primarily a log of encounters with wildlife, but also with people and places. Painting might be physically cumbersome while on the road, but sketching was like breathing to me—instinctive, routine and comforting—a way of taking hold of what passed before my eyes.

Making art was also a way of paying attention, of truly seeing the landscape. The focus required to draw or paint a scene revealed what mere looking could not. Vincent van Gogh declared that "art demands constant observation." One of my early heroes, John Singer Sargent, was more expansive: "Cultivate an ever-continuous power of observation. Wherever you are, be always ready to make slight notes of postures, groups and incidents." And he added, "Above all things get abroad, see the sunlight and everything that is to be seen."

Those words resonated. This trip, like all of the ones that followed, was never about escape or restlessness. I did not have itchy feet then, and I do not have them now. It was the opportunity for discovery that took us away.

My companion for the journey could not have been more agreeable. Like me, Bristol had grown up near ravines, in his case the Blythwood and Don Valley ravines a few miles north and east of our house on Chaplin Crescent. He had explored them just as I had explored mine, and was similarly bewitched. He, too, was a Junior Field Naturalist at the ROM, and he grew up with a burning ambition to be an explorer, a scientist and an adventurer. On all three counts he succeeded.

Bristol's father, a fundraiser for the federal Liberal Party, was a man of some means, and he agreed to bankroll the purchase of a brand new Land Rover with an ambulance body. I shared in the cost of shipping the beast, as well as fuel and food and lodgings, though we knew the latter would be minimal, since we had bunk beds built inside the vehicle, along with a mosquito netting system that dropped across the back doors. To pay for all this, I raided my savings.

I actually had savings, due in no small part to the fact that I was, at the age of twenty-seven, living rent-free in my parents' house. As an environmentalist acutely aware of his own ecological footprint, and as someone who valued family, I didn't see any sense in paying rent, not when such money could be spent more wisely elsewhere, such as circumnavigating the globe. Fortunately, my parents agreed.

The *Telegram* accepted our proposal for an occasional series of 1,000-word installments (they titled the series "The Rover Boys"), and we lined up some corporate support. Senior officials at the multinational Petrofina oil company wrote letters that would get us free gas at any of their stations along the route. Dunlop donated tires for the Land Rover. *Life* magazine offered free Kodachrome film and processing in exchange for the right of first refusal on a feature article (the option was never exercised). Total cost to each of us of the entire trip, including depreciation on the Land Rover: $2,000.

In order for us to manage our own maintenance and repairs on the Land Rover, Bristol sailed ahead of me to England to visit the factory where the models were made. He watched and took notes as one vehicle was taken apart and reassembled. Our model was a so-called Series I, an off-road version originally made in 1948 as a British response to the American Jeep, and it proved a runaway and durable success. Bristol took possession of a rugged and utilitarian beast, high and boxy, with a roof hatch and a spare tire attached to the vehicle's hood.

Joining us for the African leg of the trip would be an artist friend and fellow naturalist, Erik Thorn, then based in London and working as an artist with the British Museum of Natural History.

Bristol and I travelled to Liverpool, where we were to board the freighter *S.S. Harrington*. While we awaited the ship's departure, someone from a local newspaper, *The Echo*, caught wind of our tour. The "Around the World" sign on the Land Rover parked dockside had been the tipoff. We made page 9, under a headline that read, "WORLD TOUR: Canadians Camp at Crosby." (Crosby is a suburb of Liverpool.) The brief story introduced us and our itinerary: Liverpool to Ghana,

then west to east across Africa to India, and on to Burma, Malaya (now Malaysia) and Singapore, then across Australia, before heading home to Canada.

Off to meet Bristol Foster for our big trip, 1957.

Bristol and I shared the writing of the *Telegram* dispatches. My recollection is that I wrote many of them because Bristol did all the driving. I would set up my portable Olivetti on the open glove box of the Land Rover and type away. I fashioned myself a poor man's Dylan Thomas, and had his *Under Milk Wood* in my head as I strove for melodious phrasing. In an age before fax or email, we used airmail to relay material to Toronto, carefully recording the dates our packets were sent from distant post offices. Sometimes the missives took five days to arrive, sometimes two weeks.

Our pieces could run to as many as 7,000 words, but we were thankful later that they were so detailed. Along with Bristol's silent 16mm movie film (all 3,000 feet of it), our photographs and my illustrations, we had ample raw material for a series of talks Bristol gave when we returned; I also did a few. Bristol's lectures with movies were hugely popular (this was before the advent of the now ubiquitous TV nature films) and were patterned after a similar series called the Audubon Screen Tours. Authorities or travellers would give a lecture in a high school gymnasium, offering commentary on the film as it rolled. The Audubon series spread the message of conservation; that was our message too, but it was also about the adventures of the intrepid Rover Boys.

Once we arrived in Ghana, we got off to an inauspicious start. The unloading proceeded without a hitch, though it was unnerving to watch our precious vehicle hoisted aloft by a cable and then dropped onto a floating platform between two canoes, which were then paddled to shore. Our ship had anchored off the city of Takoradi, which had no dock. In the interests of safe shipping, the Land Rover carried only a bit of gas in the tank, enough (we hoped) to get us to the nearest gas station. At the crest of the first hill, we ran out of fuel, and Bristol had to walk to town with a metal jerry can. We had two such

cans, one named Gin and the other Tonic. They sat in metal boxes on the front bumper of the Land Rover, which we came to call GT, short for Grizzly Torque—Torque for the vehicle's might and Grizzly after a bear in Walt Kelly's *Pogo* comic strip, a series that Bristol and I both collected and admired.

We camped that night in the Ghanaian rainforest, thrilling to our first "jungle noises"—every imaginable hoot, twitter, squawk and whistle, each with its own interval and rhythm. Bats the size of crows fluttered silently in the moonlight, incapable of competing with this complex symphony. The discomforts of budget travel soon became apparent: every day was hot, baths were not available, and the roads were rough and rocky. I found my mind dwelling on my bum, belly, back and bath, and I was ignoring Africa. I was not in "the now."

"Bateman," I reminded myself, "pay attention."

I was a trained geographer as well as an artist, and what's important to a geographer is variety. I began to observe differences along the way—differences in the clothing, the topography and ecosystems, the pottery. And with sketches and drawings I would record them all. It became clear to me that differences were important and to be celebrated. "*Vive la différence*" is my motto. In other words, variety is the spice of life. I lament the wiping out of the variety in our human heritage and our natural heritage.

I sketched almost constantly as we crossed the continent. My modus operandi was first to sketch the village, then the children, then the adults. I had no easel, so I would work on the ground, and a crowd of ten or twenty people would gather around me in a circle. To them, my sketching was a form of entertainment. I would scribble a child's face in a very loose way, then wet the page and introduce light, mid-tone colours. As the gouache dried, the colours became more intense. There would be a gratifying "aha" moment when the crowd recognized one of the children taking shape in my sketchpad. If I proffered an invitation by pointing a finger at an individual, adult or child, they would willingly smile and pose.

Erik joined up with us, and we fashioned for him a seat of cushions between driver and passenger. At night he slept on an air mattress inside a tent erected on the roof of the Land Rover. We spent several days in the rainforest hoping to see monkeys and mongoose and hyrax, but we were told repeatedly that while these animals are incredibly common, they are difficult to observe because the forest is so dense. You could be just a few yards from one and never know it. We arrived at this solution, described in a dispatch: "Better to sit down in some ant-less patch of the woods and remain quiet. Quite quickly you would become a part of the forest, and hornbills, squirrels, etc. would go about their business as usual."

Africa offered us almost daily reminders of the cool savagery of nature. In Ghana we visited a zoo near the university at Accra, where some large primates, including baboons, were kept in cages, while other monkeys roamed freely in the canopy overtop the zoo. This day a wild Mona monkey—a strikingly handsome creature with a brown back and silver-grey face—got too close to the baboon cage. We had heard stories about baboons, especially fierce males such as this one, ganging up on leopards and killing them. The male baboon has wicked incisors and baboons do hunt for meat. At the zoo, the Mona monkey had unwisely reached into the cage to steal food. The baboon, which had been eyeing the monkey from the back of the cage, suddenly leapt forward, grabbed one arm and began stripping

the flesh from it. Alerted by the monkey's wretched screams and the cries of other creatures in the zoo, we went to the cage and our shouts stopped the attack. But the grievously wounded Mona had to be shot by the zookeepers to end its suffering.

In Lagos, Nigeria, we witnessed hunting of another sort. We were invited to the home of a white official at the port authority and admired his residence's large windows and doors, open to sunlit patios and gardens. "The whole house," I wrote, "reached out to Africa and Africa came into the house . . . At night, the hosts of not-so-welcome guests arrived. The lights attracted almost every imaginable form of insect life—and some unimaginable ones. There were moths that looked like leaves or bark, stick insects, flashy bugs and bungling beetles. With them came the jewel-eyed jumping spiders and the alert praying mantis, ready for their evening meal. Now the geckos on the walls and ceiling began their hunting. They are as stealthy and as quick as any tiger. We watched one creeping along upside down on the ceiling as he stalked a moth . . . We marveled at how he could jump and land back up on the ceiling without falling, and we thought that if Sir Isaac Newton had seen a gecko perform he would have scrapped his law of gravity."

We had brought with us several cartons of cigarettes—not to smoke ourselves, for none of us had the habit—but as gifts for those who were kind to us along the way. And so many were kind. We would stop at university biology departments, where we were warmly greeted and given the names of colleagues farther along on our route with assurances of hospitality. We were never disappointed. The expats took us in without fail, offering meals or lodgings or both. We were welcomed as new blood, with stories to tell. Petrofina's letters of request for free gas were honoured without fail; Dunlop's tires saved us in southern Thailand, where we endured fourteen flats in four days. The locals, meanwhile, could hardly believe that white people were staying in their remote villages, and sleeping and eating in our home away from home, the Grizzly Torque. Some of these people

had never seen whites before, so on many counts we provided entertainment value.

Our vocabulary grew as we went. One of the first words we learned in Africa was *dash*—tip. Many Africans wanted to travel with us, hoping to make some dash as guides and see the continent. A *mammie-wagon* referred to the semi-open lorries that provide public transportation in West Africa. *Beef* was any animal that might serve as food, from monkeys to feral pigs.

Our menu was unvarying. Breakfast was porridge for Bristol and Erik; for me, it was raw oatmeal sweetened with sugar. Lunch was white bread, bananas and peanuts. Supper was a tin of Argentine corned beef (available everywhere) fried with onions, plus rice cooked in a pressure cooker with canned peas. We never tired of this fare.

Through small paintings on the body of the Land Rover, I started to record each individual country we had travelled through, beginning at the driver's door and going all around the vehicle. By this point on our journey, I had depicted Canada, Britain, Ghana and Nigeria: a beaver, Grenadier Guards, a mammie-wagon, palm trees and natives. In most of West Africa we travelled on dirt roads, the kind that in rural parts of Canada lead to cottages and cabins. We were travelling in the rainy season and often over mud-choked roads that were passable only by four-wheel-drive vehicles. Countless times the winch in front of the Land Rover's grill got us out of the gumbo, and countless times we praised our equipment. Erik and I also praised Bris' training at the Land Rover school in England; when rough roads bent a steering rod, he knew exactly how to extricate it before hammering it straight again on a concrete bridge.

Near the end of October 1957, we entered the Belgian Congo. The first thing we noticed was how older Africans would doff their hats and bow to us as we passed. This was a legacy of Belgian colonial rule, which had been brutal, but was much more benign by the 1950s.

At the time that we passed through, half of Africa's pygmies lived in the eastern Congo, and our time with them would count as one

of the most moving experiences of the entire journey. The magic of those five days began with the pygmies themselves—their joyfulness, their singing, their harmony with the rainforest and their skill as hunters. It would be wrong to call them child-like—and this had nothing to do with their small stature (most were about 4'4")—but certainly they were an unspoiled people, as if an original, untainted version of *Homo sapiens*. We were impressed too with the devotion and dedication of the whites we met, all of them fascinating characters, who were drawn to these tribal people and who well understood their vulnerability.

First, Anne Putnam. Our encounter with her on October 29 had a Stanley meets Livingston quality about it; indeed, the town of Stanleyville, where we stocked up on food, was close by. We had heard a lot about "Camp Putnam," little of it good. Some had described it as an expensive, touristy place with pygmies as the main attraction. Our initial plan had been to camp in the forest near one of the tribal villages in the hopes the pygmies would come to us. We tried that without success, so we relented and went to Mrs. Putnam's house.

Anne Eisner was a New York–born abstract and landscape painter who had met the man she would marry, Patrick Putnam, by pure chance on an island off Nantucket. They each happened to be walking on a solitary beach, and they fell into idle chat.

"What do you do?" she asked him.

"I run a hotel for pygmies," he replied.

Patrick Putnam was a Harvard-trained anthropologist who, in the 1930s, had set up a camp on the Epulu River in the Belgian Congo, a hotel where he took in paying guests while also offering legal and medical help to the local people. He had died just a few years before. Anne returned to New York to continue her art and write her book *Madami: My Eight Years of Adventure with the Congo Pygmies,* published in 1954. But she missed the Ituri Forest and the pygmies or Bambuti pygmies as they are more properly called. Our visit coincided with the visit of British anthropologist Colin Turnbull who was working on the pygmies for his graduate degree from Oxford and would also write a well-known book about them called *The Forest People.*

This is how I described our greeting at Camp Putnam. "The lady coming towards us was small and dressed in slacks and striped shirt. Her hair was black and fluffy and her face was lit with a broad smile. We inquired, 'Mrs. Putnam?' She nodded and soon we were in her house, talking to her as if we had known her for years." She fed us a lunch of rice with cassava leaves cooked in palm oil with peanuts and, for dessert, paw paw banana salad.

She seemed to expect us to stay the night, but that hadn't been our intention. "Suit yourselves," she replied cheerily, but then she added that if we did decide to stay she could arrange to have the pygmies take us on a hunt the following day. No more convincing was needed.

We had continued to collect mice and other small animals to add to the collection back at the Royal Ontario Museum, and when Mrs. Putnam discovered this she directed some young boys to assist us. Soon a great many pygmy boys descended on the Land Rover, each with a mouse or shrew or flying squirrel hanging on the end of his arrow. The fee for each specimen was two francs (four cents). We skinned each specimen and then properly stuffed it, placing wire inside the tail, pinning the skin on a board, and preserving the skull. I still took great pride in this task, primping the nose with cotton to give the creature a natural look.

At mid-morning the next day we broke off from skinning our specimens to join the hunt. Evidently the chosen site was some way off, and it was arranged that Vaizi, the head pygmy, along with a hunting party, would shoehorn themselves into the Land Rover with Bristol, Erik and me. As the hunters began to arrive with their nets, we made room for them in the GT. We became somewhat concerned as the number of hunters kept increasing. Then the women arrived, some carrying infants. We were not quite sure how they could help in the hunt, but evidently they wanted to come.

My best guess is that we had at least twenty-two people on board, excluding infants, both inside and on top of the GT. Bristol had his hands full seeing around Vaizi to know which direction to turn, never mind the road ahead. But Bris got the hang of it, and as we rolled down the highway we picked up speed, and with this the pygmies began to sing at the top of their lungs.

Theirs was unlike any chorus I had ever heard. "The pygmies are natural harmonizers," I wrote, "and improvise chords in the particular song they are singing. The songs often take the form of rounds; sometimes successive notes are sung by different individuals scattered

amongst the group, causing the tune to bounce around. Each person may have his own little tune, which he sings at the appropriate beat . . . Some yodeling may be added. The overall effect of one of their songs has been compared to chimes or a Glockenspiel. The words may describe the forest and its animals, or tell a story, but most of their songs are joyful songs of thanksgiving." Never a dirge.

We arrived at the hunting grounds and marched single file through the forest. The pygmies fanned out, and each of us was led by a hunter. Despite their diminutive stature, they moved with astonishing agility and speed through the forest, and we were hard-pressed to keep up. Using handmade nets 5' high and 100' long with 2" mesh, the hunters formed a giant U in the forest. One man would tie the end of his net to a sturdy tree and then pay the net out, finally tying it to another tree when his net was fully extended. This was his post and there he would crouch nearby. Then a second man would do the same, so that the vast net was unbroken. As they did this, the hunters showed us which plants they had used to craft the fibres for the netting. Finally, all was set, and the families moved into place.

Then the women—we thought they had simply come along for the ride—formed a line in the distance at the top of the U and began to advance, shouting, screaming, yodelling and clapping their hands.

After a time we joined a crowd of hunters who were focused on a creature struggling in the net. It was a duiker, a small forest antelope. One bound and it might have leapt free. To eliminate that possibility, two men grabbed hold of the animal's legs and snapped them with a twist. The suffering of animals mattered less to the pygmies than keeping the tribe fed. They also hunted forest elephants, the smallest of elephants but still formidable creatures, by smearing themselves with elephant dung and urine before tracking one unfortunate victim. A brave hunter would creep up behind the elephant and drive a spear up into its bladder, then the party would patiently track it for several days until it died.

Our leader, Vaizi, ended the antelope's struggle with a knife. Within minutes the antelope was drawn and quartered, and each hunter wrapped a tidbit in a broad leaf. As we drove home, the singing reached a fever pitch—songs of praise and gratitude for the fresh meat the hunters would enjoy back at camp.

One night while staying with Mrs. Putnam, we gathered around an elevated bonfire in a tall thatched hut with a pounded-mud floor. The smoke found its way out through the thatch high above the fire. We stayed up until the small hours of the morning listening to Colin Turnbull's stories about being arrested as a spy in Egypt, about being a torpedo boat captain during the war, about the role of curses in African culture. The stories were all unsettling, unforgettable and often very funny.

When we packed up at the Putnam Camp on November 3, we agreed that of all the fascinating places we had visited thus far, this was the one we were most reluctant to leave. That morning we took

a crowd of pygmies on a joy ride out to the highway, as they had requested. They sang the whole way, and on disembarking they all eagerly shook our hands and danced. This is the memory I will retain of them, along with the lessons they effortlessly imparted.

There was no crime in their culture, no curse words. They'd make their shelters (sticks and broad-leafed plants woven together) in forty-five minutes, lightly hunt an area and then move on, leaving nature to erase any trace of their visit. They were perfect ecologists. Unlike us, they didn't scrape the bottom of the barrel of natural resources until they were gone.

We travelled in a gentler time, when dangers were fewer. In Kenya the Mau Mau uprising had yet to be completely vanquished, and we were warned of bandits in India, but aside from a hitch-hiker losing his wallet to a crowd of men who encircled the Land Rover one night in that country, in all that time, I had only one item stolen: my brother Ross' 3-D camera, which was taken in Burma. The people we encountered on our journey were more likely to give us their possessions than to try to take ours.

In Rwanda we visited a primate research station and witnessed a full-grown mountain gorilla being brought in. I'm not sure that a silverback had ever been captured at that point, nor should it have been, of course. He had been restrained by a net made of thick nylon rope, and when we saw him he was in a thick wood-plank crate, rushing the sides of his prison each time we came near. He was very angry, and I'm not sure that anger dissipated even after he was released into a "natural habitat" enclosure at the station.

In Uganda we visited Queen Elizabeth National Park, where the warden's assistant, a tall, soft-spoken African, took us on what I then described as "a wild and wonderful Land Rover ride through one section of the park." He drove his vehicle so that we could both approach wildlife and escape it, in an approved and safe manner. The land was flat, with short bushes or trees here and there, so we were able to drive in any direction. From a downwind position we would draw near a

herd of antelope, and "they would stand and gaze at us, posed like statues in the golden light of the evening sun." When they caught our scent, they bounded off a short distance and we would approach again.

We saw hippos grazing "like tubby, inflated cows," surprisingly far from water. We later spoke with an American Fulbright scholar named Bill Longhurst, who noted that the hippos then were so numerous that some had to travel up to eleven kilometres every night to find suitable grazing. Overgrazing was the enemy then.

We were also able to drive within yards of Cape Buffalo, and even the ones lying down wouldn't rise. But once they had our scent, these dangerous game animals charged and pawed the ground. With elephants our driver was far more cautious, out of respect for their size and their intelligence, which made them unpredictable. Coming as close as we dared, we observed several families, "animals ranging in size from huge, wrinkle-skinned tuskers to tiny *totos* (it means baby in Swahili) toddling along under the mother."

ERIK ONLY ACCOMPANIED US for the Africa leg of our trip, and so we exchanged goodbyes and Bristol and I continued on together. We travelled third class in a large Indian passenger liner from Mombasa on the Kenyan coast to Bombay, with our Land Rover in a cage below decks. Sharing the space with us were approximately one hundred and fifty Sikhs. Most people, including us, tried to camp on deck for the night. In those days before the advent of tourism, things were a lot simpler.

For example, on our visit to the Taj Mahal we were virtually alone. We camped overnight in the parking lot, wandered around this beautiful building at sunset and again under a full moon. There were no guards or other tourists. At dawn we went inside the main mausoleum. Since there were just the two of us, I had the courage to test the famous echo. I took a deep breath and bellowed what might pass as a C chord. C-E-G-C, at full throttle. The echo that came back sounded

like a garbled Mormon Tabernacle Choir. I described that moment in my journal: "The dome above our heads shouted back with a hundred voices, trailing off in a hollow hum." The echo had lasted precisely fifteen seconds.

Crossing the Ganges River was an adventure. Bristol drove the Land Rover over two planks and onto a small raft—so small that the front and back ends of the vehicle hung over the edge. The raft was a tippy thing piloted by a man with a long pole, and if memory serves, the river was a kilometre wide at our point of crossing, so I had lots of time to admire his craft.

A few days later we entered Nepal and witnessed the splendour of the Himalayas. As we traversed the Ganges plain, it wasn't the "bone-breaking bumps" on the "Grade D bullock track" that got to us, nor the "axle-cracking potholes," but the dust. It was unlike anything we had seen in Canada, Africa or India.

"The pale powder lay on the ground," I recorded, "five inches thick, and it trailed behind us like a vast column, even though we were only able to do about 12 km/h. When we stopped, our column would catch up to us and envelop us in a choking cloud. While moving, it welled up from the doors and floor, coating everyone and everything in the GT with a filthy film. And when we looked at each other, we appeared as grey-haired men or flour millers."

That night we camped on the summit of the Katmandu Valley and put on every stitch of warm clothing to stave off the freezing cold. Our reward came in the morning, a Sunday, February 16, 1958. "With the first faint morning light, we dragged ourselves shivering from our beds to witness the most spectacular sunrise of our lives. From our back doors, we could see the succession of violet hills, shading paler towards the jagged horizon—the Himalayas. They were dark and sharp in the moments before dawn . . . As the sun rose, its light crept along the crest of the range, touching the eastern edge of each peak with a glint of pink gold."

Soon a blood-red sky was echoed in the rhododendron trees—the

most glorious trees imaginable—all around us. I had seen wild rho-
dodendrons in the Arctic, but they were little more than ankle-high,
while these were twenty feet tall and covered with clusters of blooms.
The trees' trunks and twisted branches seemed to have been designed
by the same Creator who gave us Japanese ornamental pines, but
these branches were crusted with orchids and draped with wisps of
moss. In their branches frolicked tits, miniature chickadee-like birds
with clown markings.

In Burma, I was painting the villagers. Bristol was elsewhere. As
dusk approached and the villagers had left for home, it was just me
and a little girl. But as I was painting, I could hear peals of laughter
from the village. At first I thought that Bristol was entertaining the
people, but then I spotted the source of all the mirth. In the glow of
dusk on the sandy street that ran through the village of woven palm
houses, a tug of war was under way: the men against the women, and
the women were winning and dragging the men all through the vil-
lage. So I got on the men's end of the rope. Everyone else was barefoot,
but I was wearing commando boots and could dig in. We routed the
women; then I got on the women's side, and finally, the tug of war
broke up in more peals of laughter.

We crossed into Thailand by driving through a river and into the
village of Chiang Rai, where we were met by a young military captain,
who promptly took our passports and sent them by bus to Bangkok.
We had just come through an area in total rebellion (it still is today).
We were treated to three days of house arrest. There was a barricade
at the border, the captain explained, and it could be easily skirted. But
he added that if we did cross the border, the soldiers would be obliged
to chase us, and we didn't want that.

So Thai police held our passports while they checked that we
weren't spies, either for local drug lords or Chinese Kuomintang in-
surgents. We were unperturbed and passed three blissful days there.
We visited the Miao hill tribe village and enjoyed a Buddhist festival
then under way.

Once cleared, Bristol and I pressed on to Malaya. We were waiting in Kuala Lumpur for the post office to open when Bristol was approached by an old Toronto schoolmate, now an officer serving in the British Army's Special Air Service (SAS) in Malaya. This was before the Vietnam War and communist insurgents were trying to take over southeast Asia. He informed us that a major military push against the insurgents was looming on the west side of the country. The plan was to fly into the centre of Malaya, an area virtually untouched by Europeans, and be ready to receive the insurgents if they tried to escape the military operation. He offered to have us taken there by military helicopter, and we accepted without hesitation. Apparently, when the old school friend asked permission from his commanding officer to grant us this adventure, the colonel feigned hearing difficulty.

Dressed as (unarmed) tommies, we went into the jungle with a military escort and were introduced to tribesmen who hunted with blowguns. The military had instructed these tribesmen to greet any

strangers with a shout in their dialect, and if upon second greeting no answer came, they were to kill the strangers. We slept at night in hammocks under canopies, surrounded by booby traps. When I got up to relieve myself, a twig snapped, and I instantly heard the safety catches of a half-dozen rifles click off. "It's just Bob having a pee," I said.

Last stop on the journey was Australia. There we travelled some 4,500 kilometres in the Land Rover, from Derby in Western Australia, across the Northern Territory to Cairns on the northeast coast, through Queensland, and ending at Sydney. We stopped on the east coast to take in the Great Barrier Reef from tiny Northwest Island, a mere 247 acres in size and one of more than 8,000 islands off the Aussie coast. For five days, we wandered the coral flats to see what we could see. "Our favourite pastime," I wrote in late July, "was turning over loose coral. Sometimes it took both of us to lift the pieces off the sand floor. But always it was worth it. As the dripping rough mass lifted clear of the water, we would expectantly crane our necks to peer below. The first impression was that we were peering at a painter's palette. Every colour of the rainbow shone glistening before us. Green, blue, red, orange and purple sponge splattered much of the surface. Coral-pink coral (a common colour for coral) filled in some of the hollows, along with sea squirts, dainty fairy crayfish and, yes, some tropical fish too."

We also saw coral sharks, just two feet long and prettily marked. They have amazing strength, but it was easy to grab and hold them.

Our odyssey ended much as it had begun—with a reporter, this one from the *Sydney Telegraph*, who spotted the signage on the Land Rover and requested an interview. By that point we had put over 43,000 kilometres on the GT. Bristol and I went our separate ways in August of 1958. I boarded a ship that would get me home by September to resume teaching, while my travelling companion stayed on in Australia until November in order to visit with other scientists.

The Land Rover accompanied Bristol back to Canada in December of that year, and it was quite a conversation piece on the streets of Toronto. The panels below the windows featured my art—the

aforementioned Grenadiers to illustrate our stay in England, a drawing of a gorilla tugging at a pygmy's clothing as a memory of the Belgian Congo, a kookaburra laughing at Galahs to pay homage to Australia, and pictures corresponding to all of the countries in between. There were also emblems to acknowledge our sponsors, as well as drawings of the various creatures we inadvertently ran over on the trail: millipedes, chickens, a dog. My paintings and the Land Rover paint jobs did not make it through all of the road salt of a Toronto winter so Bristol had the whole thing painted over.

I HAD NEVER FELT SO CAREFREE in my life as I felt on that trip. If we came to a place that captured our interest, we could stop for five minutes or five days. The landscape and the wildlife surpassed anything we might have imagined, and I felt immensely enriched—perhaps even changed—by encounters with other cultures. I greatly admired the pygmies and the Bantus and the Sikhs, even the remnants of British colonial culture. I could see virtues in them all.

Even then, I felt what a pity it would be if those cultures were wiped out and replaced with the instant-pudding culture of crass capitalism. Sadly, that onslaught has quickened in the decades since; it's why a mall in Nairobi today can look very much like a mall in Houston or Bangkok.

We counted ourselves lucky to have made the journey to Africa when we did. The decline of the pygmies anticipated by Anne Putnam and others is beyond tragic: the peoples of their various ethnic groups have been slaughtered in civil wars in the Congo and Rwanda, and decimated by mining, deforestation, Westernization and poverty.

The threats to wildlife that I wrote about then have not abated but only grown worse. I wrote about the nomadic Masai, with their huge populations of cattle, sheep and goats, using prime grazing land and leaving the second-rate and third-rate land for wildlife. I wrote about poachers and the ivory trade in Asia that was playing havoc

with elephant and rhino populations. Despite stepped-up measures to counter illegal hunting, elephant ivory and rhino horn still command astonishing prices.

And yet. We never recovered from what Bristol called "Africanitis," and we vowed to return. We both did, many times. The appeal of Africa is that it is the continent richest in human heritage and natural heritage. Africa has huge variety, and as I said, variety is the spice of life. Most places in the world are falling rapidly into urban sameness, all slick and convenient and all manufactured. East Africa is our favourite part of the continent, the only place in the world where you can still stand and see tens of thousands of living large mammals. But even the vast Serengeti is threatened.

POSTCRIPT: *Bristol and I were always curious about the fate of the GT. Did the old Land Rover still exist, or had it gone to scrap? Bristol put out feelers through various Land Rover clubs, and in December of 2014 he got news that a vehicle bearing a likeness to the GT was sitting in Mission, B.C., east of Vancouver. Bristol went there and identified our vehicle by its underlying paint and customized features. My murals, sadly, had been erased by sandblasting. We purchased the vehicle and restored it so that it looks just as it did in 1958, including the body art. See the photo section for the before and after.*

V : MR. BATEMAN

All my life I've loved sharing ideas and explaining things. It could have come from Mom or her brother Newman. From the age of sixteen, I was an instructor in the Junior Field Naturalists at the Royal Ontario Museum. Perhaps being an older brother also had something to do with it. I would share ideas with Jack and Ross. As well, my mother seemed eager to learn from me about art and nature and for more than two decades, from 1955 to 1976, I was a teacher of high school art and geography in Ontario, with a two-year stint teaching in Nigeria. Teaching defined me then, and to a certain extent it still does. It seems I cannot shake the habit.

Following graduation from the University of Toronto in 1954 with an honours degree in geography, I took the requisite tour of Europe on a shoestring budget with my friend Erik Thorn. Then I pursued a teaching certificate from the Ontario College of Education before embarking on my first posting, at Thornhill High School north of Toronto, in 1955. I stayed there two years, then moved

During my teaching trip in Nigeria, I sketched these parakeets.

on to Nelson High School in Burlington and later to Lord Elgin High School in that same community. During all this time, I continued with my art, painting for myself, not for the market.

In my first year of teaching, I had an experience with alcohol that confirmed my approach to that substance. During those summer months at the research camp in Algonquin Park, we had many campfires featuring songs and beans but never booze. Even during my university years, alcohol was simply not part of the experience. I was never comfortable with the Dionysian, but there was one evening that cured me of the temptations of excess ever after. This, in other words, is how I came to be known as "One-Beer Bateman."

That year, 1956, a fellow teacher at Thornhill High was about to be married, and a stag party was held in another teacher's rec room. We drank vodka and vermouth with beer chasers while consuming vast quantities of kolbasa sausage and perogies. I became so inebriated I had tunnel vision. Almost everyone was drunk; the groom struck his forehead on an I-beam and knocked himself momentarily unconscious.

I recall nothing of being driven home to Chaplin Crescent by a non-drinking colleague, but I do remember waking in the morning with nausea and a splitting headache. I sat on the edge of the bed and the floor seemed to tilt away from me. I ran to the wall and held on to it, and the floor tilted back the other way. So I ran back to the bed and steadied myself. This process repeated itself a few times, but I finally got dressed and headed off to school. At school that day the janitor, who had caught wind of the debauchery, gave the male teachers cold, wet towels for our sorry faces as we arrived. I vowed I would never do that again, and I never have.

In my teaching days, I would invite my senior students to an end-of-year dinner at my house. There was never alcohol on these occasions. One time as the students were leaving the house, I heard one say, "Next stop is Ghost Corner." This was a reference to a cemetery on nearby Walker's Line, where they had left a package containing certain leaves behind a tombstone. "We were afraid that if we brought it

here," the student explained, "you might get busted." I thought, "How considerate of them."

Back in the classroom, I like to think that same respect prevailed. As many veteran teachers know, the key to control in the classroom is to win it on the very first day. I believed in being calm but quietly firm. I could defuse bad behaviour by instantly stopping everything that was going on in the classroom. It was a variation on Uncle Bill's technique, and it was effective. Communication is best if only one person is talking at any given time. I would stop talking until silence resumed. If the circumstances warranted it, I had only to raise my voice once. After that, it wasn't necessary.

During the last leg of my trip with Bristol Foster in 1958, I had sent a telegram to the Burlington school board from Calcutta, applying for a position at a brand new school, Nelson High. In those days there were scores of teaching jobs for every applicant; I got the job and started in the fall.

Also, my closest friend and Thornhill teacher was Emerson Lavender. He became head of history at Nelson High School and Orie Gilmour, my old geometry teacher from Forest Hill, was principal. To top it off, Miss Robinson, who "failed me in French" in grade 12 was on staff. They all seemed to want me as the new art teacher. There was only one small wrinkle, and it was easily ironed. As the population of the school grew, the school administration awarded department heads. Since I was the senior geography teacher and the only art teacher, I had to choose. I chose art: I liked the notion of having my own students in my own world.

Meanwhile, the growth of Halton County meant that a director of education was required. They hired Jim Singleton, who routinely went through the qualifications of the teachers in the county. He came across the fact that the head of the art department at Nelson High School had the lowest qualifications possible for an art teacher. He

asked the principal, "Can you do better than this?" The principal replied, "Bateman is a very good teacher and an excellent artist." Singleton responded, "Well, we have to make his paperwork look better."

So for two summers I studied at the Ontario College of Art (now the Ontario College of Art and Design). I fondly remember John Hall, the drawing master in the school of architecture, who also taught teachers of art at OCA during the summer. John was a kindred spirit—a canoeist, an outdoorsman and a man who loved nature. He had a cabin northwest of the city, where he sometimes cut down trees to enhance the views. But he cut them down one at a time, and each time he would contemplate the effect before cutting down another; he had that kind of sensitivity.

I HAVE ALWAYS FELT THAT QUALITY of life was number one. I knew I wanted to live in the country surrounded by nature but be able to travel to a city within an hour or so. The advantage of Nelson High School was that it was near the Niagara Escarpment. The closest rough natural land to my hometown Toronto. I felt a great desire to buy land in the country, especially near the escarpment itself—a ribbon of rough, wild land running across the most densely settled part of Canada. This was where I wanted to live, and that made Nelson High School a perfect place to teach. On a topographical map I drew a twelve mile radius with the school at the centre and proceeded to visit every property for sale within the circle.

I found an ideal spot: a 10-acre parcel near Lowville on the Niagara Escarpment that, coincidentally, was owned by the father of one of my students. What a beautiful tract of land it was—set on the slopes of Mount Nemo, looking toward Rattlesnake Point, it offered woods, a meadow, a stream and a stunning view facing north—ideal for the studio I would build. Here I could live in nature no more than an hour's drive from Toronto, and I could enjoy a pleasant commute to school. It was mine for $4,500.

I had a secure and rewarding job and an undiminished passion for painting, and I had drawn up plans for the Mount Nemo dream house. All I was missing was a partner. I had been looking for ten years for a serious relationship, the ideal being a woman who possessed the right chemistry and a love of nature and the outdoors. Such a creature seemed rare in the 1940s and '50s, and certainly in my circles; I fantasized that we would somehow discover each other on the third floor of the ROM (the natural history floor), but it never happened.

Then in the fall of 1959 came a breakthrough. I was introduced to a young woman who had recently joined the Toronto Field Biologists, an outgrowth of the Brodie Room Intermediate Naturalists. Suzanne Bowerman was from Alliston and a student of sculpture at the Ontario College of Art. She was very attractive and a very accomplished artist. I thought her drawings then were more lovely and elegant than my own; she could do line drawings of sunflowers and plants in a dried state that were still beautiful to behold.

I invited Suzanne to Sunday dinners at Chaplin Crescent. Mom was delighted. Hers was a house of men, and she was longing for a daughter-in-law. Dad, true to his character, expressed no opinion, but he seemed happy. I took Suzanne to the piece of land on Mount Nemo, which she loved. We seemed intellectually compatible and shared a strong commitment to art, and I was eager to marry.

I somehow talked her into an engagement. Suzanne's mother was against the marriage, insisting that her daughter—then just twenty—was too young. In retrospect she may have been right. Nevertheless, I pressed my suit, and in the summer of 1960 we did marry, at a gathering of family and friends at St. John's United Church in Alliston.

We agreed that Suzanne should spend the next two years finishing her degree at art college, so we rented a flat on Indian Road on the west side of High Park. It was a compromise location. On weekday mornings I drove west on the Queen Elizabeth Way to my school in Burlington, a breezy trip because the commuter traffic was going the opposite way. Meanwhile, Suzanne headed east on the streetcar to OCA.

BEFORE SUZANNE AND I SETTLED DOWN, I thought it would be a good idea for us to go to Africa. Suzanne had done virtually no travelling, and I had been around the world. I thought it would be helpful for her to get more experience under her belt. Besides, I loved Africa and had not been back since my trip with Bristol Foster. So it was decided: we would spend a year or two in Africa.

From 1963 to 1965, I taught at Government College in Umuahia, a small town in southeastern Nigeria. Such postings were made available through a Department of External Affairs aid program, and I was pleased to get my job. But truth be told, my first choice had been East Africa, where the wildlife was far richer.

I taught A-level and O-level senior geography. I had to prepare my students for exams set in Oxford and Cambridge, and marked in Oxford and Cambridge. I was replacing a Nigerian senior geography teacher who was much better than I was in every way that mattered— or so my students told me. I met him, and from what I could determine, the students were right. My Nigerian students worked harder and were more motivated than my Canadian ones. The students in Umuahia were aiming for admission to high-profile universities in Britain, so their main concern was marks. I had come there hoping to broaden their minds, so we operated for a time at cross-purposes, which led to some frustration on both sides. It took them almost a year to train me to help them pass those exams. After that, my lessons consisted mostly of reviewing old exams and teaching them how to write a good paper.

Just as Bristol and I had done on our travels through Africa, I let it be known in neighbouring villages that I would pay for specimens—anything that moved. I was the poor man's Gerald Durrell. Suzanne and I came to possess a Genet, a cat-like creature related to the mongoose family. A sketch dated 1965 captures his huge eyes, his long sleek form and his wariness. But when he first came to us, he was a little ball of fur in the bottom of a basket with banana leaves as a lid.

Some Genets become pets, but this one was vicious, and he tested us many times. I kept him in a chicken-wire cage, and every time I brought him food he would snarl and snap. I often thought he would have preferred my finger. When he was fully grown, we opened his cage and gave him his freedom. We would leave a bowl of milk for him near where his cage had been. For a time he lived nearby, sleeping on the thatched roof of our house by day and hunting at night. We never closed our windows, and one evening after we had set the table for a dinner party, he helped himself to half a pound of butter.

We also took possession of several Demidoff's galagos, also known as bush babies. These are tiny, big-eared nocturnal primates; some boys brought the first one to us in a Campbell's soup can. We fed the bush babies a diet of milk and honey and grasshoppers, the latter held as they would an ice-cream cone and eaten head first. The bush babies were like Ping-Pong balls made of fluff, but they were capable of enormous leaps. I would take them out in the evening for exercise.

When they were with us they would explore our necks and ears with their small, human-like hands. Afterwards I would feel sticky, and this was a mystery until I read that these creatures urinate on their hands and feet before going out on the hunt, so that a scent trail can guide them back home. Five such creatures came to us during our time in Nigeria, and some of them later ended up as stuffed specimens at the Carleton University museum in Ottawa. Other small primates, including a golden potto, went to the Bronx Zoo Small Animal House in New York City.

The year before, we visited the Mandara Mountains, a volcanic range that extends for some 200 kilometres along Nigeria's border with Cameroon. The villages in this area contained tribal peoples who had had virtually no contact with the outside world. Our ticket up to this sanctuary was a Scottish nurse whom the locals trusted because she was not trying to convert them to any religion. We had heard that two Muslim missionaries had been killed for trying to do just that.

Each village, we were told, spoke its own language and would, on occasion, wage war with neighbouring villages using bows and arrows. The nurse, and others who worked for the Sudan Interior Mission, would have to tend to the casualties on both sides of these conflicts. But the clinic was small, and the wounded combatants had to be separated. Some were placed inside and some outside on the porch. Whenever people from one side heard that someone from the other side had succumbed to his wounds, they would cheer.

Thanks to the nurse's endorsement, we were more or less

accepted. I took many photographs and executed one painting, *Mandara Mountains, 1964,* that showed umbrella-shaped thatch huts and a woman carrying a large vessel of water on her head. It recalls a time when these various tribes gathered down on the flats to trade their wares.

It was there I purchased a decorated calabash—a gourd bowl— much like the one in the painting. I have seen other calabashes in museums around the world, but none to match the artistry of the one I found in that market. What was special about that market was that it formed only once a week, when the warring parties put down their weapons to engage in trade.

LIFE TOOK A TURN IN AFRICA on two fronts. My art found a home— and a market—at the Fonville Gallery in Nairobi's New Stanley Hotel. Hemingway used to drink there in the Thorn Tree Café. I may not have been living in East Africa, but my paintings were. And it was while Suzanne and I were living in Nigeria in 1965 that our first son, Alan, was born, much to our great joy. Indeed, that sojourn in Africa marked the happiest period of our marriage.

Alan was followed by daughter Sarah in 1966 and a second son, John, in 1968. Both were born at Joseph Brant Hospital in Burlington. Suzanne was a conscientious and giving mother who put her children's needs before her own, but the relationship between us had begun to show fault lines even before we went to Nigeria. Despite the common ground of art and a love of nature, we could not reconcile our two very different temperaments. As I saw it, Suzanne craved solitude; I craved companionship. Still, our union brought me three wonderful children and I cannot imagine my life without them.

I WAS PERSUADED BY THE SCHOOL AUTHORITIES to become an art consultant for the Halton County Board of Education in Ontario. I was

reluctant, but they said the advantage was that I could spread my philosophy far and wide. Of course I got a raise and a part-time secretary. Basically, I travelled to the art classes of the county, from kindergarten to grade 13 (in those days), doing demonstration lessons. I enjoyed being the performer, and the students and teachers seemed to love the lessons, but in the end I felt that it was more entertainment than meaningful work, and I craved my own student "family." So I asked to go back into the classroom. I was warned that my pay would be cut and that I would no longer be the department head, since the new school, Lord Elgin, had already assigned the headship of the arts department to a music teacher. I said that was just fine.

Lord Elgin's innovative design featured open-concept classrooms, and its curriculum system was likewise liberal. Students were allowed to choose as many subjects as they wished, as long as the basic academic courses were covered. In those years I taught art history, pottery and sculpture, and drawing and painting to students who were mostly eager and engaged.

I organized field trips to galleries near and far to expose students to the widest possible range of work, often introducing them to artists and art movements for the first time. At the McMichael Gallery in Kleinberg, they met the Group of Seven figuratively and, on one occasion, literally. We encountered an elderly A.Y. Jackson taking his ease in a quiet gallery room. At the extraordinary Albright-Knox Gallery in Buffalo, they confronted modern and contemporary art that was entirely new to their experience.

Before we went on any field trip, students would be well grounded. My technique was to lecture as entertainingly as possible, discreetly using sex and violence and opinions because that seemed to get the attention of the teenage mind. Students did not have to write essays or answer questions, only keep their eyes fixed on the classroom screen. I deliberately brainwashed them with broad cultural images that were beyond the popular instant-pudding entertainment they were bathed in. We would then have identification reviews—competitive

and boisterous affairs. The following week we would have a test. Their art history mark always brought up their studio mark. And the brainwashing worked. My students needed no docents on gallery tours. Unlike the students from other schools, who seemed distracted and bored, ours were engaged and excited. Preparation pays off.

One of the most striking examples of this system was brought home to me when at least five years after he graduated, a former student sent me a postcard that read, "Dear Mr. Bateman. I am in Madrid and I have been to the Prado. I couldn't agree with you more about the lower left corner of Fra Angelico's *Annunciation.*"

Examples of the success of this system— entertaining learning by rote—are too numerous to mention. Recently I asked one former student if he remembered a particular slide I had showed him in grade 11. It was of a simple path in the Katsura Temple in Japan. The exercise was to imagine walking the path slowly and noticing every detail on the left and right. He not only remembered the slide; he said that it had changed his life. That was more than forty years ago.

There was a poster in an art museum in Munich that said *"Kunst öffnet die Augen"* ("Art Opens the Eyes"). It certainly does.

Meanwhile, Bateman sketches, drawings and paintings were finding their way into the classroom when they served a purpose. The students were aware of my growing reputation as my works appeared more frequently at shows and exhibitions, but I doubt the public's attention impressed them greatly.

IN 1971 LORD ELGIN DECIDED TO HIRE another art teacher. In those days hiring was done in May at what the teachers called "cattle calls." Individual school boards would set up desks in various rooms at the Royal York Hotel in Toronto and advertise their needs with simple signage: "Math teacher wanted" or "Biology teacher needed." Teachers capable of filling those positions would set up interviews with the school where they hoped to teach.

Principal Wayne Burns and I wanted to recruit a suitable teacher. Birgit Berry was my first candidate. I started asking this young teacher questions in order to find out what sort of person she was, which is far more important than qualifications on paper. I was by then a fifteen-year veteran of the classroom. I asked about her interests, her enthusiasms and her passions. How much did she know about art? How did she motivate her students?

I soon discovered that Birgit was much more qualified to teach art than I was. She had a degree in art education at the senior high school level from the University of British Columbia and had taught for a year in Calgary. Her husband was in the wine business and had been promoted, thus the move to become manager of the Ontario branch of his company in the Niagara wine-growing region.

Wayne, who had been listening to the interview, intervened. "Will you excuse us?" he said to Birgit. Our private exchange outside in the hall went something like this.

WB: "What do you think?"

RB: "I think she's very good. She has the right philosophy, she's progressive. She's open to new ideas and has a generous spirit."

WB: "Should we hire her?"

RB: "No. I think we should interview three or four others and then decide."

WB: "I disagree. Grab her. There are other art jobs available today and we might lose her."

And so we hired her on the spot.

Birgit's skills benefited the art department almost immediately. I was an artist, but one with only elementary training in education. She, on the other hand, had had a great deal of training at the university level in the teaching of art. Together we developed a terrific program. We expected a great deal from our students, some of whom had drifted into art class thinking it would be easier than French or chemistry. They were in for a shock. We had standards that we

expected students to meet; we upped the standards a notch when Birgit arrived. One semester the art department had the highest failure rate in the school. It wasn't that we demanded talent but that we demanded effort.

There was no shirking in our classes. Rather than the usual copying of pop images or rock stars and action heroes, the art of our students came from each person's individual and particular life. A certain girl might really love horses or a certain boy might be into motorcycles. Therefore all of their work—whether abstract, realist, fabric art or sculpture—derived from their hearts. It was not escape art or art as fantasy. This is what real artists have done through the ages: worked from their own souls.

I had designed the art room so that it led directly into the woodworking shop where the students learned to frame their own work. It was important for them to take care in the presentation of their work, and we would mark a student's final project only when it was hanging in the school halls. We were proud of our students' work, especially when it depicted their own world, as true art should.

This was one of my constant refrains. One year I was asked to judge the art of volunteers at the Art Gallery of Hamilton. I didn't like judging, didn't like all the hurt feelings that go with declaring that this art has merit and this art has none. Nevertheless, I accepted the invitation.

The works were hung on a gallery wall, and I walked from painting to painting, offering a commentary on each one. The subject matter varied—palm trees, a sunset, flowers in a vase, waterfalls—but in a critical respect it was all the same. I tried to be kind, but I was also honest. It's escape art, I told them. It does not reveal you or your lives. Where are the backyard barbecues? Where are the shopping malls? I repeat: all true artists depict what is close to their lives.

I singled out a woman who had painted a scene of people in their Sunday finery, chatting on the steps of a church after the service. "Bingo!" I said. That's a meaningful scene in the artist's life.

BECAUSE TEACHING YOUNG PEOPLE has played so important a part in my life, it is no small honour that three Canadian schools, in Burlington, Ottawa and Abbotsford, British Columbia, bear my name. The latter school selected the timber wolf as its mascot. For the school's logo, I lifted three wolves from my painting *Clear Night—Wolves*. I depicted the wolves at eye level, all of them trying to see the viewer in spite of a scrawny tree in the way. Wolves view humans with respect, and most of us view wolves the same way. I suggested that the school motto be "Eye to eye, with respect." Students and teachers should respect one another eye to eye, as should children and parents, friends and strangers, citizens and communities. Respect will take us far in the twenty-first century, and it can be learned at school.

I didn't really sell art until 1965, when I was thirty-five years old. But over the next ten years I seemed to be paying more taxes on the income from my art than on my income from teaching. In 1975 I was asked by Aylmer Tryon at the Tryon Gallery in London, England— one of the world's premier galleries of wildlife art, which had been displaying my work in group shows for more than a decade—to put together pieces for a one-man show. That year, I found it impossible to fit in both teaching and painting, and I took a six-month leave of

absence so I could dedicate all my time to art. The London show sold out, with prices ranging from $7,500 to $10,000.

Let the London show serve as an omen, I had told myself before it opened. Birgit also encouraged me, and so I made the decision that if the works sold well, I would quit teaching and paint full-time. There were no lingering doubts and no sleepless nights while I second-guessed myself. I left teaching with some regrets, but I knew that I would maintain contact with many of my students and that I would always teach in one form or another. One side benefit, I told myself, was that I could now travel any month of the year. I could, for example, see the Rockies in the full colour of fall.

Art was no longer something I would do during the evenings and weekends. Mr. Bateman had for all intents and purposes left the classroom. The canvas called.

VI : HAPPY TRAILS

The lesson of the ravine behind the house on Chaplin Crescent was that, by being both quiet and vigilant, I could see and hear a great many birds and mammals. But I also knew, almost instinctively, that the more I travelled and the farther afield I went, the richer the flora and fauna would be. My university geography studies paved the way for all kinds of free trips while I mapped for iron ore in the Arctic, or surveyed in rural Newfoundland or tracked yellow nosed vole populations in Northern Quebec. And all the while I was painting.

The journeying started in 1950, at the age of twenty, when I travelled across Canada and into the United States on a Greyhound bus with Erik Thorn, fellow artist and naturalist. We pretty well lived on a dollar a day, with bread, peanut butter and oranges as staples. We had a tiny gas stove, and for supper we'd fry up tinned Spam or corned beef with canned peas or dehydrated beets, and maybe a Dad's cookie for dessert. Breakfast looked a lot like supper, and they were the only two meals of the day.

Bus Trip, *1950.*

Our routine was to hop off the bus at lunch and coffee breaks, trek into a natural area nearby, do some watercolours, then get back on the bus. The trip was about new experiences, spending time in nature and birding. It was also about proving to myself that I had the discipline to live the spartan life. And I did manage it, though Erik was far more of an aesthete than I was. I was hungry all the time.

Our route took us through Chicago, and we had to wait there one night before catching the next bus headed west. Erik and I hauled 80-pound packs that housed all of our necessities: canvas tent, canvas sleeping bag, oil paints and Masonite boards, plus mouse traps and a shotgun for collecting museum specimens. No one at the U.S. border had bothered looking in our packs. The next bus was in the wee small hours of the morning. The plan that night was to seek cover under some bushes in Grant Park, Chicago's version of New York's Central Park.

Around ten o'clock, an African-American man approached us. He was kind and gentlemanly but direct with his advice. "You fellas shouldn't be in the park," he said. "Someone was murdered here a few weeks ago." We heeded his counsel and spent the night in the bus depot.

In the morning, our bus continued west, through forest and across prairie. I will never forget seeing snow-capped mountains for the first time. Once in British Columbia, we made our way to Victoria, Erik's childhood home. Like me, he was a museum junkie and therefore knew Clifford Carl, director of the B.C. Provincial Museum. Clifford allowed us to sleep in the museum's basement. We were dry, and the price was right for sleeping on the floor, but the air was pungent with formaldehyde emanating from tubs that contained dead sharks.

One of our ambitions was to climb a mountain, and we had selected Mount Arrowsmith, a proper snow-capped, 1,800-metre high mountain on Vancouver Island. Our packs were so heavy that if one of us fell backwards he was pinned like an overturned beetle. So we unburdened each pack of half its contents and hid the items in the

bushes. The plan was to unload again farther up the mountain, return
with empty packs to retrieve the first cache, and through a shuttle
process achieve the summit. The first night was spent in a disinte-
grating log cabin, where we were assailed by mosquitoes. We hid our
faces in our raincoats and tried breathing through the sleeves, but the
bugs came up that passage and bit our faces.

The following day was hot and sunny, and we sat atop Mount
Cokely, adjacent to Mount Arrowsmith, to paint the majestic view. We
cooled off by stripping down to our underwear and worked in com-
fort. I think I did six paintings that day. But we had seriously underes-
timated the strength of the sun at that altitude, and both of us suffered
terrible sunburn. Any notion of summiting Mount Arrowsmith was
abandoned, and we endured instead the torture of our fully loaded
packs as their straps cut into the hot pink flesh of our shoulders as we
walked down the mountain in one day.

In 1954 Erik and I hit the road once more, this time to Europe—our version of the requisite Grand Tour after graduation. Bus travel had done the job on the trip to the Rockies, but it wasn't really ideal transit for a naturalist. You see a bird and you want to stop, yet the Greyhound bus has a mind and a schedule of its own. A car was a better bet.

That thought led us to purchase a big black behemoth, a 1937 Studebaker Dictator, once we arrived in England. The unfortunate model was dropped that same year, and for obvious reasons. It was all front end and no back end, with running boards and small windows. A used car salesman straight out of central casting sold us the car. He was a cigar-chomping, check-suited, fast-talking guy who claimed the car had been driven by an elderly couple who had put it up on blocks during the war—thus the low mileage. He said the couple had traded it in on a Rolls-Royce. Erik and I didn't believe him, but we bought the car anyway.

The vehicle was big enough that we could each curl up on the front seat or back seat if need be. We drove to Brighton, on the south coast, and we had stopped at a layby to dine on bread and cheese when a Rolls-Royce drove by, slowed down and then backed up. A little old lady rolled down her window and said sweetly, "We think you have our car." And so we did.

Our modus operandi on this European tour was to hit the nearest city in the morning and head straight to the museums and art galleries, cramming in as many as we could. Then before dark we'd get out to the country, find a farmer's lane and cook up the same kind of meal we had mastered on the western trip, with Spam as the main course. The car was always available as a bunk in the event of rain, but we preferred to sleep outside on ground sheets. With a Maxwell House coffee tin, I would scoop out a hollow for my shoulders and hips, arranging clothing as a pillow.

In Paris, Erik and I drew street scenes. We stayed in a students' residence, and I spent one entire day just looking out the window to see what I could see. Two sketches stand out: one, *Parisian Woman*, is

a loose rendering of a woman I could see in an apartment across the street. (The influences of Picasso, Matisse and Toulouse-Lautrec are evident.) She's catching a few winks, she's washing her hair, she's putting on her makeup before a mirror. Another, a watercolour I called *Woman on Balcony*, portrays the subject leaning on an outside railing, completely absorbed in what is happening on the street below, just as I was (see colour insert).

Italy was nice, but we didn't trust the hucksters or the drinking water, and it was a relief to get to Switzerland and Germany, where the water was better and no one harassed us. But for Erik, the real destination was Scandinavia. He had taken language lessons from a Swedish lady in Toronto. Even before reaching that country, while in Denmark, Erik began to think—and occasionally speak—in Swedish. Our destination was the northern region of the Scandinavian peninsula and Lapland; for $40, we could buy a round-trip train ticket from Copenhagen all the way to Narvik, a port on the Norwegian side. We could get off wherever we wanted and simply flag down the next train.

Narvik had been the scene of a great naval battle involving the German, British and Norwegian navies, and though many of the sunken ships had been taken away, there remained many poking out of the water. We were staring at this scene when Erik began chatting with someone—in Swedish, of course.

"Don't tell me where you're from," the stranger said. "Let me guess. You're from Stockholm."

This was a great compliment to Erik, for his Toronto teacher had been born in Stockholm.

I can point to two sketches from our time in Scandinavia that pay testament to the fact that as an artist, twenty-four-year-old Robert Bateman had not yet found his identity. I did two sketches of virtually the same scene—the wharf at Trondheim, a city midway up the coast. One was done in the cubist style, the other in the realist style.

While in Sweden I came across the work of Bruno Liljefors, a Swedish impressionist painter who is widely viewed as a master—even the Michelangelo—of wildlife art. But I was an art snob, convinced that realistic art was not art of the highest order.

These sketches, which I did in Sweden in 1954, reveal how in just a few lines the unique character of a species of tree might be captured.

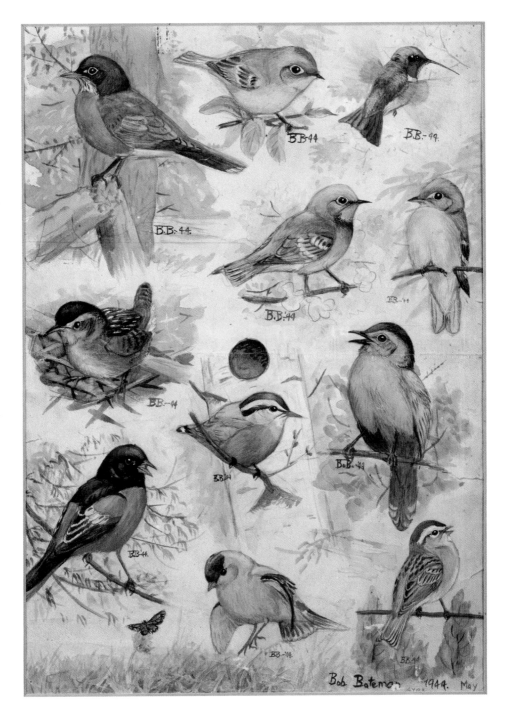

Backyard Birds, *15" x 10½", gouache on paper, 1944.*
I was fourteen when I painted these birds I saw in the backyard during their migration.

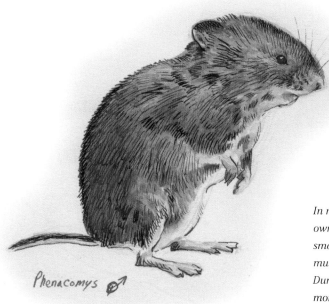

Phenacomys ♂

In my twenties, I felt that I was making my own contribution to science by collecting small mammals, which I donated to big-city museums. Phenacomys *is a very rare vole. During the summer of 1952, I collected more of them than are housed in all of the museums in the world.*

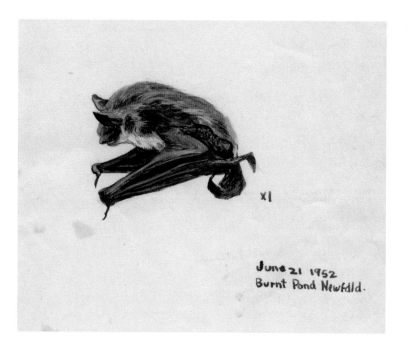

×1

June 21 1952
Burnt Pond Newfdld.

A life-sized painting of a bat. I created this at the age of twenty-two while working as a field assistant with the Geological Survey of Canada.

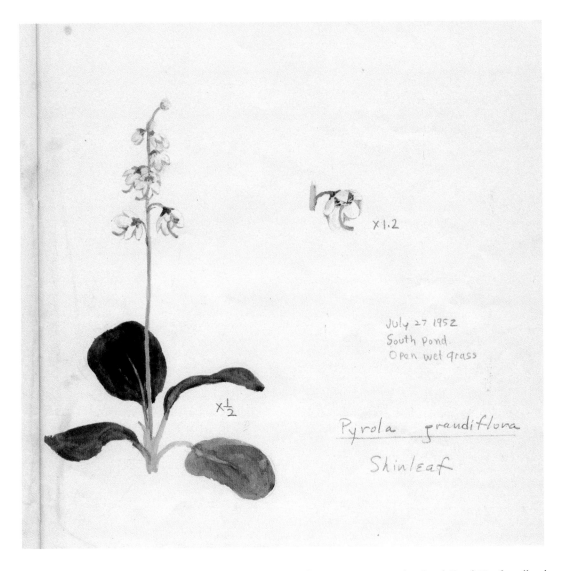

From the same summer, one of many watercolour sketches of specimens I painted at South Pond, Newfoundland.

Newfoundland River, *12" x 16", oil on canvas, 1952.*

There is a memorable line in Kevin Costner's film Field of Dreams, *which says, "If you build it, he will come." In my master class workshops, I rephrase it, "If you think it, it will come." For example, if you really think the form of an iris petal, you will be much more likely to be able to render it with three-dimensional accuracy. Before starting this painting, which I began and finished in the presence of the river, I tried to think of all the forms of the patterns displayed by the moving water: wide, thin, concave, convex, etc. As in the Stanislavski method (see Chapter IX: A Day in the Life), I put myself in the life of a river. Then I painted it quite quickly. I'm convinced that thinking the river with some intensity produced a better painting.*

Leaf Bay Village, Ungava, *12" x 16", oil on canvas, 1953.*

Perhaps the most remarkable summer of my life was in 1952, when I was part of a four-man geological party mapping iron ore in Ungava, Nunavik. We knew that we were the first Europeans to walk on that land, and our two Inuit assistants told us that their people had never walked there. It was a tundra Garden of Eden with abundant wildlife and fabulous fishing. Inuit are mainly coastal people. One day, I took an eight mile hike to the tiny tented settlement belonging to our two helpers, Jimmy and George. This painting in semi-cubist style is based on my first view of their village.

Boats and Dock, Trondheim, Norway, *15" x 19", oil on paper, 1954.*

Sketch of Ship—Trondheim, Norway, *15" x 19", gouache and Conté on paper, 1954.*
At age twenty-four, I had not yet found my artistic identity. The lower painting is done in the cubist style while the one above it is in the realist style. They are the same place, painted one right after the other.

Woman on Balcony, *Paris, 15" x 19", mixed media on paper, 1954.*
Erik Thorn and I travelled around Europe for four months in the summer of 1954. In Paris, we stayed at a
student residence. I spent a day sketching street scenes from the window, including this lady in an apartment
across the street.

Lapp Herder.
Erik and I took the train to
Narvik on the Norwegian Arctic
coast. We then hitchhiked up into
Lappland, where I did this sketch.

Thai Man, 12 ½" x 9 ¼", watercolour on paper, 1958.
On our trip around the world in 1958, Bristol and I
would stop our Land Rover a short distance from
an attractive village where I would do a quick
watercolour. Onlookers would come by and watch,
and I'd sometimes do quick portraits of them. I
developed a technique of scribbling the face lightly
with a ballpoint pen and then wetting the paper and
introducing lighter colours, then shadows, gradually
getting darker and ending with black drawing.

Tibetan Muleteer,
10 ½" x 13", mixed media on paper, 1958.
In those days, the Tibetan mule trains were allowed
to cross into Sikkim to trade. I did this sketch near
an encampment in the state of Sikkim, close to the
Tibetan border. The Dalai Lama was still in Tibet
at this time in 1958, so we did not go right to the
border because of Chinese sensitivities.

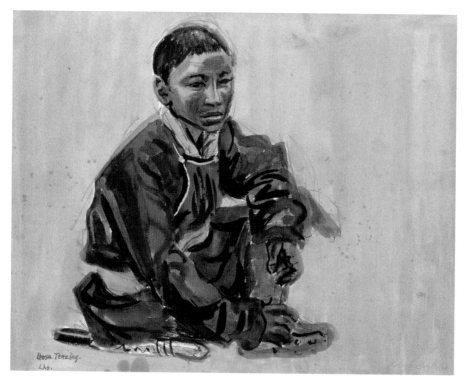

Congo Forest, *20" x 12", oil on canvas, 1957.*

In 1957, the Belgian Congo was very different from the Democratic Republic of the Congo today. The last half century has seen rapid exploitation of resources, including destruction of the forests. As with all my paintings from that period, I worked directly en plein air. At one point, I had a good view of the northeast Congo River and painted this scene while thinking about Emily Carr, the great painter of British Columbia forests.

Dragonfly drawing, 15" x 22",
Conté on paper, 1961.

Dragonfly Country, *24" x 32", oil on board, 1961.*
I had done a sketch, in the cubist style, of a dead dragonfly I found when we were on a camping trip in Ontario—
a little bit of a Marcel Duchamp's Nude Descending the Staircase, No. 2 *style, showing the dragonfly in a buzzy*
pattern. You can see different poses at the same time if you know how to look in a transparent kind of way. The
Conté sketch has aspects of reality of the dragonfly—the transparency and the "buzziness" that you wouldn't get in
realism. After doing that drawing, I did a landscape painting with the imagery of the dragonfly in my head. The far
shore reflects the thorax and abdomen. The water and, to some extent, the sky are facets of the dragonfly's wings.

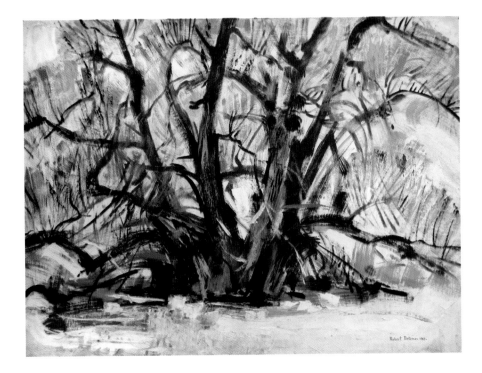

Winter Willow, *36" x 48", oil on board, 1963.*

Various new philosophies, such as transcendental meditation, were floating around in the 1960s while I was exploring styles. In this painting, I tried to empty my mind to "become" the willow. Then very quickly, trying not to think, I sloshed the oil paint on the board, giving the feeling of "willowness."

Meadow Edge, Goldenrod and Bracken, *20" x 24", oil on board, 1962.*

Nature is full of visual possibilities. Even for abstract and semi-abstract paintings, I start with a slice of reality. This piece is based on a scene just at the edge of our Haliburton cottage. I had passed it over a thousand times when one afternoon it "spoke to me." I then created this work, using reality as a vehicle for creating shapes and swathes of colour.

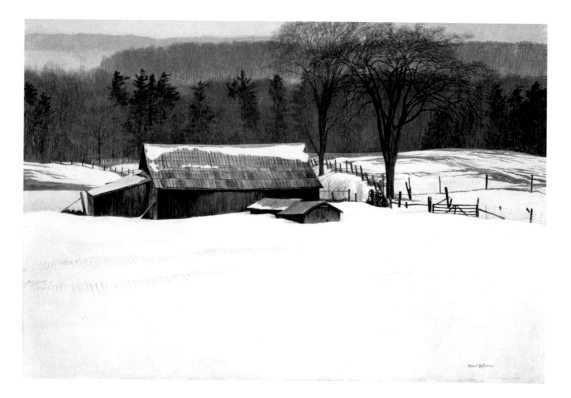

Along Walker's Line, *23½" x 35", acrylic on board, 1967.*

My transformation from an abstract artist to realist painter happened after seeing an exhibition of Andrew Wyeth paintings. The rural countryside around Chadds Ford, Pennsylvania, which Wyeth depicted, was very similar to the area where I chose to live—a world of traditional family farms and scattered forests. Here was an artist who used abstract forms in his compositions but cared about the particularity of the actual surface of his world.

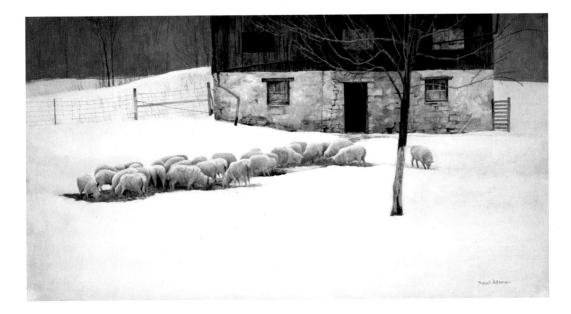

Winter Barn, *18½" x 33", acrylic, 1967.*

This painting was done as part of a project to depict the natural and human heritage of the country in which I live. I chose subjects which have been in existence for at least one hundred years. I did this painting only a few years after being an abstract painter.

Wildebeest, 30" x 40", acrylic on Masonite, 1964.
This is one of the first paintings I did as part of my career shift back to realistic wildlife art. That career began at the Fonville Gallery in Nairobi. The concept of the wildebeest was based on Paleolithic cave painting.

Thomson's Gazelle,
size unknown, oil on board, 1964.

Leopard and Thomson's Gazelle Kill, 34¼" x 40", acrylic.

In 1974, Birgit and I went on a safari in the Seronera River Valley, hoping to see a leopard. With just minutes until sunset, we finally sighted one, and we were able to take several photos of the animal next to its freshly killed dinner—a Thomson's Gazelle. These photos led to my painting Leopard and Thomson's Gazelle Kill. *For the whole story, see Chapter VI: Happy Trails.*

GALAPAGOS

NOVEMBER 29 — DECEMBER 6 2014

The Endeavour Nov 29

Greater Flamingo
Las Bachas
Beach
Santa Cruz

Birgit and I were aboard The Endeavour, *which explored the Galápagos Islands in 2014.*
These pages were scanned and downloaded for fellow passengers as a keepsake of our travels.

OF COURSE, LIFE ITSELF IS A JOURNEY best taken with a companionable soulmate. In the early 1970s I fell in love with the partner who would accompany me on that journey for the next forty years and who does so still. You will have guessed that she is Birgit, the beautiful young teacher who joined the art department at Lord Elgin High School in 1971.

Birgit's marriage had ended after less than two years; mine was maintained for the sake of the children. In 1973 I made the wrenching yet necessary exit that was bound to confuse and frighten Alan, Sarah and Johnny. But equilibrium was eventually restored, thanks to their mother's magnanimous decision to allow me every opportunity to be with them, and to Birgit's ready acceptance of an instant family. Birgit and I married in 1975, in high summer, with the kids in attendance. In time, two new little ones—Christopher, born in 1976, and Robbie, who arrived in 1979—made us a rambunctious and close-knit crew of seven.

CAMPING *EN FAMILLE* WAS THE BATEMAN PRACTICE from earliest days. During summer in the 1970s and 1980s, Birgit and I would typically set aside several weeks for cross-Canada trips with the five children in tow. By then we had a used Volkswagen bus, which was notorious for being too cold in winter and too hot in summer. Birgit would sit in the back to be in reach of the young ones; the older ones took turns riding shotgun. The music on those trips became the soundtrack of our family's life: The Beatles, Bruce Springsteen, Simon and Garfunkel, Bob Marley.

Once again, travel accommodation was provided by the vehicle itself. A local handyman had rigged up a hinged piece of plywood on the roof of the VW bus so that it lay like a flat box while we were on the road. But once the bus was parked, the plywood could be refashioned as an enclosure with canvas sides and roof, and fibreglass screened windows. Birgit and I slept up top on a foam-rubber mat with the two younger children; the older ones slept inside the bus.

Finding a campsite for the night was always a preoccupation. I have an aversion to public campgrounds, where we would likely be subjected to other people's music. Instead we preferred to wild camp, sometimes on private property—illegal, of course, and easier done then than now. We would choose a farmer's lane, preferably one that looked like it was seldom used, or a quarry site. Quarries were never used after dark, they were free of rubbish, and they offered the added advantage of being virtually mosquito-free, since the insects need vegetation for cover. The trick to successful site choice was all in the timing. If you left it too late, you were scrambling in the dark. On the other hand, the closer to dark you made your choice, the smaller the chance of being detected.

We wanted the children to pay attention to the natural world we were passing through, so the first child to spot a Golden Eagle, a Bald Eagle or a Pronghorn Antelope might get his or her treat of choice at the next Dairy Queen. We used treats to compensate for being cooped up in a crowded vehicle for as long as five weeks at a time. Sometimes dinner was no more than canned ravioli or canned beans cooked on a Coleman stove. Camping was not relaxing, but the kids adapted well and the experience worked its magic. I know of no family that is closer today than our five children, as well as their spouses and their children.

Another objective of these trips was to introduce my children to some of my friends—extraordinary photographers, adventurers, explorers, eccentrics. For example, in the early 1970s the Bateman entourage several times descended on the home of Miles and Beryl Smeeton in southern Alberta. The Smeetons had experienced a life of adventures that defied belief: in the 1930s the two had climbed the Hindu Kush, Beryl being the first woman to achieve that 7,000-metre height. In the decades to follow they would log over 209,000 kilometres, from the Arctic to the Horn of Africa.

The story I loved to hear is not described in their biography, *High Endeavours.* It concerns the time they were reunited in Tibet. Their daughter, Clio, had just been born in Darjeeling. Miles was then a

Rough sketches of a horseback-riding adventure in Montana that we took, as we so often did in those days, en famille.

colonel in the British army fighting the Japanese in Burma, but he got permission to go to India to visit his wife and the newborn he had not yet seen. Beryl, meanwhile, had decided to leave the baby with a nursemaid while she trekked to Tibet.

Miles arrived to find his wife already gone, and hiked off in pursuit of her. He spent an entire day walking the one path that led to Tibet through a mountain pass. That night, under a starry sky, he let loose with a yodel—their traditional method of communicating when apart in the mountains—and Beryl bolted upright from her cot in a hut farther down the mountain.

"Either that's Miles," she said to herself, "or I'm having a mystical experience. And I don't believe in mystical experiences, so it must be Miles." She answered with a yodel of her own, and soon husband and wife were together again. Beryl was quite a sight, wearing a balaclava and covered in rancid yak butter against the threat of sunburn, and she'd been eating raw garlic for several days.

"Darling," she told Miles, "how good to see you."

In 1956 the Smeetons were attempting to sail around Cape Horn when their yacht was struck by a rogue wave and pitch-poled—flipped end-to-end and lost its mast and hatch. Beryl was tossed into the sea, luckily without a lifeline or she would have been torn in two. The following year, they were again demasted off Cape Horn and again had to limp to Chile for repairs. They finally tried once more in 1968, and this time they made it.

By the time of our visits in the 1970s, they had founded the Cochrane Ecological Institute, dedicated to breeding endangered wildlife such as Swift Foxes. Beryl died in 1979 at the age of seventy-four. She was in her seventies when she had a fireman's pole installed in her house, which she used to drop from the second floor to the first, barefoot and wearing a sarong. That said it all. Miles died in 1988. Their daughter, Clio, now lives in the same house and carries on her parents' work.

We took the children on countless foreign trips too, while they

were young and later with their partners. They have all visited Europe and Africa several times; Christopher and Robbie lived with us in Germany for a year. A common memory of all that globetrotting is their father's unflagging lessons in history and natural history, geography and art, not to mention storytelling, both frightening and funny. Even around the campfires, the teacher never rested.

BIRGIT'S OUTGOING PERSONALITY and intelligence, her love of ritual and family celebration, her artist's sensibility (she is a superb photographer and painter) and her supportive nature won me over from the first and have sustained me ever after. As with me, the desire for travel was part of her DNA, and in 1974 we went to Africa, the third visit for me, the first for her. Accompanying us was fellow teacher, Sue, and her husband, Gerry McGregor. They had decided to get a divorce, but did not want that to interfere with the trip.

To save money on accommodation, we had rented a pop-up Volkswagen van, but the engine had blown and a replacement was on its way. We were staying at the home of retired Indian army colonel Hilary Hook in the White Highlands of central Kenya, so called because of the thousands of British expats who settled there in the early part of the twentieth century. Hook had served in the British army during wartime all over the world, including India and Africa. He wore a monocle, spoke the King's English and had a face like a walnut. But he was also a serious birder who took pride in his skills of observation and identification.

The three of us went out walking one evening before dinner, carrying binoculars. We saw a bird we could not identify, and when we got back to the house Hilary immediately pulled a fat bird reference book from his library. He was flipping the pages and I heard him mutter, "I hate to be beaten by a bird."

While our Volkswagen was being repaired, Hilary took us on safari in his Land Rover. Our destination was the Seronera River Valley,

one of the best places on the continent to view big cats—lions, cheetahs and leopards. I had never seen a leopard, and I wanted desperately to photograph one so I'd have the references for a painting.

We worked our way down to the Serengeti and the stunning Seronera River Valley, with its endless verdant plains, umbrella-shaped acacia trees and all the wildlife that was drawn to the meandering rivers that flowed there year-round. That said, leopards are notoriously hard to spot, and on two previous trips to East Africa—once with Bristol and once with my brother Jack—I had failed to find one. What we were looking for was a tail hanging down from a high branch. Our necks were sore from looking up, but all that vigilance had netted us no sightings.

The light was beginning to fade when a vehicle came out of a nearby thicket, and we chased it down. The guide in this truck suggested that we had roughly ten minutes before sunset and a ten-minute drive back to our lodgings. We had best be on our way, since park rules forbade tourists from being out past sunset. He pointed to his watch. But he also pointed to a tree where, he said, a leopard was lying with a freshly killed Thomson's Gazelle. Then he left us to make our own decision. I decided I wanted a photo of that leopard.

Although I am usually open and accommodating to the point of blandness, when fleeting nature opportunities present themselves I can become forceful. Art reference, after all, is my raison d'être. The light was fading fast, we were overstaying illegally and here was the first leopard of my life. At that time Birgit and I were sharing lenses. Because of the light, I started with the big one, the 400mm. Birgit was using the small, general lens. I shot bits and pieces of the scene while Birgit was still composing with that 100mm lens. I demanded it, and she almost threw it at me. Gerry, Sue, Birgit and I spent the evening discussing male–female relationships. Birgit vowed henceforth to have his and hers lenses. This was a very wise decision that would keep such a dispute from arising again.

That sighting of the leopard did yield some fine photographs that led to a painting I called *Leopard and Thomson's Gazelle Kill* (see colour insert).

ON THAT SAME TRIP, we met the author and naturalist Joy Adamson. Her book, *Born Free*, about raising a lion cub she named Elsa, had spent almost a year on *The New York Times* bestseller list. Joy's husband, George Adamson, a game warden in the Northern Frontier District of Kenya, had shot and killed a lioness that had charged him and another warden. George understood that the lioness was simply protecting her three cubs, which were found nearby. Joy tried raising the cubs, but after six difficult months, she decided to send the two bigger cubs to a zoo in Holland, while keeping Elsa and training her to hunt. She later released Elsa into the wild, where she had cubs of her own, but Joy continued to have contact with this lioness.

Born Free, a movie of the same title, and subsequent books turned the Adamsons into international celebrities, and Joy lent her name to a number of conservation groups, including one called the Elsa Wild Animal Appeal of Canada, which aims to preserve endangered wild species in this country. I became a founding director, lending my support

Joy Adamson.

to this organization, and the connection led to an invitation to visit Joy Adamson at her home in Kenya, on the shores of Lake Naivasha.

Birgit and I and our friends Gerry and Sue McGregor duly landed there one afternoon. But it wasn't our first introduction. I had met Joy at a concert in Toronto, where the Canadian contralto Maureen Forrester was performing. Forrester was a hero to Adamson, herself a classical singer and a gifted painter; her paintings of native flowers and tribal people have no equal. I had all these reasons to like this woman, and I did like her, but there is always the story behind the story.

Born in Austria to wealthy parents, Freiderike Gessner had fled to Africa to escape the violence of the Second World War. There she met George Adamson, who became her third husband. (Her second husband, a botanist, had given her the nickname Joy.) George had trouble with this overbearing and patrician woman who could none-theless become girlishly giddy when talking about animals. George and Joy lived in separate houses, and he was away—as he often was—when we visited. Joy's demeanour was nothing like that of Virginia McKenna, the British actress who starred in the film *Born Free*. The real Joy was tall, broad-shouldered and a bit masculine; she had con-tempt for most women.

Joy greeted us warmly but then proceeded to order about her white secretary. She was even harsher with her manservant and cook, a black African. That evening after dinner, she engaged me in conver-sation, pretty well ignoring Gerry, Birgit and Sue. "Robert," Joy told

me in her heavy German accent, "you are so talented. You must give up your teaching and your family and come to Africa. You must dedicate yourself to your art here in Africa. You could live in George's house; George is never here." I told her that was an interesting idea, then Birgit and I fled to our bed.

After breakfast, we were all loaded into the camper van, and Joy was bidding us adieu when, once again, she issued a directive. "Robert," Joy declared, "I wish to speak with you. Privately." Back inside the house, she inquired how the Canadian Elsa fund was doing, she asked my opinion on its leadership, and she wanted to know whether I would take it over. I think that she did not trust our capable leader, Betty Henderson. I could not get out of there fast enough.

Six years later, Joy's body was found in the bush near her home. At first, it was thought that she had been killed by a lion, and the tabloid press had a field day with that ironic possibility. But forensic investigation soon revealed that she had been murdered. Among those arrested was a former servant. After her death, reporters sought a comment from a former secretary, Kathy Porter. Perhaps the same secretary and the same servant we had met during our visit? "She got so lost in her animals," Porter said, "that she lost compassion for *Homo sapiens*."

George Adamson also met an untimely end in 1989, when he came to the aid of tourists who were being attacked by poachers. The poachers then turned their guns on him.

IN AN ASSOCIATION THAT HAS SOME PARALLELS with the free travel to far-flung fields that I enjoyed as a geography student, I count my relationship with Lars-Eric Lindblad as one of my lucky blessings. In the late 1950s, this Swedish-American would-be explorer started a travel company that combined respectful tourism with environmental awareness and conservation practices. Typical were cruises to remote parts of the world, during which passengers were educated about the places and peoples they would visit by knowledgeable on-board experts.

In 1989, Lindblad was fined $75,000 by the American government for organizing tours to Vietnam and Cambodia in defiance of U.S. trade embargoes then in place. "I would do it again," he said at the time. "Travel in my opinion is not ordinary trade. Travel is a way of communication. To embargo travel is like burning books or imprisoning journalists."

Some call Lindblad the father of ecotourism. We first met when he came to my show at the Royal Ontario Museum in 1975. A mutual friend told me that Lars was considering me as a possible resource person for his cruises, and he advised, "If you're invited, accept. It'll be like riding a magic carpet." And so it was.

An early invitation had me pinch-hitting in Kenya for Keith Shackleton, a brilliant British naturalist and artist. Shackleton was charming, handsome and gifted with a beautiful voice, used to great effect in narrating nature films. But he had to back out of the Lindblad trip at the last minute, giving me the opportunity to join the excursion.

The passengers on that trip rendezvoused at a Pan-Am first-class lounge in New York for the charter flight to Nairobi. Wealthy widows were casting about and did not hide their disappointment. They asked, "Where's Keith? I came because of Keith." They had never heard of Robert Bateman and said as much. An aide pulled me aside and cautioned, "Everyone is so disappointed. You'd better be good."

I must have passed the test, because in 1978 Birgit and I boarded the *M.S. Lindblad Explorer* for another trip, this one to the Antarctic.

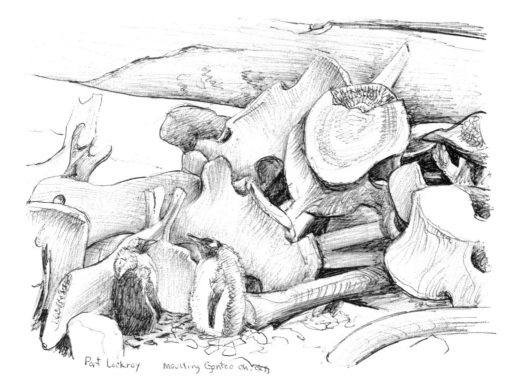

Port Lockroy Moulting Gentoo chicks

I have been all over the world since, but that first trip to Antarctica remains among the most memorable. A sketch from that voyage shows two moulting Gentoo chicks against a backdrop of massive whale bones and vertebrae at Port Lockroy. Back in the *Moby Dick* era, the port was a major whaling base. In that permanently dry deep-freeze, bones from the nineteenth and early twentieth century last forever (though climate change may alter that prediction). My drawing pays homage to those great whales—and perhaps to the sculptures of Henry Moore. There is a poignant aspect to the sketch: winter was coming and the chicks had still not moulted. They couldn't swim with all that fluff, so they would need time to feather out, get to sea and learn to catch fish before freeze-up. Otherwise, the two chicks were doomed.

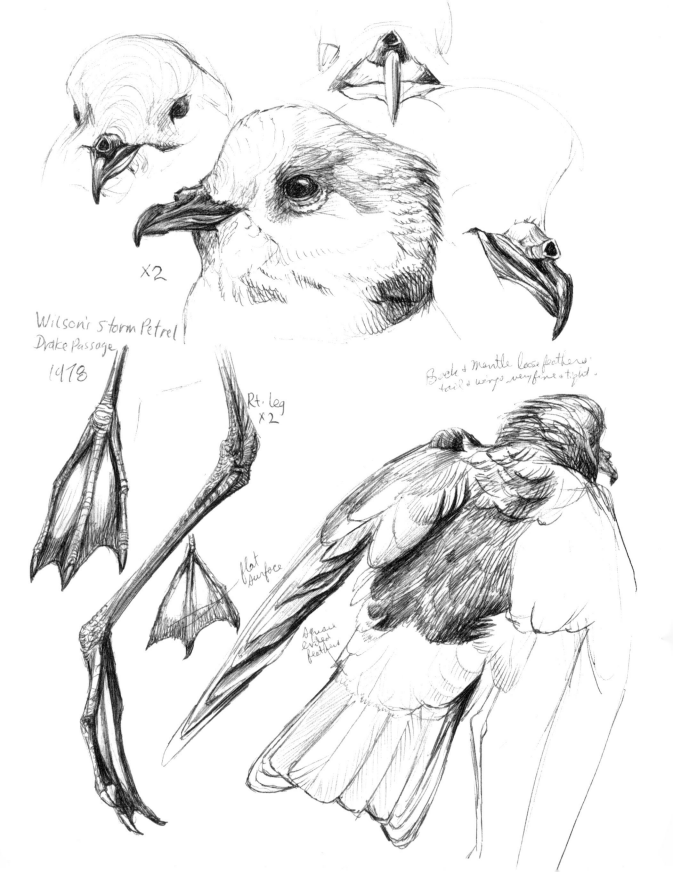

×2

Wilson's Storm Petrel
Drake Passage
1978

Rt. Leg
×2

Back & Mantle loose feathers,
tail & wings very fine & tight.

flat
surface

Squar-
edged
feathers

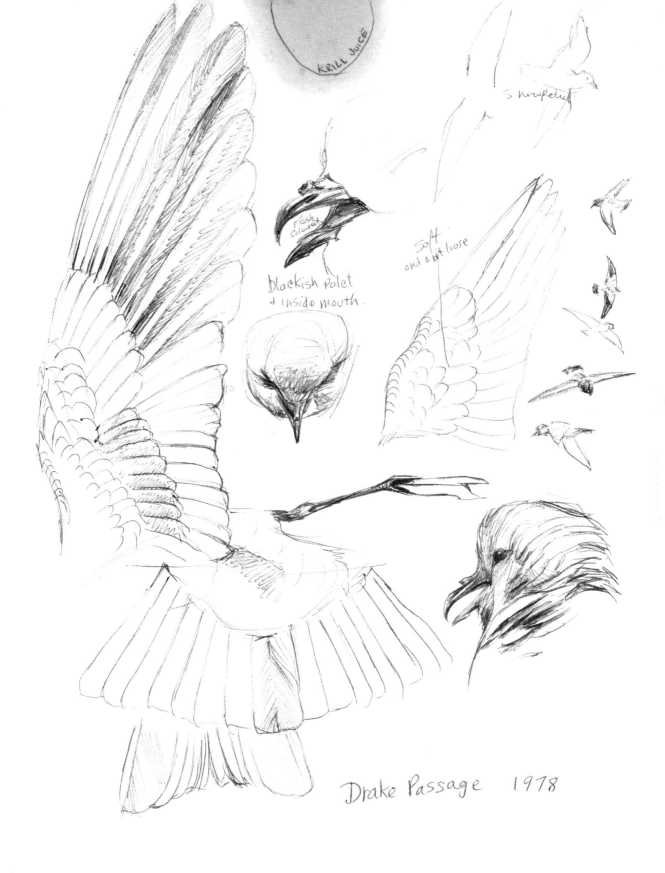

KRILL JUICE

Snowpetrel

Fleshy coloured

blackish palet
& inside mouth.

Soft
and a bit loose

Drake Passage 1978

Wednesday, Feb. 6
At Tagus Cove on the western side of Isabella Island, we are greeted by graffiti from the past. A Boston whaler trip around the cove reveals lots of flightless cormorant penguins, Franklin's gulls, also noddy tern. Hiking group saw woodpecker finch and spotted sandpiper.

Arrival at Pta. Spinoza on Fernandina in the afternoon. Greeted by lava herons and marine iguanas. The richness and variety was a fitting finale to our cruise. Snorkelling with penguins, sea lions and marine iguanas is an incredible experience.

Marine iguana digging nest...

Elegant grey snake (dromicus) seen hiding amongst the crypto carpus...

... and to top it off, during the last few moments the sun burst through with almost theatrical effect. For us Intrepids — a fantastic cruise!

brachycereus + lava flows

When Birgit and I go on these trips, our job is to host discussions—on photography, say, or the natural world—in exchange for free passage. We are very much like writers-in-residence. It's a sweet deal for us. And the rewards are immeasurable. One of them being the people we meet on Lindblad trips, not only the leaders but the passengers. It takes a special breed to do adventure travel.

In 1980 we travelled with Lars to the Galápagos Islands, another first for both of us. The Galápagos represent another world, one in which the animals are almost oblivious to humans. The tameness of the creatures—the sea lions, the Marine Iguanas, the Galápagos Penguin and the Galápagos Tortoises—is remarkable. We felt like flies on the wall of nature's living room. Darwin conceived his theory of evolution here, and to visit is a privilege, a reminder of the world's incredible abundance.

Prior to a Lindblad trip in 1981 that started in New Zealand and ended in the Philippines, Birgit and I obtained our scuba diving papers, or "sea cards," as they are called. I will never forget swimming with a dozen others at the Great Barrier Reef and diving straight down 125 vertical feet of coral wall. As we descended we passed through "life zones," each with its own fauna. Whitetip reef sharks

VALERIE TAYLOR

RICHARD
ADAMS
"WATERSHIP DOWN"

were everywhere, apparently indifferent to our presence. The dive masters on that trip were Ron and Valerie Taylor; she made the cover of *National Geographic* magazine wearing a chain mail suit while a shark tried to twist off her arm.

Valerie had trouble with one of the other diving passengers, who happened to be a resource person on that trip. Richard Adams, the author of *Watership Down*, was an erratic diver. One day, I had a sore throat and so Birgit had Richard as her diving buddy. He almost drove her crazy with his sudden changes and ups and downs. But I'll give him this: he was a compelling speaker. He gave a talk on the sonnet and quoted from the works of Siegfried Sassoon, the First World War poet whose headstone reads: "My subject is War, and the pity of War. The Poetry is in the pity." It was a very moving talk, and many of those listening were in tears.

I sketched a number of the characters on board the ship, as well as some of the native people we met on the islands where we stopped. At one Pacific island, our visit aroused an unexpected fear in the locals. The last large ship to visit had come in the 1940s, when Japanese soldiers came ashore and killed all the men and raped all the women; that memory was still vibrant. Once the islanders had been assured we meant no harm, we were given the most endearing welcome.

On another island, a great feast was prepared for us. As a special treat, four young men carried in two live trussed-up sea turtles. This prospect horrified many of those on board, and we persuaded the villagers to give us the turtles for later consumption. We sailed off, turtles in tow, and later let them go at sea. But experts on the ship told us that the turtles would swim back home, so perhaps we only delayed their fate. Nevertheless, we gave it a try.

Before letting the turtles go, we kept them on board the ship in the swimming pool.

ON ONE GALÁPAGOS CRUISE (not a Lindblad cruise, I hasten to add), everything that could go wrong did. The preamble to the misadventure was a trip I had taken to northern Manitoba in the early 1980s to help my friend Fred Cooke, then a professor of biology at Queen's University. A droll, expat Brit, Fred was an expert on Snow Geese. I had agreed to help him and his grad students as they banded chicks and took blood samples to research the birds' ecology, ethology and genetics.

Fred had also enlisted as volunteers two women, one a radiologist, the other an author of children's books. They were a tweedy and intelligent pair who assisted with the photography and the set-up of the blind. At the end of the research trip there was a slide show, and we all took turns at the projector. Finally, Fred asked the ladies if they had anything to show us. They were shy about this, but Fred insisted, and when we saw their photos, our jaws dropped. The shots were stunning—crystal clear, sharp and memorable, and all done with their Leica film cameras and lenses.

At the end of the evening, the ladies said they had chartered a boat to the Galápagos Islands. "Want to come?" they asked.

"Sure," I said.

The boat was a twelve-passenger sailboat, unlike the Lindblad ships, which accommodated one hundred passengers. The Galápagos Islands are far apart, and it takes time to get from one to another; you need a fast boat in order to get to the next island by dawn, when the light is best for photography. In our little putt-putt, we didn't arrive until noon, when the mid-day heat was intolerable, the island's black-lava rocks were hot to the touch, and the glaring light was hostile to good photography. Our 65-foot schooner had showers, but water was severely rationed. Because we were perpetually hot, sticky and salty, we fretted about salt getting into our camera equipment.

One night, we heard the engine stop, followed by a sickening crunch. There was the pitter-patter of feet and a loud exhortation to "Grab your life jackets and come out on deck!" The captain had cut a corner in the early morning fog and hit an outlier from a lava cliff. It

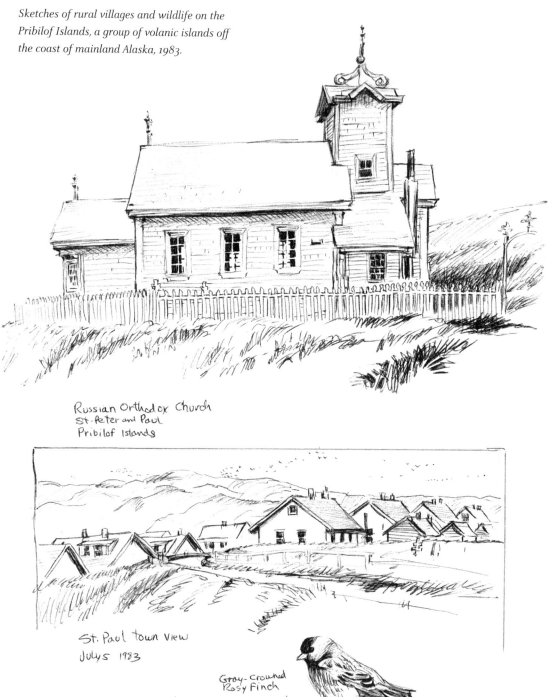

Sketches of rural villages and wildlife on the Pribilof Islands, a group of volanic islands off the coast of mainland Alaska, 1983.

Russian Orthodox Church
St. Peter and Paul
Pribilof Islands

St. Paul town view
July 5 1983

Gray-crowned
Rosy Finch
the common town bird-

Fur Seals

Murres and
kittiwake.

Pribiloff
Islands '83

was still dark, and we saw rings of foam from the surf cascading off the nearby cliff. The captain asked one of the passengers to take the wheel while he went forward to check for damage. When he came back he reported that the water pouring into the boat amounted to the quantity produced by a kitchen faucet. He told us the pumps should keep ahead of the leak. He had not tried them yet, but he was pretty sure they would work.

A mayday call was impossible for several more hours because reception for such calls only commenced at 9:00 a.m. We looked at the lifeboats: the bolts were painted over. There was no first-aid equipment, no bottled water or emergency food on board. No radio, no Global Positioning System. Had we been forced to abandon ship, we would have had to swim for the beach—if there was one—then, without a water supply, traverse a desert island through thorn scrub before reaching a settlement one or two days away. Did I mention we'd also have to climb a cliff?

I can make light of it now, but Birgit and I had terrible thoughts of our children being orphaned. In the end we did manage to limp back to port, where we were given the option to continue on another small ship or go home. We chose to go home, and I made a solemn promise to myself: no more trips on little boats.

IN 1983, WE WERE INVITED TO JOIN a legendary Canadian naturalist named Gus Yaki on a trip to Chevak in the Yukon River Delta. Gus was following in the footsteps of Roger Tory Peterson and James Fisher, who had gone all around North America (over 48,000 kilometres) on an historic birding expedition thirty years earlier. Their trip is chronicled in a book called *Wild America*.

A sketch I did on the Chevak leg of that trip shows women fileting salmon before hanging them to dry on poles. Memorable from that unique experience were the mosquitoes—you could swat your knee every second and kill twenty of the critters each time—and the birds:

King Eiders, Spectacled Eiders and all kinds of other tundra birds. The bugs and the birds are connected, of course. The insects attract insect-eating birds, which in turn attract hawks and falcons—a feast for a birder's eyes.

Chevak had no hotel or motel, so we pitched our tents at the end of the runway. The toilet comprised three poles and a tarp, with a toilet seat set over a bucket. We went to the loo in pairs, the helper brandishing a willow whisk to fend off biting insects. No one ever tarried.

I CONSIDER THE TOTEM POLES made by the Haida in the Queen Charlotte Islands to be the height of tribal art in the world. Sketches I did in 1982 on a trip led by Jim Allan, who began Ecosummer Tours, tell of our visit to see the totems on Anthony Island, south of the Queen Charlottes, and I still view the time I spent at this UNESCO World Heritage site as one of the highlights of my life.

When the steel axe was introduced into the Haida culture in the late eighteenth century, their art blossomed. I do love those magnificent carvings based on animistic beliefs, and I lament, as do others, the degradation of the First Nations culture, in part through the residential school system. The Haida were not only superb artists but also had a knack for siting their villages to esthetic and strategic advantage; those curving bays were naturally pleasing and provided both shelter from the storm and excellent lookouts for spotting approaching enemies.

Haida artists would choose an old-growth cedar and sheer off a big plank but leave the tree alive. (Modern lawyers acting for the Haida call such trees "culturally modified," and their existence has been used to settle land claims.)

We arrived on the island on a bright, sunny day only to find the place a sea of hard hats, with yellow tape everywhere and chain saws revving. This was a UNESCO reclamation project. The forest was taking over and wreaking havoc with the totems. Trees were growing right through the middle of some of them, and moss and mould were by degrees covering them. That suited the Haida fine. I didn't agree; I was happier to see the totems protected.

Two days later, we came again and the experience could not have been more different or more spiritual. Instead of the hard-hitting sun, it was grey and misty. On the trip over the ocean was like glass. A pod of White-sided Dolphins came to play at our bow. Birgit was determined to get a photo as they jumped. At one moment, a black sheep among the pod emerged alongside and kept coming and coming. It was a Fin Whale, the second-largest mammal. We stopped the Zodiac. It came up again, right beside the boat, rolled on its side and looked at us with one baleful eye. Then it blew a smelly mist all over us—whale halitosis. The dolphins disappeared.

In the village, we were alone with the totem poles in the foggy silence. The only sound was the singing of a Hermit Thrush . . . to my mind, the most spiritual bird.

OVERLEAF: *A sample of sketches from my time in the Queen Charlotte Islands in 1982.*

Fork-tailed
Petrel

Rock COD.

Leache's
Petrel

Haida Gvaii
1982

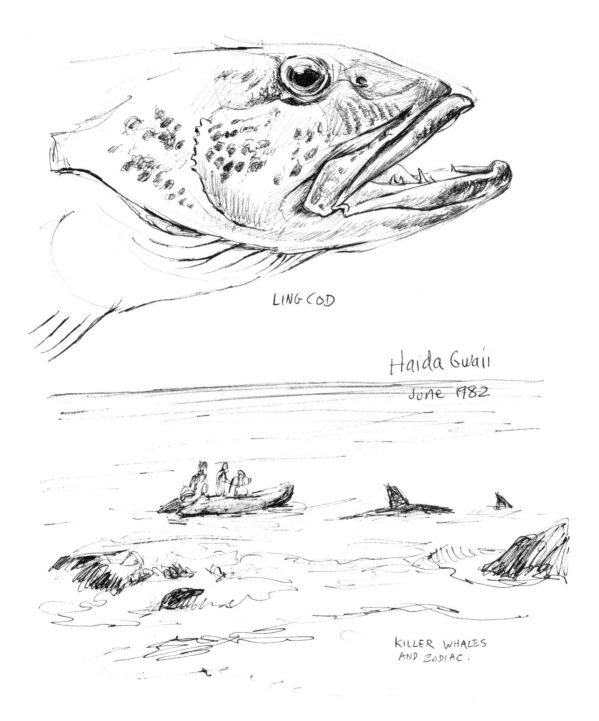

LING COD

Haida Gwaii
June 1982

KILLER WHALES
AND ZODIAC.

MY SKETCH OF MACHU PICCHU brings back a trip we took to Peru in the spring of 1998, but there is a soundscape that goes with it that exists only in my head. I was recovering from breaking my ankle while jogging on Saltspring Island. Hiking the 27-kilometre-long Inca trail with its many tall steps would have been impossible for me because of the several screws in my ankle that made bending forward slow and awkward.

Birgit and our son Christopher, then twenty-two, got off the train to begin their Inca Trail trek with a group of Canadians. I continued by train to the colonial town of Aguas Calientes, perched below the Inca Trail by a beautiful big river, the Rio Alcamayo. I had five days on my own to hike, take pictures, make art and bird-watch.

One morning I woke up to pea soup fog. Most people crave sun and bright days, but I am an artist and I cherish overcast days, falling snow and fog. I said, "Yes!" under my breath. I got on a bus to rendezvous with the returning hikers. I stood on those ancient steps the Incas had built and I marvelled at the mysterious and evocative rock walls. I was alone, and then the mist would clear and pieces of the ruins below would appear, or a shaft of light would strike an altar or a grassy area. Finally, someone below started playing a flute. The sound was otherworldly. It could not have been more magical.

Just then, the hikers appeared. I spread out my arms and said, "Welcome to Machu Picchu!"

WITHIN THE BATEMAN CLAN MY CRUSADE against food waste is well known and tolerantly accepted. I abhor seeing food left on a plate, and I'm not averse to plundering it. This penchant was revealed to friends who were with Birgit and me in western Spain in 1994.

The trip started in Extremadura, considered hillbilly country by the Spanish. While it's true that "progress" has passed it by, the region is a near-pristine part of Spain where much of the land has never been tilled, and chemicals have not been deployed. A great many

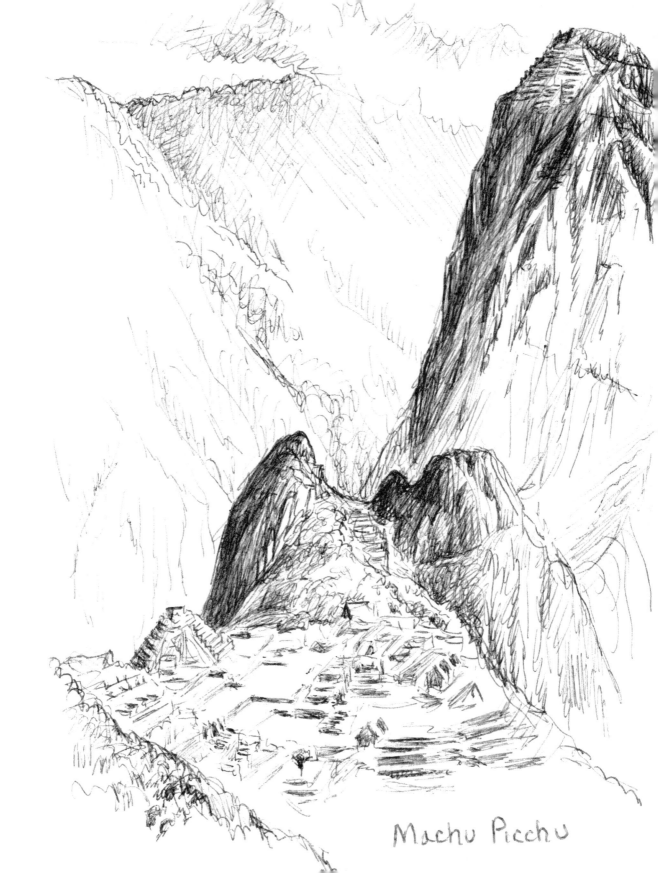

Machu Picchu

creatures—Lesser Kestrels, storks, swifts, bustards—thrive in the area. I was invited there to paint for two weeks with the Artists for Nature Foundation, and to contribute the resulting works to a book that was meant to highlight the unique aspects of the area and perhaps stave off developers' bulldozers. I gained a greater appreciation of the birdlife of that part of the world and the region's cultural heritage. One pub in Extremadura, set by a crystal-clear river with wild flowers growing on the bank, had operated continually since Roman times 2,000 years ago.

I have many sketches from that trip, including one of a rather bold and curious mule. I had been sketching a ruined monastery when this fellow, though hobbled at the front, made a beeline for me. When I fled the scene (but not before dropping my sketchbook), he stepped on the sketchbook and, with his teeth, tore off one corner and ate it. The drawing shows the result: one corner of the page is missing and the whole page bears brown stains (he had been stepping in manure). I finally ran at the mule, shouting the whole way, and retrieved my sketchbook.

Near the end of that trip, we joined our friends David and Diane Reesor in visiting the medieval convent on Montserrat in Catalonia, where we were served dinner by nuns. We ate what was presented to us—potatoes, beef and gravy, with canned peas. I love peas, all peas, whether canned, fresh or frozen. My companions turned up their noses at the canned peas, and rather than see them go to waste, I ate all four portions. (The following year, for my sixty-fifth birthday, Diane gifted me with sixty-five different brands and types of peas, along with pea-themed tea towels and aprons.)

Hoopoe

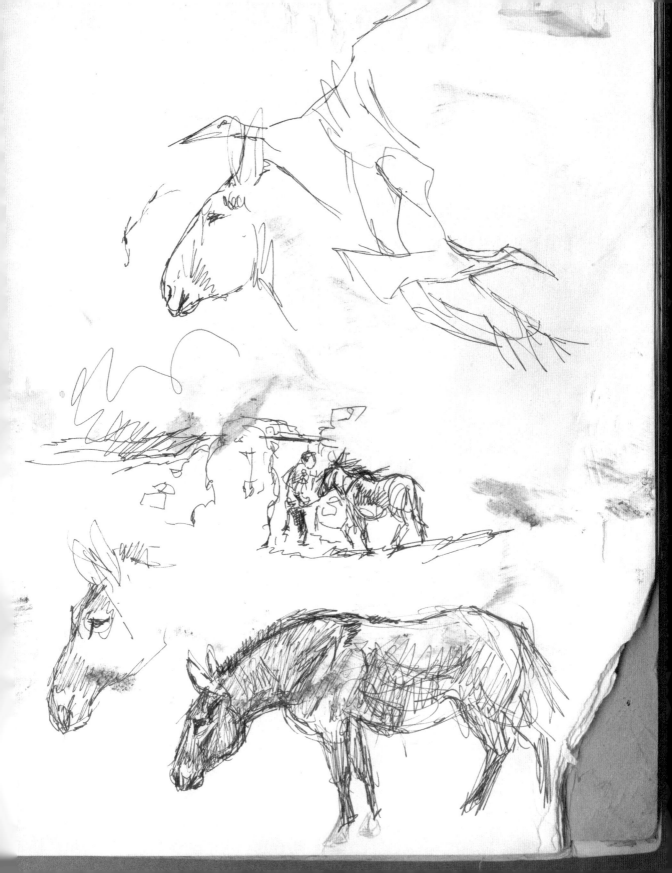

TOVEY'A

"Hamin"
Porara
Oct 24/94

WIGMAN
"PILLOW"

During the fall of 1994, we went on a memorable trip to Papua New Guinea. The country was then ministered by Australia, but the people in the villages had very much retained their culture. We were told that in remote areas cannibalism and head-hunting continued.

We asked our bus driver, who was Papuan, "Are there still bow-and-arrow wars here?"

"Yes," he said. "There's one going on now."

He stopped the bus at a bridge and pointed to the river below, where the warriors were freshening up during a recess in the battle. The driver told us that disputes between warring tribes involved pigs, land and women—"in that order."

The purpose of our trip to the Papua highlands was to visit several villages of the Huli wigmen, where the men continually decorated their faces with paint and their hair with feathers and wigs. I sketched two men, one with his face heavily painted with yellow, black and red lines, along with a headdress, the other resting in the shade of a tree on a wooden pillow he had constructed.

Huli wigmen I sketched on a special Lindblad trip to Papua New Guinea in 1994.

FACING PAGE: *Sketches from an earlier trip in 1982 to the Admiralty Islands, the Bismarck Sea and Papua New Guinea.*

JAPAN MAY 2014

Nagano

Tori Gate
Togakushi FOREST BOTANICAL GARDEN
Near Nagano

BIRGIT AND I TRAVELLED TO JAPAN in May of 2014 to visit Princess Takamado, an old friend and a member of the Japanese royal family who happens to be an avid birder (the up-at-5:00 a.m. variety) and a very good bird photographer. She and her late husband, Prince Takamado, had been patrons of an exhibition of my art held at the Canadian embassy in Tokyo in 1991, and we had seen her several times since in her capacity as honourary president of Birdlife International, the world's largest nature conservation partnership. We are members, as are some prominent Canadian birders, such as authors Margaret Atwood and Graeme Gibson. In the fall of 2013 Birgit and I had lunch with Princess Takamado in Victoria. It was then that she invited us to go birding with her in Okinawa and the Nagano Highlands the following spring.

It was like no other trip, all of it planned by the princess. I was strongly influenced by Japanese art and architecture, even before our first visit. For the Okinawa part of the trip, we were joined by Mr. and

DorterGokui Inn · shrine

Mrs. Senge. He was an amateur bird photographer. We did not know his background but were told he was paying for the vehicle rental. Noriko, the daughter of Princess Takamado, was also with us photographing birds.

The next stage of our trip was to Izumo, an ancient city on the Sea of Japan. One of the greatest of two Shinto shrines is there. It turned out that the mysterious Mr. Senge was head of the shrine, as his family had been for eighty-four generations, since Viking times. He took us under his wing, but apologized that the day of our tour of his shrine, his son Kuni Maro had to pitch in as our guide. Mr. Senge had been summoned to Tokyo for a meeting with the emperor on that day.

Days after, as we left Tokyo for the airport, we learned of the story behind the birding. It was front page news in the papers and on the television. Princess Noriko and Kuni Maro, son of Mr. and Mrs. Senge, were engaged to be married, a joining of the Imperial family and the great Shinto family. The marriage between Kuni Maro and Noriko took place in the fall of 2014 at the Izumo Shrine, which is dedicated to the god Ōkuninushi, the Shinto deity of marriage.

Sunday,
Aug. 31, 1980

View from
Tokyo Hilton

damp day
cicada songs
folk art museum
old ceramic and fabric-
Nippon Mingeikan

Hatakeyama
Collection
First tea
ceremony

Ukiyo-e
lecture theatre
Hokusai
Hiroshige

Cicadas
singing
and singing

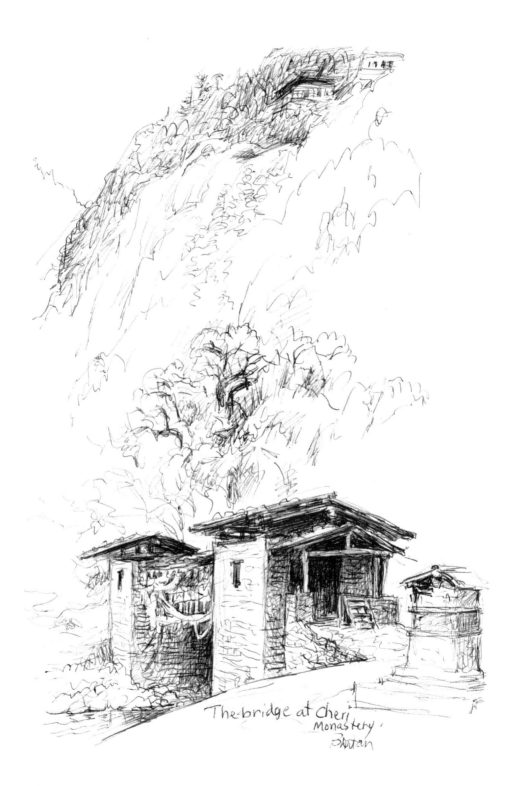

The bridge at Cheri
Monastery,
Bhutan

Ura Village Apr 15
Phobjikha Valley

Bhutan is one of our favourite countries. We visited it in 2001 and 2005. The motto of the king was "We don't believe in Gross National Product. Instead, we believe in Gross National Happiness." As a result, the country has been successful in protecting both natural heritage and human heritage. The special place for us is the Phobjikha Valley, where the Black-necked Cranes spend the winter.

House where we had lunch near Ura Apr 15

VII : PORTRAIT OF THE ARTIST

Sometimes I am asked, "How long have you been an artist and a naturalist?" The answer is: I've always been, but there was nothing special about that. All little kids in whatever culture enjoy animals and do art if they have a chance. But most normal human beings grow up and go on to more mature pursuits in their early teens. I just never reached that stage, because that is when I got serious about the "kids' stuff"—art and nature. Until I was eighteen I did small, fairly realistic, detailed paintings of birds and mammals, but from the late 1940s to the early 1960s, I moved through various styles, starting with Impressionism. Then I moved on to a Post-Impressionist period and fell under the influence of Van Gogh and Gauguin. I experimented with cubism, emulating Georges Braque and Pablo Picasso, and I came to deeply admire Japanese printmaking and Chinese painting. I would move between all these styles, sometimes in the same painting. Then I tried abstract expressionism and studied the works

of Mark Rothko, Franz Kline, and Clyfford Still. I turned to larger brushes, bolder strokes.

But I did not have a studio. I did all of my paintings, whatever style, *en plein air*. I remained a naturalist who valued every day spent in the outdoors and who continued to fill sketchbooks with closely observed depictions of creatures in their natural habitat. But I did not consider this work art with a capital A. I was determined to become a legitimate artist, and I was fully aware that art that depicted nature had no foothold in the major commercial or public galleries. Carl Schaefer's dictum still echoed in my head: art was about capturing the essence of the subject with a minimum of strokes and detail. It was teaching that ran counter to my everyday naturalist renderings, yet for decades those two very different threads ran alongside each other, separate and parallel, never crossing.

My Road-to-Damascus moment, as I sometimes call it, occurred in the fall of 1962 when I was thirty-two years old. I was with a group of friends and amateur musicians who gathered occasionally to indulge a love of folk music. Among them was Gus Weisman, a fellow abstract artist and an old friend who then taught at OCA. Our conversation went like this.

"Have you been to see the Wyeth show in Buffalo?" he asked.

"No, I haven't."

"Well, you've got to go."

"Why should I go?"

"Because," said Gus. "He's a damn fine painter."

On a cold Thursday evening soon after, Ross, Suzanne and I made the drive to Buffalo, to the Albright-Knox Gallery. It struck me as odd and more than a little ironic that the venue for Wyeth's show was the prestigious Albright-Knox, renowned for its avant-garde collection of works by Gauguin, Matisse, Pollock, Warhol, Picasso, Still and many others.

That night at that exhibit, I fell off my abstract horse. Wyeth showed the way, demonstrating that an artist could create realistic

pieces using abstract principles. "I'm a pure abstractionist in my thought," he said. "If you can combine realism and abstraction, you've got something terrific." It took me a few years more to divest myself of my abstract pretensions, but Andrew Wyeth was the essential catalyst of that process.

The Albright-Knox Gallery showed real courage in offering a show of Wyeth's paintings. To understand why, a refresher in art history may be helpful. Essentially, painting became more and more realistic until the end of the nineteenth century. Think of the Pre-Raphaelite paintings—schmaltzy but beautiful, and technically very fine. Then along came the Impressionists, who turned to yummy, if tiny, dabs of paint. The paint got yummier and yummier through to Van Gogh. The Dutch master loved yellow, to which he would add a thin blue line to make it sizzle.

What mattered more and more was the paint itself, and what mattered less and less was the subject. By the 1950s the abstract expressionists were in the ascendant, and there was no interest in subject matter. Contemporary realism had not been shown in an establishment art gallery in the twentieth century until the Albright-Knox exhibited Andrew Wyeth's work in the fall of 1962.

The Wyeth show was a turning point in my development as a painter; it gave me permission to follow the path that was faithful to my ecologist's heart. I was conscious of the variety and complexity in every square foot of the planet, and distinctions in the natural world mattered to me. The fur of a polar bear is not the same as that of a red fox. The bark of a shagbark hickory is different from the bark of an elm or a maple tree. As an artist, I wanted to explore those distinctions, and I came to realize that you cannot do that with yummy gobs of paint or with the big brushes I had used as an abstract painter. God is in the details. Thanks to Wyeth, I knew at last who I was: a painter of realism, an Andrew Wyeth artist with a nature twist.

At the same time, I am genuinely grateful to have worked through all those earlier phases. In one sense I threw them off, though another

way of expressing it is to say that they were superseded by my inherent realist tendencies. If you look closely you will see abstract and even cubist elements in my art. Sometimes those elements are present in a quiet, calculated way, but most often they inform my work instinctively and intuitively in the composition.

Take, for example, a fairly large (3' x 4') acrylic painting from 1976, thirteen years after the Wyeth show. It's called *Red-winged Blackbirds and Rail Fence*. Driving home one day from Lord Elgin School, we passed by a rail fence that traversed a swamp, one I had glanced at hundreds of times. It was late afternoon on an early spring day, and the whole scene was backlit. The cedar rails were starkly black. I slammed on the brakes, reversed the car and took a single photograph. I had slammed on the brakes metaphorically too, and said a loud "Ah-ha!"

This painting would not have come to me had it not been for Franz Kline (1910–1962), an American abstract expressionist whose

work was lodged in my head and in my gut. Though Kline himself denied the influence, critics had observed something like Japanese calligraphy in his paintings, and especially those in black and white. The dark fence rails were the starting point for my composition, with the bold vertical and horizontal lines of the cedar posts and rails very like the slashing of a samurai sword or bold Japanese calligraphy.

In the scene are two Red-winged Blackbirds vying for control of the territory. I had spent hours watching these birds, and I knew that the males adopted certain poses to drive out other males prior to finding a mate, showing red to establish dominance. Again, I thought of the samurai wearing their black armour, their colours displayed on their shoulders. That, it struck me, is what Red-winged Blackbirds are: warriors fighting over territory and females.

The painting was years in the making. I had no reference for the birds, so I did quick sketches in the field. In a few seconds I could gather enough information to get it right, because I knew about bird anatomy. Then I did a Plasticine sculpture based on the sketches, then a detailed drawing. I wanted to know, at what particular angle does the shoulder of the bird cover the lower mandible? What is the gap between the tail and the far primaries? I wanted to be as accurate as possible, and I made cutouts and placed them in various positions to see which arrangement worked best.

But remember, this scene started as a landscape. I have said many times that I am essentially a landscape painter, but one who installs wildlife in his scenes because that's what gives his heart a lift. I am a naturalist after all. And I do all I can to get the details precisely right. However, conflicts can arise between art and nature, between esthetics and accuracy, and when that happens I rule in favour of art.

That was the case with *Red-winged Blackbirds and Rail Fence*. A friend of mine, Dr. Bruce Falls, a highly regarded ornithologist at the University of Toronto, told me he liked the painting, but he pointed out an error. He could tell that the dominant male was the one flashing all the red on the left side of the painting, and that he was driving

away a bird to the right that was flying just above one of the fence rails. The dominant male, Bruce said, would never put himself in that position below the sub-dominant male. This news bothered me, but not enough to change the composition. Sometimes I do make changes in the interests of accuracy, but in this case I did not because to me it looked better the way it was. It's my painting and I can make it wrong if I want to. But I do so with my eyes wide open.

Roger Tory Peterson, in his introduction to *The Art of Robert Bateman*, observed that my subjects "are ready to go somewhere else, to fly away. His creatures are invariably off-centred. They enter from off canvas or are heading out towards the edge This apparent imbalance gives Bateman's compositions a marvelous sense of action; a split second later the bird would be gone." William Whitehead, who narrated several films about my art, made a similar comment: "Robert Bateman captures a moment in time, a moment that *could* have happened."

A work completed in 1966 illustrates both of these observations. It's called *Winter Elm—Rough-legged Hawk*. I could see the elm in that painting from the bathroom of Suzanne's parents' house. The shapes in that wonderful tree were abstract expressionist in form, and in its first incarnation four years before, the painting featured bold vertical and diagonal strokes. Here, too, I owed something to Franz Kline and his sense of positive and negative spaces.

In 1962, the revelations of Wyeth's approach caused me to return to this painting to work on the elm tree's bark. I retained the dynamic forms, but now I painted the elm's texture as it really was. Finally, in phase three I introduced the Rough-legged Hawk, placing the bird in the branches far to the left. I consider this painting, four years in the making, a pivotal work.

What I strive for in my paintings is verisimilitude. I want the viewer to feel the very real possibility that the landscape and the creatures in that work are genuine, that the viewer has glimpsed a fleeting truth and that he or she is the richer for it.

IT HAS BEEN SAID that I am an "idea painter." The source of those ideas is completely unpredictable. It is as hard to pin down as intuition. The genesis of a painting can be something as simple as seeing two similar colours juxtaposed. *Cardinal and Sumac* was inspired by a chance observation at an exhibition at the Smithsonian a year before my show there in 1987. Between meetings to discuss the arrangements, I took in a virtual open-air museum on display. The curators had recreated a series of villages from India, with artisans from that country on the scene and going about their business. There were tinsmiths, ceramic artists and wood carvers, all speaking Hindi and seemingly oblivious to the visitors in their midst. At one point I observed an artisan in a flaming vermillion turban and matching robe walk past a terracotta mud wall. Seeing those colours juxtaposed—sizzling red on red— was the inspiration behind my well-known painting of the Cardinal and the sumac. There was no denying that the Muse had struck, but execution can take a while. I finally produced the painting in 1993.

THERE IS A GICLÉE OF ONE OF MY LARGEST WORKS (the original is more than 6' x 8') at the Robert Bateman Centre in Victoria. It's called *"Chief"—American Bison,* and it's based on an encounter I had with a bison in a wildlife park. I have always been attracted by the bison's almost prehistoric appearance, but this particular beast was not attracted to me.

I had stepped out of the car to take a better picture. When he charged towards me, I got back into the car. I was reminded of the work of Eadweard Muybridge, the nineteenth-century photographer who used stop-action photography to answer an age-old question: When a horse (or, say, a bison) gets up into a canter, do all four feet come off the ground? The answer is yes. Muybridge's book, *Animals in Motion,* published in 1899, remains a classic.

"Chief" was painted for the National Museum of Wildlife Art in Jackson Hole, Wyoming. My plan was to obscure the whole hind end

of the bison in a cloud of dust. I wanted the beast to come at you like a speeding train. I had started the painting using raw umber, and then I laid on white with yellow ochre. At some point I began to throw white paint on the work and dab it with a sponge to create the illusion of dust. This was the scary part. There's always a risk that the painting will be ruined and that I'll have to start over. But I'm fearless when it comes to my own work. I wanted the hind end of the bison to vanish, and I believe I accomplished this.

I have done quite a few bison, including one that I started in front of a class of 150 art students in Dubois, Wyoming. That day, as I always do in these teaching sessions, I started from scratch with a whiteboard and worked out my ideas—and doubts—verbally so the class could hear the wheels turning in my head. I had also brought with me photos of bison on my iPad, some taken in the wild and some at zoos.

My aim was to marry a selected image of a bison with the Wyoming landscape, so at one point during that weekend I went out for a drive with a cowboy artist. Along the way, the composition for the work unexpectedly presented itself to me. I spotted a nicely eroded road cut that seemed to echo the curve of the bison's hind end in a photograph I had taken at the Calgary Zoo. That may seem an unlikely connection, but it could be what separates me from some other artists: I am alive to images that can shape compositions. I asked the cowboy to back up. I had seen something, and I had to photograph it.

I KNEW A PAINTER WHO WORKED FROM REAL LIFE, perhaps keeping a bird in a small enclosure. To me that's cruel. I do have a Kestrel, and a few other birds that I sometimes haul out of the freezer while I check a detail or two, but I rely on photographs and, of course, the stacks of sketchbooks kept in boxes in the loft above my studio. An interesting

thing about those sketchbooks: my style has not changed since I was a teenager. The quick loose drawings done in the 1940s are indistinguishable from those sketched this year. In fact, I have used sketches from those very early days as references for work I'm doing now.

Like virtually all artists who depict wildlife, I work mainly from my own photographs and sometimes from my sculptures. Occasionally I work from memory, but memory is not to be trusted. When I take photographs of landscapes, likewise to be used later as reference, I will often hang my reading glasses on a twig, or ask Birgit to stand in the scene so that I have a reckoning on scale and perspective.

But once early in my career, Birgit's own photography made possible a painting that has special significance. While we were teaching colleagues in the early 1970s and not yet a couple, I started work on *By the Tracks—Killdeer*. Among my resource materials was a picture I had taken in my youth of a baby Killdeer, sitting in a nest by the side of the ravine railway tracks behind Chaplin Crescent. It actually wasn't a bad place to build a nest. The lumbering trains came through only twice a day and posed no threat to the birds, and there were few walkers in that particular area.

My problem was that I needed detail of a railway bed, ideally one with natural gravel, gnarly rocks and weeds. All the tracks I had seen recently featured same-sized crushed stone. Birgit offered a photo of a rail bed she had taken in east Vancouver. It was a gorgeous black and white photograph of an aged railway line in the city's waterfront area. It was taken in 1964; she had an eye even then. I used the photograph as I worked on the Killdeer painting, and added to it a dandelion that grew in a pot in my studio.

The painting became part of a show in Hamilton. Birgit arrived early on the day of the opening and was second in line; she wanted to buy that Killdeer painting. The person before her in the lineup was another of our colleagues at the school, Jim Peachey. And when the doors opened, he headed for the Killdeer.

"Peachey got it," Birgit later reported to me sadly.

Years later, after Birgit and I were married, I told Jim the story and made him an offer: any subject and double the size in exchange for the Killdeer. Jim had five children, so we settled on five 12" x 16" portraits. The portraits were done in a loose style, and I doubt I could do better today, but Jim's wife was not happy. She loved that Killdeer too.

Nonetheless, the following Christmas Birgit was delighted to find *By the Tracks—Killdeer* under the tree.

WHEN I EMBRACED THE REALIST STYLE IN 1963, the first challenge was to find paint that would dry quickly and that would suit the over-painting I was doing, laying on layer after layer. The usual paint dried too slowly for my liking. My habit, then as now, was to view the work as a fluid, changing concept. With oils and egg tempera, I could not immediately make changes but had to wait for the paint to dry. I tried the old method of mixing egg yolk with the various pigments. That didn't appeal to me, nor did the commercial products I tried.

It was during my time teaching in Nigeria that I tried my own take on egg tempera (watercolour plus egg yolk), and it seemed to work well but with one unintended result. I would teach by day and paint in the evening, and every morning when I went back to the easel I would find tiny thread-like trails on my painting. Little sugar ants were eating the egg yolk in my concoction.

When acrylics became popular in the early 1960s, I leapt at the chance to use them. They dry within minutes, though still too slowly for me. I sometimes use a hair dryer to expedite the process. Once the paints are dry, I can change my mind and paint over them—and I am always changing my mind, always making corrections.

EACH OF MY PAINTINGS BEGINS with an idea—an experience, a photograph, a sketch or a scene imagined. Letting a painting sit and simmer ("composting," as I sometimes call it) is critical to my process.

Sometimes I will look at fifty images—photographs of lions, say—and allow them to linger in my brain over a period of time until a fresh image emerges. That's the one I paint.

I'll do thumbnail sketches, experiment with different designs. With a small sketch, I can immediately see the abstract possibilities. And once I have the essential composition, I select a canvas or a ⅛" Masonite board coated with gesso, a kind of primer. I begin setting down the big shapes in a loose way, using a large brush. Then I go about refining smaller and smaller areas, adding the darker tones later. Of course, I may decide halfway through this process that the mammal or bird is in the wrong position. In that case, I sand the offending area and, if necessary, use a razor blade to eliminate any bumps. Then I start over again.

On one wall of my studio hangs a small mirror, a tool that can help with composition, and indeed with many problems associated with painting. Staring at a reflection of the work in progress can make its problems—and its solutions—clearer. When a painting is going well, viewing it this way actually enhances it, lending it a three-dimensional quality. If the painting has problems, the mirror will exaggerate them, making them easier to identify.

Almost every painting I have ever done has undergone major revisions. There's a saying I have heard horse people use: "Seven falls make a rider." In the art world, an old master painter once said, "Two thousand mistakes make a master." I think he was right. I have never done a painting that I was happy with all the way through from beginning to end. I always have high hopes, but a quarter of the way in I can become dissatisfied, without knowing how to make it right. The Muse is toying with me. The answer is to put the work aside and start another, literally a fresh canvas. There is such a thing as painter's block.

As I was working on this memoir, I was also working on a painting of a Great Grey Owl, but the composition was boring. I came to call the work Great Grey Owl with Spaghetti. I would show it to

people as an example of the artist needing to know when he's beat. I have another one, a painting of a bull moose, cow and calf, that serves the same purpose. My bull moose looked goofy and the composition was split in two—cow and calf with grass, and bull moose with sticks. I redid the painting with new underbrush and a quite heroic-looking bull moose with calf and cow. That one was the keeper.

I LOVE PAINTINGS THAT LOOK LIKE PHOTOGRAPHS (and photographs that look like paintings). Vermeer was the master. His *Girl with a Pearl Earring*, done in 1665, makes me weak in the knees. His use of light, his ability to convey a real moment in time, and the magic in the everyday all set him apart.

Vermeer almost certainly used a camera obscura, a box with a hole on one side, a single light source and mirrors, that would have allowed him to "photograph" a scene long before the invention of photography. There was no film in the seventeenth century, so Vermeer was unable to preserve the image, but it would have been true in terms of colour and perspective. He would have been able to view the scene very much as a camera would.

What Vermeer or Degas, Brueghel or Krieghoff share is that snapshot-of-life sensibility brilliantly rendered in paint. The photographic look does not diminish the poetry or the deeper meaning of a piece. What separates the poetic from the prosaic is the thought.

CARL SCHAEFER USED TO SAY, "You'll know a masterpiece. When you look at it, it's as if you're seeing it for the first time. And the work will look as if done without effort." That is the aspiration of every artist, no less so the wildlife artist.

I use the term *wildlife artist* only because it is so commonly used to describe the work of people such as me, not because I approve of it. In fact, I wince when I hear the phrase. I find it demeaning, restrictive

and stereotypical. *Naturalist artist* is another moniker applied to the likes of Roger Tory Peterson, Allan Brooks, Louis Agassiz Fuertes and Bob Kuhn.

The earliest art, that of the Egyptians and the Sumerians, made no such distinction. The depiction of wildlife was considered a normal part of art, and certainly cave art, such as the more than 17,000-year-old paintings at Lascaux in southern France, was exclusively about wild animals. But when the Christians came along, there was suddenly more interest in heavenly matters than earthly ones. The creatures of the earth were given a back seat. Think of that line from Genesis in the King James version of the Bible: "And God said, Let us make man in our image, after our likeness: and let them have dominion over the fish of the sea, and over the fowl of the air, and over the cattle, and over all the earth, and over every thing that creepeth upon the earth."

Nature was the enemy, the deep dark forest was frightening, and witches who went in there to dabble in herbalism were burned at the stake. And the art world reflected this world view. It was fine to portray live domestic animals, but wild animals were commonly presented dead on a table or at the end of a spear. Only in the nineteenth century did artists such as Bruno Liljefors and Germany's Wilhelm Kuhnert win acceptance for works that depicted wildlife with respect. But they were not part of the art museum mainstream, yet the old prejudices linger, however contradictory they may be.

Birgit and I went to Europe with five-month-old Robbie and three-and-a-half-year-old Christopher. I was on a Bruno Liljefors pilgrimage to pay homage to the man whose works I had not fully appreciated when I visited Sweden in 1954. Liljefors was universally regarded with awe and approval as an Artist everywhere we went. In Holland, at the art museum in Enschede, staff pulled out Liljefors originals for me. In Stockholm we visited the Thiel Gallery, which gathers some of his work. We had tea with Liljefors' elderly daughter at her cottage near Uppsala before pushing on to Göteborg, where the state Museum of

European Woodcock
Wiltshire
June 1979

Rt.
foot

Art held more work by Liljefors. I had brought with me photographs of my own work in an 8" x 10" envelope for show and tell.

The curator in Göteborg seemed very impressed. "You know," he said, "you should have a show here in Göteborg at the Museum of Natural History." The work of Liljefors, I could not help but notice, was displayed in Sweden's state art gallery, an institution that featured new exhibitions of contemporary art.

I said, "What's this about museums and subject matter?"

He said, "Well, if you paint ships, you would show in a marine museum. If you paint railway trains, you would show in a railway museum."

I thought, but did not say, "And if you paint wine bottles and guitars, you should show them in a wine bottle and guitar museum? And if you paint nudes, you show them in a nudes museum?" Subject matter is irrelevant to contemporary art. Why are wildlife artists still pigeonholed?

Art about nature, I would argue, is still art.

TOP: *The Dolly Varden Trout, caught by Art Wolfe, the brilliant nature photographer, during our trip to Taku River in 1997. Drawing specimens that are still means my drawing style is much more detailed. Compare the style here, for instance, to the style of the river rafting sketch on the next page.*

BOTTOM: *I gave an art class on the concept of framing compositional ideas. Holes of a particular shape are cut into paper or cardboard. Then with one eye closed, the artist can look through the hole and see just the chosen view. These four drawings on one sketchbook page show the endless possibilities for the same subject matter.*

FACING PAGE TOP: *River rafting during our trip, we started in northwest B.C. and finished in Juneau, Alaska. The advantage of river rafting is that the river carries you. The disadvantage is that it's more difficult to stop on a dime for bird-watching or for taking a particular photograph.*

FACING PAGE BOTTOM: *At one of our Taku River campsites in British Columbia, we built a big fire and heated many medium-sized boulders. We then used them and a tarpaulin to create a kind of steam bath.*

Art Wolfe's Dolly Varden Trout.

July 15

July 14

Shooting Sheslay's Demise July 13

Sauna + Rock Heating Fire July 12

VIII : PORTRAIT OF
THE PROFESSIONAL ARTIST

GRAYLING
WILTSHIRE

I was a late bloomer when it came to girls, and that's true as well of my career as a professional painter. I continued to teach art full-time until I was forty-six years old, and I didn't sell my first piece of art—art of the kind that I do now—until I was thirty-five. In 1965, I sold a painting of an owl to Kay McKeever, who would later set up an owl rehabilitation centre on the Niagara Peninsula. My buyers in those days were fellow naturalists and teaching colleagues; the going price for my work was a few hundred dollars.

To follow my career as a professional painter, one who actually makes a living by his art, you have to follow the bouncing ball. There were some fortuitous bounces. It started in Nigeria, while I was teaching at Government College Umuahia, a secondary school for boys. I was travelling during school holidays, going on safaris, taking lots of photographs, sketching always—and painting. One day around Christmas in 1963, I was walking down a street in Nairobi and I spotted a poster announcing a calendar competition sponsored by the East African Esso Company.

I submitted two paintings, one of a Superb Starling, a striking East African bird with black head, iridescent blue-green back and red-orange belly, and the other of a Thomson's Gazelle. I didn't win the competition, but my work caught the attention of an art dealer located in the New Stanley Hotel, an establishment made famous by Ernest Hemingway and still popular with international travellers.

The Fonville Gallery was owned by Roberta Fonville, the wife of an American cattle baron who had been ranching in Kenya. Some of her clients were big-game hunters and wealthy tourists who were also interested in conservation. Roberta showed them my paintings of animals in East Africa and they snapped them up. Tourists and colonists in that part of Africa did the same. "Paint me more," Roberta said. "Big, ambitious." Word spread, commissions followed. Over the next decade, while I continued teaching full-time in Ontario, buyers of my original African scenes emerged in Germany, England, South Africa and the United States.

The year 1967 marked Canada's centennial, and as my personal project to honour the nation's birthday I did a series of paintings of the heritage sites in my home county of Halton that had been there for at least a hundred years. (See *Along Walker's Line* and *Winter Barn* in colour insert.) I wanted to do these paintings but thought it would be fun to exhibit them, see them on a wall somewhere. I didn't expect they would sell, but I figured at least fellow teachers, friends and relatives would come in and view them. I approached the best small gallery in Burlington, the Alice Peck Gallery, introduced myself to Alice, and said I would like to show my Centennial paintings, explaining the project. Alice said, "Well, I don't know about that. We just don't take people who walk in off the street, you know." I assured her I knew that.

She went on, "We have a very high standard here with a good stable of artists, so it's quite an achievement to get a show; you have to prove yourself." I said I realized that too, which was why I had started with her. Then she said, "Where do you work, anyway?" I told

her I was the art teacher at Nelson High School. She thought she might have heard of Mr. Bateman; in any event, she took a chance. And so the rest is history. She had never had a sell-out before, and the show was sold out on the first evening. As best I can recall, the highest-priced painting sold for $240.

I was surprised, but Alice wasn't. Once she saw my work, she predicted that every painting would go that first night, that I would be pursued by larger galleries, and that her humble gallery would never have another Bateman show—and she was right about everything. Still, she was happy for the crowd that night.

A small part of me felt some sadness at seeing the paintings go, and I still experience a sense of loss today when certain paintings are purchased. On the other hand, I had no more room on my walls for my art, and I was glad to know the Centennial pieces had found new homes.

The surprise was that buyers were ready for me. That show was the start of my career as a painter, eventually as a full-time painter. But the market hadn't been my primary focus. Probably two-thirds of the show was human heritage, the rest natural heritage, both highly personal and essential elements of my art and my life. Sadly, almost all the human heritage elements I painted for that show, buildings that had stood for a hundred years and more, were bulldozed within the next decade. I began to worry that painting a subject might be its kiss of death.

IN 1969, THE POLLOCK GALLERY, then on Markham Street in Toronto, was the scene of my second one-man show. Jack Pollock was a flamboyant character who had an eye for young talent. Ken Danby (who had been as strongly affected by the Wyeth show in 1962 as I had), Norval Morrisseau and Charles Pachter were among his stable of artists. Jack and I set the prices for the pieces, and I remember him calling me up to report on what buyers were saying in the gallery before the opening. My paintings were on the floor, not yet hung.

"Wow," one visitor said. "Only $2,500. Ridiculous." Jack suggested that we double the prices. We did, and the paintings still sold. An old pal from the Chaplin Crescent neighbourhood, Lionel Schipper, bought two. Some clients took several originals and then resold them at a profit. The market was now setting the prices for my paintings.

In 1971, I had another one-man show, this time in Hamilton, Ontario. After the show at the Peck Gallery, word had spread in the area. I was approached by Tom Beckett, owner of the Beckett Gallery. Tom was a nimble man, lively and positive. He always had a smile on his lips and a twinkle in his eye, but he was also a good businessman, a wise dealer and knowledgeable about art. (We also became his customers, purchasing two drawings by Arthur Lismer, one by Clarence Gagnon and another by Jack Shadbolt.)

As one show at the Beckett followed another, a pattern was established—if a feeding frenzy can be described as a pattern. I kept a photograph from *The Hamilton Spectator* that was typical of the scene: people lining up, maybe fifty deep, before the gallery opened, then running as fast as they could through the gallery, looking and choosing as they ran. Buyers had only seconds to decide, and when they put their hands on a painting it was considered theirs for the asking price. It was utter chaos.

Tom and I decided that having clients tear through these events to claim paintings was uncivilized. It was harrying for Tom's staff, it was stressful for customers and it was frustrating for the many who missed out on the painting they wanted or missed out on the show altogether. There was something of the impresario in Tom, and he came up with an ingenious solution. There would be an opening for my shows, but nothing would be for sale. Not yet. Potential buyers would be told that if they wanted a particular work they were to write out a cheque for the full amount, and their names would be put on a card and placed in an envelope. Some paintings attracted up to a dozen would-be buyers. Ten days later there would be a public event, with the artist in attendance. Tom found a top hat and dumped in all

the names vying for the first painting. Then he asked someone in the audience to pick a card. If the person chosen was not in attendance, they were called on the telephone. The procedure was repeated with every painting, and thereafter all my paintings, unless commissioned, were sold that way.

In 1975, the Royal Ontario Museum assembled an exhibition called *Animals in Art*. Five of my pieces shared space at the ROM with works by three of my heroes—Bruno Liljefors, Terry Shortt and John James Audubon. Attending the exhibition was another of my heroes, the ornithologist and painter Roger Tory Peterson. His field guides, given to me at a very early age, were like second bibles to me. He was then sixty-seven, long and lean, a standout out in the crowd. With his strong nose and slightly hooded eyes, he looked like a benign hawk or owl. His paintings were not in any way spontaneous but rather arrangements, in the same way that Michelangelo or Rafael did arrangements. Roger created centrepieces.

A few years later, when Roger first saw my painting *Winter Cardinal*, he pronounced it "discouragingly good." Roger was picked on by hotshot birders, who listed inaccuracies in his paintings, and there were some. But he was a man of tremendous accomplishments who possessed a lovely sense of humour besides. At a birdathon held at Long Point Provincial Park on Lake Erie, he greeted a great many people who had come. I remember him saying, "If I have to remember the name of one more person, I'll forget the name of a bird."

It seemed I was on a trajectory, and demand for my work kept rising. In 1978, Bob Lewin at Mill Pond Press in Venice, Florida, began to publish limited edition prints of my work. And in 1981, *The Art of Robert Bateman*, a coffee-table book, was published. It was reprinted over the course of several years.

The word *trajectory* is perhaps not accurate, and certainly not if you take that word to mean a steady ascent. For there were hiccups along the way. For example, in 1978 I had a show in New York City that can only be described as a flop.

The Honourable Aylmer Tryon from the Tryon Gallery in London had a friend in New York with two galleries, one of which was The Incurable Collector, on East 57th St., down the road from Tiffany's. I was still feeling more like a school teacher than a professional painter, but I have Scottish blood in my veins and I was convinced I could muster some sales down there. We filled our Volkswagen bus with the originals painted for this show, and Birgit and I drove the more than 700 kilometres to the Big Apple. I had a good feeling about the show. The opening was lovely, with men in tuxedos serving caviar and fine wine.

I kept waiting for the red sale dots to appear on the paintings; halfway through the evening, I could spot none. By the end of the night a grand total of two paintings, the least expensive ones at just over $100 each, had sold. I was somewhat cheered by the fact that, according to the dealer, the man who had bought them also owned an Andrew Wyeth.

The dealer suggested we come back the next day; sometimes people don't buy on opening night. They ponder and then return. They did not return. Birgit and I spent a lonely day in a near-empty gallery. Nancy Kissinger, wife of Henry Kissinger, the former U.S. Secretary of State, did have a look around, and she nodded to us as she left. Then Robert Redford called (with Paul Newman in tow, apparently) to notify the gallery that he was en route to pick up an antique chair but was stuck in traffic. Though he called again with another traffic report, he and his cohort never did show up while we were there. Finally, Birgit and I looked at each other. "This is silly," we said. Waiting around to say hello to movie stars on the run? "Let's just get out of here."

We left, my tail between my legs. I remember driving the VW out of the city in the pouring rain, the wipers slapping, a kind of grim

silence in the air. But eventually we shook off our gloom, and I drove to our next destination, Hawk Mountain, Pennsylvania, famous as a place to watch hawks passing in migration. We found a logging road, parked on a flat place, got out the foamies and sleeping bags, and slept. That lovely smell of wet fall leaves permeated the place, and the gloom lifted. We even had the good fortune to run into Dr. Joe Hickey, a prominent ornithologist from New York City.

The next day, New York was well behind us. Morning offered a beautiful bright sky, the air fresh and the hawks circling overhead in the wind. This day had a totally different feel from the one before. We were back in nature, and nature once more had acted as a salve.

Two weeks later, with no more sales recorded, the paintings were sent to the Beckett Gallery, where everything sold within two weeks. Two years later, Fred King at the Sportsman's Edge Gallery in New York caught wind of my work, and I had two shows there that were both sellouts. Ken Taylor, the former Canadian ambassador to Iran, widely recognized for his role in the so-called "Canadian caper" (in 1979 he had helped six Americans flee Iran by giving them Canadian passports and having them pose as a Canadian film crew), was now the Canadian Consul-General to New York City, and he came to one show. We had treated my mother to a trip to New York, and I remember seeing her in a corner of the room, happily chatting with Taylor, he of the oversized glasses and mane of curly hair.

QUEUE FOR ROYAL
WEDDING GIFTS,
ST. JAMES'S PALACE,
LONDON

Sept 26

In 1981, while we were en route to Scotland and Ireland, we made a stop in London. It was the year of the royal wedding of Charles and Diana, and I wanted to see on display the gift that the government of Canada had presented to the couple: my painting called *Northern Reflections—Loon Family*.

A sketch of mine records us, standing under umbrellas for three hours in a slow-moving queue outside St. James' Palace. I chatted with a Scottish couple who had boarded a bus at 4:00 a.m. in order to see what governments and individuals from around the world had bestowed on the newlyweds. My ego got the better of me, and I told them that they would be seeing my painting, the only gift from

MY LOONS
AT ST. JAMES PALACE

Canada. They were singularly unimpressed . . . They were Scots, after all.

When we finally got inside, I scoured the gift-laden rooms looking for the loons, without success. A crowd had formed around a bullet-proof display case housing a gilded offering from the Saudis. At last, at the very end, I spotted the loons. They were at knee height, hanging on a flimsy pegboard of the kind sold in hardware stores. No one was looking at the painting, but when a man finally did, I went over to him. "Ahem," I said. "I did that. I'm from Canada. I congratulate you on your good taste."

Then we hightailed it out of there.

I did these sketches during an Adventure Canada trip by ship around Ireland and Scotland. On this particular evening, we visited a pub belonging to Matt Molloy, a talented flute player and member of The Chieftains.

FACING PAGE TOP: *Feral sheep in an abandoned village in the St. Kilda archipelago in Scotland.*

FACING PAGE BOTTOM: *Tory Island, a place almost no one visits.*

Matt Molloy

St. Kilda
June 9 '97

Tory Island
Ireland June 11

IN 1982, A SOLO EXHIBITION OF MY WORK named *Images of the Wild* was organized by the Canadian Museum of Nature in Ottawa and began making the rounds of natural history museums in cities all across Canada. The exhibit travelled to the Museum of Man and Nature in Winnipeg, the Provincial Museum of Alberta in Edmonton and the Centennial Museum in Vancouver. But the first stop was the only *art* museum on the tour, the Musée national des beaux-arts de Québec, where I was honoured to see my work one floor below that of Jean-Paul Riopelle, an avant-garde abstract artist whom I very much admired.

Years before, Aylmer Tryon brought me to England. He had run off 400 prints of my painting of a Cape Buffalo and wished me to sign them, which I did at a printing press called Royals. It was a Dickensian place, where we also had lunch. Imagine a great long table with the boss at one end, a portrait of the founder looming over him, and me at the other end of the table among the junior clerks.

Aylmer invited me to his home at Great Durnford on the River Avon in Wiltshire. Most of the houses in the village had thatched roofs. Some of the houses had images of animals woven into the thatch, the signature of the builder. Aylmer's house, which I sketched, had a millrace: the river flowed through his house, and when the salmon were running he would toss food into the stream from inside the house to attract them. One sketch of mine shows the view from a window overlooking the river, complete with a "bonking stick" embedded in the riverbank so that kingfishers would have a perch to bonk the minnows they caught.

THE FOLLOWING YEAR, 1983, the *Images of the Wild* show opened at the California Academy of Sciences in San Francisco, followed by stints in St. Louis, Cleveland, Cincinnati and Greenville, South Carolina.

The art critic for the *San Francisco Chronicle* attended the show and wrote a review, serious critical attention that was a major step for me. He started by praising my skill, technique and talent, and the way

ALAN
BATEMAN

AYLMER
TRYON

AYLMER TRYON'S
PLACE

THE MILL
GREAT DURNFORD AUG 1 1982
WILTSHIRE

I handled paint. Then came the kicker. "But after all," he wrote, "this is not true art, but mere illustration." *Mere illustration.* What was this about mere illustration?

The view from "The Mill," Alymer Tryon's house.

I thought about this a great deal, and I came up with what I believe defines a case of illustration: It's where the assignment comes from the outside. Someone suggests to E.H. Shepherd, for example, that this book called *Winnie the Pooh* by A.A. Milne would be improved by illustrations of Pooh and Tigger and Eeyore. I am not an illustrator. There are a few exceptions: I did some illustrations for David Suzuki's book *Tree*, and for one of my own books, *Thinking Like a Mountain*. But all my life, my paintings have come from within me, designed to express my own ideas and not to illustrate someone else's story.

You can find all sorts of definitions for art. The *Chronicle* reviewer had quoted a scholar who opined that true art is not about something else but about itself. By that, the scholar meant abstract art, with its emphasis on colour and form. But does that mean that Michelangelo's work on the ceiling of the Sistine Chapel isn't art, or that Leonardo's *The Last Supper* isn't art? In the meantime, you can buy abstract art painted in Hong Kong, in chartreuse and beige to match your drapes, for $40, framed. Michelangelo and Leonardo were creating scenes from the Bible, so the works were illustrations. But *mere* illustrations?

Others say that art must provoke. Sometimes art does provoke; I think of Picasso's *Guernica* and its portrayal of war-induced suffering. Much of his work does not arouse in the same way, though. I have found myself declaring that art must have a sense of mystery, then questioning that claim in the next breath. A cardinal rule of composition is that nothing, either vertical or horizontal, should be placed at the centre line, but sometimes even I break that rule.

There is no "must" in art save for this rule: Art should come from the essence of the person's life. For Degas, it was backstage at the ballet, or the racetrack. For Toulouse-Lautrec, it was the Moulin Rouge. For Bateman, it's the wild and nature. You do what's in your heart.

"I'm happy for your success," someone will say to me. Somehow the word *success* does not fit. I never set out to be successful or famous, but fame did come to me. My definition of success remains quite simple: How well did I do with each picture? And what do my peers think of my work?

I DON'T THINK OF MYSELF AS COCKY, but I may have been so on occasions in the past. That was certainly the case in November of 1985, when *Maclean's* reporter Brian D. Johnson interviewed me at my mother's apartment. Let me set the scene. I was in the middle of a two-month book tour, the Canadian distributor of my prints was downstairs waiting to take me to a gallery, and an art dealer in Orangeville was coming by shortly to pick up a small painting of a Canada Goose that I was close to finishing.

I painted while Mr. Johnson and I talked, and I have a memory of carrying on like a big shot. I was certain that I was going to be the magazine's cover story. All very shameful to recollect. And when I asked him, "Do you have any hardball questions?" I'm sure I was waving a red flag to a bull.

Johnson noted in his piece that my first book, *The Art of Robert Bateman,* had sold in record numbers and three languages since it had come out in 1981. And that the second book, *The World of Robert Bateman*—the one I was then promoting—had an initial print run of 135,000 copies, another record at the time.

And Johnson documented prices: The small piece he saw me working on would later sell for $3,800. Some Bateman reproductions were then fetching more than $4,000 on the secondary market, which I have nothing to do with. Morton Mint, president of Penguin Books Canada, was quoted as saying, "It's like a cult."

But not everyone was on board. Johnson sought out two painters I admired, Harold Town and Alex Colville. The former called me "a good illustrator—no more, no less," and the latter said, "To me,

Bateman's stuff is less interesting than photographs taken by a good photographer." *Ouch.*

The article, which was thorough and fair, especially given how cavalier I had been, conveys Johnson's puzzlement at my success. He did at least throw me this bone: He opined that "Although he may never get the respect he is seeking, he already has achieved serious recognition in his field: Next year the Smithsonian Institution in Washington will mount a major, three-month show of his work."

In fact, the Smithsonian show would not happen until 1987, and the year before that would be devoted, in part, to planning that event. Meanwhile, I had more slings and arrows to endure.

Hubert de Santana wrote a scathing piece for *Canadian Art* magazine in 1986 that compared my work—most unfavourably—to Alex Colville's and George McLean's, and predicted that "Time, and not the fickle public, is the final judge of an artist's work, and it is not likely that time will be kind to Robert Bateman and Glen Loates (who was similarly slammed in the piece). If they are remembered at all, it will be as examples of artistic emptiness."

Sometime later, a CBC documentary crew descended on our home on Saltspring Island. They filmed footage, which was later rather selectively edited, for a storyline that came back to the theme of "lack of respect" from critics and galleries that Brian D. Johnson (and others) had trumpeted. I had to accept that I was in the public eye, where slings and arrows are just part of the package.

It was difficult to reconcile those claims with the many unexpected honours that came my way in those years, from honourary doctorates, to civic recognition, to citations from organizations whose activities in the name of conservation and human rights humbled my contributions. Whether these honours were always deserved or not, I could look to the sales of six books, to the attendance records at multiple exhibitions in Canada and abroad, and to the demand for my prints and originals for proof that there were people who understood and respected my work.

IT WAS AS A WILDLIFE ARTIST that I was invited to show my work in a solo exhibition in the new Evans Gallery at the Smithsonian Institution, the largest museum and research complex in the world. A normal touring show might feature fifty-five paintings; this one would have 120. Mill Pond Press, my printmaker, had hired a limousine and a driver for the whole week we were in Washington. A publicity agent was engaged to drum up interest from *The Washington Post*, National Public Radio and local TV stations.

I thought to myself, *I'm fifty-seven years old, my whole clan is with me (my children, my brothers, my mother, my aunts, Birgit and her parents) and I'm having a great time.* I had had many shows by this point, but this was the Smithsonian.

Mom, being Mom, wanted to make sure I looked presentable, and on the sly she called Bob Lewin to suggest that I buy a new suit and a pair of black shoes, rather than wear the brown ones I always did. With Bob as my guide, I bought a suit (I think I've worn it twice since) and a pair of black loafers with a moccasin top and tassels. I did wonder whether the loafers were too casual for the event, and even gave some thought to clipping off the tassels, but in the end I decided to keep them.

The night before the opening of the show, there was a reception at the residence of Allan Gotlieb, the Canadian ambassador to the United States, and his wife, Sondra Gotlieb. Lorne Greene, the Canadian actor, flew in from California along with his wife, Nancy Deale. A cultural attaché with the embassy, a tall, thin francophone who oozed savoir-faire, was organizing the receiving line when I happened to look down at his shoes.

"You're wearing tassels!" I declared.

"Good heavens," he replied. "We forgot to install the tassel detector!"

The common perception is that these receptions are stuffy, but I've been to a number of them, including one at Buckingham Palace, and they're actually more fun than stuffy.

Opening night drew some 1,200 people. There were many speakers, including Allan Gotlieb, Roger Tory Peterson and the president of the Smithsonian. In sonorous tones, Lorne Greene told the throng that he was immensely proud of me, a Canadian cultural hero and "a legend in his own . . . "—here he hesitated—"mind." There was an awkward and stunned silence as people looked at the floor or the ceiling. Everyone realized that he had unintentionally misspoken.

A luncheon was held before the event, and members of the press were invited to view the show, with me offering commentary. The only attendees were writers for local weeklies and a gardening magazine, all of them female. The lone male was a stringer for *The New York Times* who let it be known by his body language that he would rather be anywhere else. He stood apart from everyone and seemed eager to make his escape while I stood before a painting called *Coyote in Winter Sage.*

"If you look closely at the painting," I told my audience, "you will spot a discarded Budweiser beer can in the underbrush. Everywhere you go in nature, there are beer cans." I said it was a sign of disrespect, and that I wondered why humans tossed cans in nature ("God's living room," I called it) when they would do no such thing in their own homes. Then I said, "I respect everything in nature, even slugs. In fact, I respect slugs as much as I do senators." With that, *The New York Times* man got out his pen and started scribbling. And so was I quoted, which was a little unfortunate, because several senators had attended the opening. The real meaning of my remark was missed: that I respect the humblest creatures in nature as much as I do anyone in high office.

The Washington Post had also sent its art critic. He arrived after the exhibition was hung but before the opening. He, too, studiously avoided other reporters, and he insisted on viewing the works by himself. He took a long time on the tour and said, as he left, "I think you've got a winner here." In the piece published the following day,

he panned the show, arguing that, while I was a very accomplished painter of fur and feather, the creatures in my work were altogether too glorious. Where was nature, red in tooth and claw? Where was the lousy weather? I thought he was right on that score. I had painted the darker side of nature, and I wanted at least some of those paintings included in the show, but the Smithsonian curator, who was also a botanist, had overruled me.

My friends and family all thought the *Post*'s criticism was unfair, but I considered it smart and thoughtful writing. It was an honour to be panned in *The Washington Post*. The show ran for several months and drew 250,000 viewers, a record crowd that I am told has not been matched since.

When we left Washington, our limousine driver—whom we had grown to know and like—bade us farewell but not before offering me some advice. "I've been watching you," he said. "You have this town by the tail. I take a lot of people around—senators, ambassadors, congressmen. If you play your cards right, you'll never have to paint again."

Maybe that was the Washington way. I told him that I actually *liked* to paint.

I AM AN ARTIST AND ART TEACHER who does not believe in art schools. Art courses, perhaps, but not diploma and degree programs aimed at churning out painters and watercolourists. I never imagined myself making a living as an artist, and I believe it's folly to think along those lines. My advice for any aspiring artist is to get a job that pays real money—as a teacher, a carpenter or a stock broker, whatever suits you—and learn about art by making art whenever time allows. If you're one of the lucky ones able to convert a passion into a livelihood, as I was, then you are blessed.

I also advised my students not to paint for the market, or try to guess what would sell and then provide it. "Do what is you," I told

them. No doubt authors offer the same advice to aspiring writers: Let the work well up from some deep and very personal source. Be happy if others find your efforts appealing and wish to buy your work. But the hard truth is that many of those who hope to make a living as an artist, like the many who aim to make a living by their writing, never realize that dream.

A shrewd reporter in Kingston once asked me, "How do you account for your popularity?" Which is a little like asking, "When did you stop beating your wife?"

"You know," I replied, "I'm quite puzzled by it. It can't be because I paint popular subject matters because hundreds of artists paint loons and wolves. My theory is that I used to be an abstract artist and there's something in my approach that uses abstract art as background to my wildlife art. Most wildlife illustrators and most artists don't know the world of art. I taught it."

I thought that was a good answer, possibly even the right answer, though it may not have been the one she was expecting. There is ample evidence that my art—paintings depicting wildlife from all over the world—has touched a chord with a wide audience. Whatever the merits of the work (and I leave that for others to judge), I am heartened and deeply touched that nature as the subject of artwork clearly matters to so many.

In October and November of 2000, I had the biggest show of my career—a show where the work was for sale, that is. The Smithsonian exhibition thirteen years earlier had featured more works, but those were for display only, not for purchase.

The venue in 2000 was the Everard Read Gallery in Johannesburg, South Africa. The gallery is a former Dutch mansion that was converted into a postmodern gallery, with sculptures in a courtyard and one spacious room with a retractable roof, so that when weather permitted, visitors can stand under the stars.

Everard was a cultured, urbane gentleman who knew more about nature than any of my other dealers. He had a beautiful wilderness property outside the city, home to wildlife and wetlands, and it included caves that had been occupied by early hominids and were now the exclusive domain of archeologists. Everard's son, Mark, was equally knowledgeable about art and nature; I was in good hands.

The show was called *Diversities* and featured twenty-seven new works. Mark Read had challenged me. "Forget the market," he counselled—though he need not have. "Paint what's in your heart."

The opening was well attended. It wasn't long before all the paintings were sold, save one. It was called *Lost Wildebeest*, and it was based on a photograph I had taken of a newborn calf on a dried-up lakebed in Tanzania at Ndutu, on the southern Serengeti. My brother Jack and his wife, Agnes, had been with us on that trip, and Agnes especially had felt sorry for this animal. It began to move toward us after I took the photo.

The creature had made two mistakes, and they would prove fatal. One, when he became separated from his mother, he tried to nurse from another female. She sent him packing. And two, he did not follow the herd when it moved. He had been born only three hours earlier, and he would be a hyena's snack before nightfall.

The painting is unusual in that it's almost all foreground. The wildebeest occupies only a small part of the canvas. I got the idea for framing the work this way from a scene in the David Lean film *Lawrence of Arabia*. Lawrence (unforgettably played by Peter O'Toole) and a Bedouin guide are at a watering hole, and they see in the distance a dot, perhaps a mirage. But then the dot very gradually grows larger, and we can see that it's a camel rider (Omar Sharif) all clad in black. Once in range, he shoots and kills the Bedouin. When Lawrence asks him why he did such a thing, the reply is, "This is my well."

What stayed with me was that huge expanse of desert and sky, and the way the director had held the shot for so long. It takes more than a minute for the rider to come into full view. And my photograph of

that doomed young wildebeest staring at me in the distance brought back the scene from the movie. The emptiness of the painting was also influenced by the abstract canvases of Mark Rothko.

The painting of the wildebeest was one I particularly liked, and I was pleased that it hadn't sold, for it looked like I would take it back home with me. But one day, a Saudi prince came into the gallery. Mark didn't much respect the man, who had apparently filled his modern-day castle with bad art. His heart sank when the prince put a red dot on *Lost Wildebeest*. Mark assumed that the prince had bought the piece not because he recognized its quality, but because he knew the show was a sellout and he thought he would ride the wave.

Days later, a friend of Mark's named Jennifer Oppenheimer visited the gallery. She was a Harvard-educated, American-born lawyer and the wife of Jonathan Oppenheimer, and thus connected to the De Beers diamond fortune. "I'll take the wildebeest," she said, whereupon Mark delivered the bad news that it was already taken.

"Nevertheless," Oppenheimer said. "I want it. Find a way."

Mark Read contacted the prince and offered to swap the wildebeest painting for any two others in the gallery. Jennifer Oppenheimer got her wildebeest. I still feel mild regret that one of my more interesting pieces resides so far away.

IX : A DAY IN THE LIFE

In the ninth decade of my life, I regard myself as a contented man. Among the keys to that contentment is meaningful daily work, Birgit's love and the love of family. I am blessed to have all of these, and I marvel that, partly by design but largely by good fortune, I have arrived at this sweet spot.

Birgit is by my side in life and in work. As she, too, is an artist, I appreciate her thoughts on my paintings and value her critiquing and her intellect. Because of Birgit's background, especially as an abstract artist, she has an eye for composition, which is important to me. There are so many choices, and I regularly ask her for her opinion. For example, when I was painting a work called *Cheetah's Siesta*, which is three-quarters big, empty sky, I wasn't sure where to put the horizon. She kept encouraging me to lower it so that the sky would be a more important element and would make more of a statement. Similarly, I'll often ask about where a bird should feature in my composition, and Birgit will suggest the right balance.

An early sketch I did of Birgit during a staff meeting after I hired her to teach art with me at Lord Elgin High School.

We both like to read in bed at night and share exciting thoughts and writing styles. When she is doing the finances, her correspondence or her photography, we work in the same studio and thus are usually together twenty-four hours a day every day, as we have been in every place we have lived. But up the hill she also has her own studio, in one of the small houses built by the writing ladies who previously occupied the property. When Birgit is in her painting or print-making mode, she has more room there than in my studio to work on larger paintings, and she is able to immerse herself without interruptions from office business, family or phone calls.

She continues to be excited by both painting and photography, and was thrilled to be asked several years ago to hold a solo exhibit of sixty-seven of her large photographs in the Stroganoff Palace in St. Petersburg. The photos were on display for four months, during the high tourist season, under the auspices of the State Russian Museum. When we have people over for dinner, Birgit's love of colour stimulates her to create a dramatic and beautiful table, as well as either gourmet and ethnic meals or comfort food, depending on who the guests are. Many times, visitors have suggested that she publish a book about her table décor and her comfortable home. She makes all the arrangements for our travels for work and pleasure (she quips drily that this sometimes seems to be a full-time travel agent job!). Somehow, she has managed to print out photographs of all our experiences since the beginning. She has made a photo album for each year, in essence, recording our life together. This has amounted to forty-three volumes so far.

She remembers to make personal cards—including birthday cards—for all of our family and friends, which in itself is a massive job now. If this were left to me, I am afraid that it just wouldn't happen. From Christmas Eve presentations, to decorating Easter eggs to hang on branches while creating an Easter "tree," she is the custodian of our family's beloved traditions. To top it off, she is my colleague in shared crusades on behalf of art and nature, and she cares just as

deeply as I do. But right now, she makes babysitting the grandchildren a top priority.

Birgit is also relentless in keeping me healthy, not only with an organic diet but also with hiking. She insists that we both work with a personal trainer once a week, and I really appreciate this relentlessness (although it seems to undermine her avowed intention of dying before me because she doesn't want to have to deal with all of my "stuff.")

Birgit and I are both artists and romantics, since being together we have felt obliged to do original artwork for every Valentine's Day, birthday, anniversary and Christmas. This means coming up with something four times a year for forty-three years! Some of this art is on the walls, and a lot has been collected in albums. There was a little display of these romantic pieces at the Bateman Centre in 2015.

I AM INCREDIBLY PROUD OF ALL OUR CHILDREN, their choices of partners and the grandchildren they have given us. Alan is one of Canada's finest living artists, represented by galleries across North America, and a rare member of the species who is making his living as an artist. He and his wife, Holly Carr, also an artist, live in Nova Scotia's Annapolis Valley with their two children, Jack and Lily. Like me, Alan cannot abide idleness; unlike me, he is a mechanical genius and adept at all forms of construction.

Sarah teaches a program in ecology to schoolchildren on Saltspring Island. She studied biology and chemistry at university, then pursued a diploma in costume studies that landed her a job at the Stratford Festival. But working in the theatre would have meant a peripatetic life; what she desired was to be here on the island, with her husband, Rob Barnard, an accomplished house designer whose talents we appreciate every day at Ford Lake. Sarah and Rob have two daughters, Ruby and Jade, now almost adults. I am especially proud that Sarah has made the central theme of my long-held ambition—to

connect people with nature—her life's work. She is an executive on the board of the Robert Bateman Foundation at present.

John and his wife, Jocelyn Ferguson, also live on the island, just a few kilometres from us, in a house John built with a contractor. They operate a gem of a guest house, the two-storey Lost and Found B&B, which John built himself. Like Alan, he may have inherited gifts from his shipbuilding ancestors. With a degree in creative woodworking and printmaking from the Nova Scotia College of Art and Design, he is a skilled carver and carpenter. He also builds web pages, and is a musician and soundman; he is the co-host of a program on the local radio station. He and Jocelyn, also an artist, have two children, Annie and James, who are, happily, free-range kids. John is also currently on the board of the Robert Bateman Foundation as well.

Birgit's first born, Christopher, though a talented artist is also a born administrator and diplomat. He has always had a sense of wisdom about him. I remember asking him for advice even when he was a little kid, not that any of our other children lack wisdom. I do ask any and all of them for advice from time to time. I believe that Christopher was not consciously following in my footsteps when he graduated with a B.A. in geography. He also got his teaching degree in high school art, and today, he and his wife, Jenn Bateman, teach high school at St. Michaels University School in Victoria. They are also house parents to international boarding students. They have two daughters, Grace and Cleo. There's no denying Chris' esthetic sensibility: he paints, draws, illustrates, takes photographs and plays guitar. I liken his style of art to that of Gauguin; it is resonant of the globetrotting he did as a child and young man.

Rob, another keeper of sketchbooks and round-the-world adventurer, is perhaps the most outdoor-oriented of all the children. During university, he spent his summers leading kayaking trips along the rugged west coast of Vancouver Island. Today, he is an urban planner with the City of Victoria, dedicated to thoughtful development that will have a positive impact on the environment and on society. He

at Alan's Place.

July 15/98

paints in his spare time. He and his wife, Madeleine Challies, a French immersion teacher, take their two children, Pierre and Sadie, into nature and teach them to name birds and plants whenever they have the chance, just as we had done with young Rob.

Gathering this clan of twenty-two is no mean feat, but we accomplish it because being together is important to us all. Between times, I know the emails fly, not a few having to do with the patriarch and his eccentricities. Sometimes the family banter of our kids reminds me of the *Seinfield* show.

My day-to-day life is a somewhat contradictory blend of routine, which sustains and disciplines me, and spontaneity, which I welcome. It's true that I juggle many balls, but I am a happy juggler, and if

This is our son Rob at Alan's place.

Christopher taught for three years at the Island School located on the island of Eleuthera in The Bahamas. The school is totally environmental and off the grid. Even the food scraps are used to feed tilapia, which they farm and eat. Students attend for one semester, but that one semester changes their lives and their perspective on the environment.

WIND POWER

SOLAR CAR PORT

someone were to ask, "Have you ever juggled a banana along with those balls, or a pineapple?" I would say, "No, but I'll try." I tell people (more or less quoting Winston Churchill), "I like it when things happen. If it's not happening, let's make it happen."

At the same time, I am a notorious creature of habit; on my daily hikes I always leave by the side door and return via the front door. Our days on Saltspring Island have a reassuring sameness to them, though they cannot be described as idle or even leisurely. In my day there is no unallocated time, no down time. Time is precious, and I try to spend it wisely. It means that my life is highly structured, but that, too, is how I like it. Family, friends, work. Nothing, as far as I can see, is missing.

A typical day begins for Birgit and me at 6:45 a.m. when the alarm goes off, followed by coffee and a breakfast of fruit, nuts and yogurt, all consumed while sitting in bed and watching the birds gathered at the feeders outside. Then I rise and begin my stretching exercises and have my morning shower. Next I tackle my domestic duties: wash the dishes from the night before, clean the kitchen counters and sweep the floor. As I work, I listen to CBC Radio One, to which I am hopelessly addicted, especially *The Current*, with Anna Maria Tremonti. Then I make for the outdoors, with one ear still tuned to the CBC and the other to the sound of birds. I alternate; one morning, I'll do a brisk walk down to the lake and up the hill above the house; the following day, I'll bike our long and hilly laneway.

By then it's 10:00 a.m., and Birgit is likely at her desk, just a dozen feet from my easel in the airy space that serves as both studio and office. For our first ten years together, we handled all of the aspects of my career ourselves. Now there are four who help to keep everything running smoothly. Our assistants, Alex Fischer and Kate Brotchie, have arrived and are on their computers, ready to tell me about the day's appointments and upcoming commitments. Steve Jarman, a genius at carpentry, electronics and photography who keeps the whole operation functioning, might come by to discuss framing, landscaping or

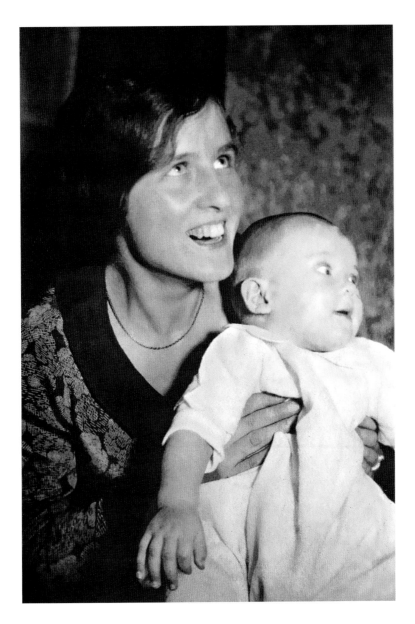

One of the earliest photos of me, taken the year I was born, 1930, with my mother, Annie.

Taken at a studio, this photo is me at two years of age.
I am posed in this shot, a rarity in my photos going forward.

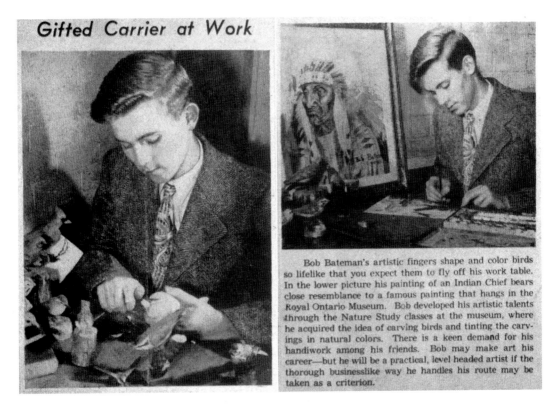

Gifted Carrier at Work

Bob Bateman's artistic fingers shape and color birds so lifelike that you expect them to fly off his work table. In the lower picture his painting of an Indian Chief bears close resemblance to a famous painting that hangs in the Royal Ontario Museum. Bob developed his artistic talents through the Nature Study classes at the museum, where he acquired the idea of carving birds and tinting the carvings in natural colors. There is a keen demand for his handiwork among his friends. Bob may make art his career—but he will be a practical, level headed artist if the thorough businesslike way he handles his route may be taken as a criterion.

I was a Globe and Mail *newspaper carrier boy and at some point was chosen as the subject of a profile. My painting of a chief in the background reveals that even from a young age, I was fascinated by native culture and had deep respect for First Nations' ideals and practices.*

In 1947, I spent the first of three happy summers working as a chore boy at the Algonquin Wildlife Research Station at Lake Sasajewun. I met Robert Helmer MacArthur, who would go on to become one of the founders of evolutionary ecology. Robert was excellent at the guitar, so along with my routine repair jobs and work on the bird census, I started playing camp songs too. (Dr. Don Smith)

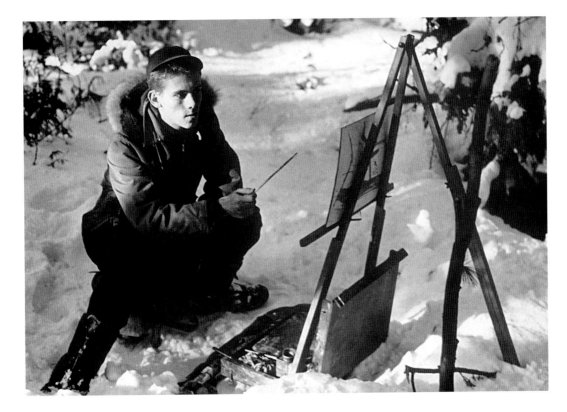

This is me in my late teens, once I began pursuing real art and doing what I thought real artists did. Here I was following in the footsteps of my heroes, the Group of Seven, who painted not in studios but en plein air. *(Dr. Don Smith)*

FACING PAGE TOP: *Painting the Grizzly Torque in Nigeria, 1957. I added a new panel for every country we visited. Bristol and I became quite accustomed to drawing an audience of curious onlookers wherever we went. (Bristol Foster)*

FACING PAGE CENTRE: *Bristol, Erik and I hopped into the Grizzly Torque near Lake Manyara in Tanzania on our way to see flamingos. For fun, we did figure eights and other fancy moves on the flats you see in this photo, but as the dry earth got thinner and thinner, we broke through and got stuck—for hours—in the muddy gumbo clay. We never did get to see those flamingos.*

FACING PAGE BOTTOM: *Visiting with some members of the Semang tribe, an indigenous group in the interior of Malaysia. Few Europeans had made contact with these people prior to our visit in 1958. I am drawing the young woman in front of me while Bristol looks down at my sketch.*

Here you will see the fully restored Grizzly Torque with Bristol and me in present day. (Birgit Freybe Bateman)

I do a lot of signing. If you ever get a job offer where you are paid to write your name over and over, take it! In this photo taken at Mill Pond Press in 1983, I feign sleeping after signing these massive stacks of books about to be shipped out.

FACING PAGE TOP: *A very friendly Gentoo chick approaches me as I sketch it in Port Lockroy, Antarctica, 1978. (Birgit Freybe Bateman)*
FACING PAGE BOTTOM: *At Sir Peter Scott's Wildfowl and Wetlands Trust near Slimbridge, Gloucestershire, 1981: me (left), American artist and naturalist Roger Tory Peterson (middle) and Sir Peter Scott (right), British conservationist, painter and son of Antarctic explorer Robert Falcon Scott. (Birgit Freybe Bateman)*

In my studio when we first moved to Saltspring Island. From the works in progress on my easel, you can see that I work at many paintings at once. The tiger never got finished. Instead, I redid it in an entirely different setting at a later date. I need windows in my studio; I need nature right outside. In this photo, I'm looking through my telescope at water fowl in the ocean. (Birgit Freybe Bateman)

Jane Goodall visited Birgit and me at Saltspring Island in 1992—a proper overnight visit to get away from the crowds. I admire her dedication and sensitivity to nature as well as her belief that all animals, great and small, are from the same family. (Birgit Freybe Bateman)

In 1997, I painted "Chief"—American Bison. *I gave this—my largest painting ever at 71" x 98"—to the National Museum of Wildlife Art in Jackson Hole, Wyoming. This seems to be a memorable painting for many people. I based it on a grumpy male bison I saw at Elk Island National Park in Alberta. I tried to get close to it, but when it took two steps towards me, I quickly got back in the car. (Birgit Freybe Bateman)*

FACING PAGE TOP: *I'm part of the Artists for Nature Foundation who travel to parts of the world where the hand of humankind has had only a gentle interface with nature. In 1994, we visited Extremadura in Spain as part of this project. It's a place where nature is untouched and unspoiled. The umbrella in this photo keeps the sun from landing on my painting and creating shadows. (Birgit Freybe Bateman)*

FACING PAGE BOTTOM: *Birgit and I survey my painting of a cougar and cubs in our studio at Fulford Harbour. Almost out of sight behind the fern fronds is a painting I did of Birgit. To the right of it is a painting that my son Alan did of the door to his grandfather's bedroom.*

Birgit and I are dressed to the nines here—me in a rental tux and Birgit in a beautiful gown she made herself. We were special guests at a Conference of Conseil International de la Chasse hosted by Prince Rainier III of Monaco. It was an enjoyable evening, but not really the kind we're used to or representative of our usual garb. (Dick Lewin)

Three days after the elegant soirée in Monaco, Birgit and I were back in our element—much more comfortable in life jackets and hip waders in the Queen Charlotte Islands (now Haida Gwaii), where we led an art workshop. (Ramsay Derry)

The Spotted Owl is an iconic endangered species. There are only a few left in Canada. It was a huge controversy when the Endangered Species Act declared them threatened. This meant no industrial activities, such as logging, were permitted around their nesting grounds. The scientist who led us to this site had to hide her car from potential owl assassins. These birds are very tame and confiding creatures, as you can see by how close I am to this youth. (Birgit Freybe Bateman)

At the Lodge at Buck Slides, 2014. From left to right: (back row) James, Jocelyn, Alan, Holly, Lily and Jack; (middle row) John, Annie, Cleo, Jenn, Grace, Christopher, Jade and Ruby; (front row) me, Birgit, Sadie, Rob (Bateman), Pierre, Madeleine, Sarah and Rob (Barnard). See Chapter XI: The Power of Place.

The west coast of Vancouver Island is home to the largest Sitka spruce trees in the world. In 1989, these were under threat by loggers. Artists were invited to join activists and paint these beautiful specimens. As I was standing there with my hand against that ancient tree, I could hear the horrendous sound of chainsaws. The trees were eventually saved, but we must remain vigilant to protect them and our nature's entire heritage.

Raising consciousness for the Great Bear Rainforest in British Columbia, here I am sketching driftwood as film crews follow me and spread the message about the threats to this precious natural space.

photography projects. Steve's brother, Casey, lives in our little farm-house and performs caretaking duties.

Alex coordinates my professional life most ably and has done so for twenty-four years. Her sister, Jane, worked for us for the six years before that, then left to pursue a degree in theology and a vocation as a minister. (I'm not sure what that says about being in the Bateman employ.) Alex possesses in spades what is required for the job: a memory like an elephant, a velvet glove to protect me and my time, a keen sense of order and organization, a wordsmith's instinct for language—and a wonderful sense of humour.

Above us in a loft space is Kate, a geographer, teacher and archivist who wears many hats. She helps me with my lectures and talks, and is one of the office's technical wizards. For almost two decades she has managed and catalogued my slides, art books and digital images.

The basket—a simple and highly effective piece of technology.

I need these references close by, and thanks to Kate's work they are now as close as my iPad. When I need certain images, I let Kate know by calling up to her. She loads them onto a thumb drive, drops it into a basket, and lowers the basket from the balcony. The simplicity of this "technology" appeals to the Luddite in me. (The Luddites were not opposed to technology, but they were staunch advocates of hand-crafted work, and they worried that machines would be our ruin. I think they had a point.)

There is always a work in progress on the easel, and while I pre-pare paint and brushes, Alex will give me a précis of any new corre-spondence. Part of my attention is on the painting at hand, but another part is able to deal with queries arising by mail or telephone. I receive many requests from people seeking support for their worthwhile causes or requesting my presence at their functions as a speaker. It's an honour to be wanted, but sometimes we are swamped with these requests, and Alex earns her wage as gatekeeper. Time for the paint-ing, commissioned and otherwise, must be found amid charity events, lectures, book projects, gallery tours and media interviews.

We talk as I am working, with that perfect northern light falling across my left shoulder. I may conduct an interview or take a meeting on the phone, chatting as I paint. (And if I stop painting, Alex will grab my attention and make a brushing motion to get me back on track.) I can't be on the phone when I'm planning the composition of a piece, but once the painting commences, the phone is no distraction. It seems like another part of my brain controls my hand, and more than once, I've resolved a painting problem while chatting on the phone.

I work until about 12:30 P.M., then break for lunch—most often a salad made from vegetables grown in our own garden, plus a mix of beans and onion and salsa, which I cook up. I combine that with a piece of organic turkey or wild salmon or eggs. We'll go for a hike after lunch, and at other times we may go for a swim, or paddle the canoe, followed by an afternoon nap of forty-five minutes or so. After napping, I have my wake-up cup of coffee and a bit of fruit and yogurt

while I read our local community paper, *The Driftwood*, or *Island Tides*, an environmental bi-weekly. We also subscribe to *The Week*, *Harper's* and several conservation magazines. I have recently turned to a ten-minute meditation with prayer beads. Until Alex and Kate leave at 5:00 p.m., I may handwrite correspondence. Usually I'll return to the easel until about 6:00 p.m.

Birgit may bring supper to the studio, where we can watch a bit of PBS or Knowledge Network television. Then I'll continue painting until just before 10:00 P.M. When I work after dark, I rely on halogen lights, strategically placed on a crossbeam high to my left to avoid glare. To protect my eyes from any glare, day or night, I wear a base-ball cap. The day ends with a few minutes of tai-chi and the CBC national news, taken with a small nightcap of gin from time to time. It was the Queen Mother's favourite tipple, and she lived to 101.

My alcohol consumption has always been modest and Birgit and I are careful eaters of what I call "virtuous food." We read widely about nutrition, and try to always buy organic and local (though that doesn't prevent me from occasionally dipping into the potato chips or French fries when they're on offer). My daily dose of eleven almonds caught the attention of former CBC broadcaster and fellow Saltspring resident Arthur Black. I told him, "Ten almonds a day supplies all the calcium you need and is reputed to be good for the mind."

Arthur turned to Birgit, "So why does he eat eleven?"

She winked at him and said, "He likes to have an edge."

EVERY DAY OF MY LIFE is occupied with making art, but I haven't entirely stopped teaching art, either. At least once or twice annually, I will find myself before a group of like-minded artists—my tribe, as I call them—who seem interested in what I have to say on the subject. Indeed, I am befuddled but also thrilled by the fact that, while these sometimes week-long classes all follow a similar format, people will return to repeat the experience. A few have attended two and three

sessions, travelling great distances to do so. (When this was mentioned in one class, an artist in the audience joked, "Yes, that's called stalking.") Except for those years in the classroom, I am doing more teaching now than ever, either informally or in master class workshops.

I don't mind distractions, but I prefer clarity to confusion and cacophony. So in a single group, I like one voice at a time. As a teacher, I had mainly one rule, based on clarity and politeness: During lesson time, only one person speaks. If I am giving the lesson and someone else starts to chat, I will stop until they finish. I love listening to stories as well as telling them. To me, that is what life is, a series of stories. I don't want to miss bits of a story due to distraction.

I look forward to gatherings of so-called master art classes. What could be better than to be out in nature with kindred spirits, smart people whose hearts are in the right place? Loretta Rogers, the widow of the late Ted Rogers, is an accomplished artist and a friend. She organizes teaching events at her homes on Tobin Island, in Ontario's Muskoka lakes area, and in the Bahamas. During these painting sessions hosted by colleagues, I sometimes put on my "master hat." I also teach classes once a year at the Hollyhock Centre on Cortes Island, one of the Gulf Islands on the B.C. coast. Late in the summer of 2014, I taught a class of forty-four fellow artists at the Bark Lake Leadership Centre, an outdoor education facility about 200 kilometres northeast of Toronto.

Bark Lake is a ten-minute drive in from the highway on a solitary road that cuts through the forest. Not a single building dots that route, and there are no cottages along the shoreline. Motors are forbidden on Bark Lake, so the only sounds are those of creatures—Ravens, Red Squirrels, chipmunks and frogs were the most vocal when I was there; loons and wolves are often heard too. A dirt road and various footpaths meander among the centre's lodges; one trail leads to a beaver pond.

Virtually every artist there was also a photographer, so at dawn and dusk, the pond was a special draw for photographers. They came

with tripods and long lenses, intent on gathering images for use in future paintings. I am always on the hunt too, either for landscape or fauna images; 90 percent of my art is based on photography, and a single painting may draw on dozens of photographs.

When in the field with the camera, I always avoid the hammered light of mid-day, which destroys detail. To drive home this point during these art classes, I typically show two images taken at the very same spot—a view from our house on Ford Lake. One shot, front-lit as if with a flash camera and taken at noon, makes the various trees on the hillside indecipherable. I describe it as coleslaw. It is confusing to try to distinguish the trees. The next shot, the exact same scene, is backlit, rich in texture and dimensions, and was taken at dawn. I describe it as a tossed salad, where it is easy to distinguish the lettuce from the cucumber. In real life, I gather I am unusual in preferring coleslaw to tossed salad. In my art, my taste is the opposite.

Light, I tell students, is critical. I love backlit scenes, or scenes lit from the side. I like diffuse light, the kind offered on a cloudy day. I love mist and fog and ambience. But when you paint a scene where there is any kind of light, the key question is this: Where is the light coming from? Every shadow in that painting must be true to the source of light. I tell students: Be a slave, not to the creature you're depicting, or the feathers on that bird's body, or the landscape you're describing, but to the light source and the form that it reveals.

For four days, I taught these artists—some of them very accomplished—what I could of technique and method. I showed slides of work I admire and work I detest. I love Leonardo, but I loathe his *Mona Lisa*. The composition is as interesting as a Chianti bottle.

The classes took place morning, afternoon and evening, and it was often the day's last order of business to critique the artists' work. It's a tall order for me and for the artist. A tall order for me because I come to these assessments cold. The students have sent their chosen digital image to the class organizer in advance, and these have been arranged willy-nilly in a PowerPoint presentation. The image of

someone's painting pops up on a screen at the front of the room, and I must respond to it honestly but without hurting anyone's feelings. It's a tall order for the artists because even though they are technically anonymous during this exercise, often the people in the room know one another's work.

By this point in the week, I had gone through some of the basic guidelines concerning composition, shading and a great deal more, always with the caveat that I stray from the guidelines myself all the time. Still, the critique proceeded. When I referred to "coleslaw" in a work, I meant that the artist had placed too much confusing and formless business in the painting. When I said to "kill it," I was suggesting that the artist subdue part of the painting with a wash of tone so that it lies more quietly on the canvas. A "fried egg" composition is one in which the main aspect of the painting sits dead centre.

I also took the time to critique some of my own work (there is a certain painting of an eagle that I wish I could take back), as well as the work of legendary British painter Sir Edwin Landseer. Those sculptures of lions in Trafalgar Square? They are his. The painting I talked about was *Monarch of the Glen*, a portrayal of a stag done in 1851. It's a fried egg composition, but that's the least of its problems. The face of this seemingly noble creature is not that of a Red Deer (of which the Elk is a cousin) but that of a Jersey Cow. Landseer has glamourized the face. The proportions of the body are wrong; the legs are too thin to support that obese mass. Where, I wondered aloud, are the ribs? Why does the mountain in the background fight for attention with the Elk in the foreground? Nevertheless, Landseer is a very good painter and a giant of Victorian art.

Faced with an unsuccessful piece of art during the Bark Lake sessions, I tried to find something positive to say and then deconstructed the piece. There was, for example, a painting of a grey cat sitting on a windowsill. The artist understood where the light was coming from in that scene, so the shading was well handled, but the cat's proportions were wrong, and it was clear that the painter had not worked

from a real feline or from a photograph of one. On the other hand, there were two paintings that I thought were truly first-rate—another one of a cat on a windowsill, and one of two mallards on a shore. Later, at the risk of offending all the artists whose work had not been singled out, I sang their praises.

Another aspect of these classes involves students looking on while I start a painting and wrestle with the choice of subject and composition, just as they do. During these sessions in 2014, I wanted the painting to involve a scene at Bark Lake. I held my iPad aloft and showed the class some photos I had taken the day before, including one of the beaver pond at dusk.

"Is it not too dark?" a student standing beside me had asked as I shot the scene. The sun was very low in the sky.

When I showed him the photo, he was astonished. The camera, as if by magic, had found the light. The dead cedar on the left of the image beckoned, as did the line of trees at the far end of the swamp, and the foliage in the foreground. But how to arrange, or rearrange, all this? What part of this scene had merit, and what parts were just so much coleslaw?

My first step was to stare at the image for a long time from a distance of about five feet. I then approached the iPad and, with thumb and forefinger, played with the image—coming in close, seeing what was there in more detail, exploring every corner, then backing off to get the long view. The students were silent as I stood there, two fingers at my lips, as if in prayer. I told them that I liked the abstract shape, with the dead cedar as a kind of anchor, and while I also liked the far shore, I wasn't keen on the treetops. Perhaps subconsciously I was praying—for inspiration. I am, I told the class, constantly full of doubt. Normally, at this point I would pull out my sketchbook to play with the possibilities, but in order for the class to see me experimenting, I drew a very rough sketch on the whiteboard. I tried a horizontal approach, then a vertical one. I cropped the treeline. I consulted my iPad and found an image of a heron that I liked, and dropped in the

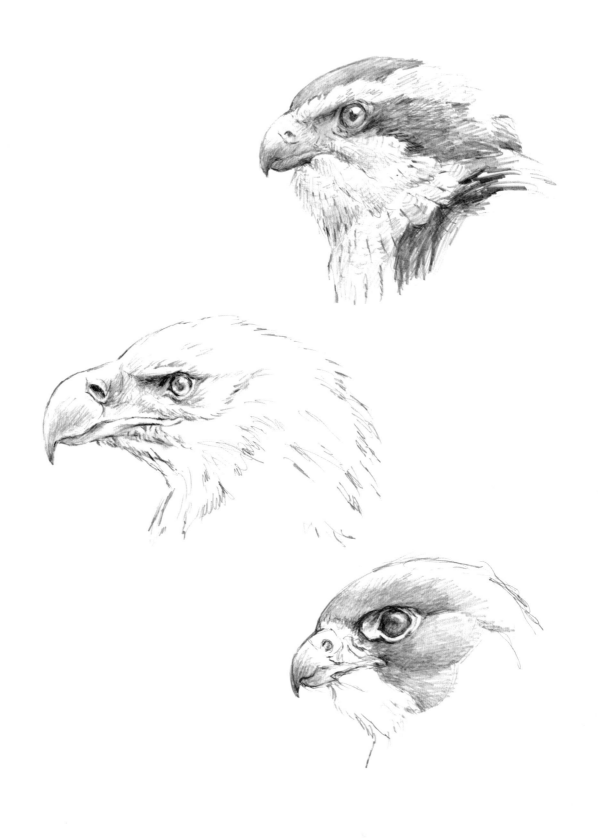

outline of a heron in front of the cedar to see how that might look. The heron faced left, but I flipped him so he faced right. Better, I said aloud. Is the heron too big? Is he fighting with the cedar for prominence? No, they're the same colour, so I left it. I decided to make the heron an adult with a white crown, so that his head popped off from the grey of the cedar. All of this consumed at least an hour.

I always start from a blank canvas or a Masonite board. On this canvas, I began roughing in shapes—cedar, pond, foliage, heron. The bird was casting a reflection on the pond. How long should the reflection be? I taught a simple trick to the artists, at least one of whom had need of it. That week, I had critiqued a painting, an otherwise capable work whose singular flaw was that the reflections of trees on the water were far too long. To determine the correct length of my heron's reflection on the water, I simply measured his height, using my brush. From the end of the brush to where I had placed my finger: that was his height. I then turned the brush upside down and made a mark below him. That was the true length of his reflection.

As for paints, I told the students, I use acrylics because they dry fast and I can change my mind quickly. Nowadays, I often finish the pieces in oils and I go for gloss, which brings out the darker colours I tend to favour. Vermeer did that too. If you get close to one of his originals, you can practically see your own face, so glossy is the finish.

Sometimes I go to an art show where my work is displayed alongside that of others, and I am always reminded how bold some artists are, especially the watercolourists, and how subdued my colours are in comparison. But my paintings are true to me. In art, music and poetry, I tend towards the gentle, the subtle and the slow. In classical music, I prefer the adagios; the allegros are too jolly for me. I like traditional jazz, not bebop or fusion. Even my taste in weather runs to the dull and misty over bright and sunny.

With my students, I try to be clear and precise. But we are talking about art, and certain aspects of art end up sounding nebulous even to me. And perhaps they are nebulous. Let your brush dance, I told

What I often do—almost subliminally—when sketching a creature is follow in the footsteps of method actors like Marlon Brando, imbuing the animal with a characteristic borrowed from some other source.

The Goshawk has an impassive face like an axe or a hatchet, harbouring very little emotion.

The Bald Eagle, to me, feels reptilian.

The Peregrine Falcon has a heroic quality—handsome, masculine, like Clark Gable.

the class. I actually try to *feel* like a pine or a cedar or a Hemlock when I paint one of those trees. It's hard to explain, but I move the brush in a different way for each species. Every tree of every species is unique, and I challenged these artists to be true to the essence of the tree they are painting. Likewise, when painting a Bald Eagle or a Peregrine Falcon, try to feel like that particular raptor. In acting, it's what known as the Stanislavski method (see *Newfoundland River* in colour insert).

On the second day of working on the painting, I switched to a bigger brush. I was still feeling playful, unusually so. Would I make the pond a peach colour, or lemon yellow, or purple—the colour I claim to loathe? I was thinking of making the treetops moody and mysterious, à la Wyeth. A student came up to me at the end of class to report that, from the other end of the classroom, the piece looked quite good. But it was rougher up close, which is what I expected at this early stage.

The last bit of business with this painting, as with all my others, was to lay on light and dark. And on this matter, I go back and forth, like a man on a swing. I add light, then take away light. I add dark, then take away dark. Back and forth I go until, one hopes, the swing stops. Sometimes it never does. A painting of two Wood Ducks teased me for six years. Two swans likewise confounded me. I could not get them to lie well in the water, and I finally abandoned the piece altogether.

One of the reasons I love this kind of teaching is that it allows me to paint, to pass on what I've learned, and to talk about things I'm passionate about—all at the same time. While I worked, I told the group at Bark Lake about Sylvia Earle, the American oceanographer who has spent more than 6,000 hours under water. Earle worries that we are turning the oceans into carbonic acid. And when this happens, the phytoplankton that supplies most of our oxygen will die. There I was, adding a white crest to my heron while beating my environmental drum. I may well have been preaching to the converted, but I dared not assume. Since I do not like dead air, I filled in the time while painting, giving opinions on the environment and politics,

telling jokes, and even reciting poetry that has stuck in my brain since high school.

The students at Bark Lake got the real Robert Bateman. This is who I am: a painter who can't stop teaching or sharing his opinions. I will explain how mixing some Payne's grey with white will produce lavender, and in the next breath, I will speak of the interconnectedness of all things, how happiness and fun are totally different concepts, how Schweitzer and Gandhi believed that the only way to be truly happy is to be of service to others. Happiness and fun are two different things. Party-going-type fun raises your dopamine, too often with the use of substances. Three fun-lovers are Lindsay Lohan, Charlie Sheen and former Toronto mayor Rob Ford. They relentlessly pursue "fun" rather than happiness.

I paint and I rant, happily.

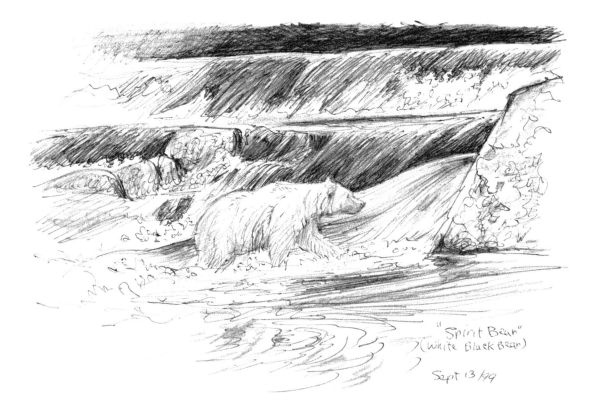

"Spirit Bear"
(White Black Bear)

Sept 13/99

A memorable trip on board a sailboat along the northwest coast of British Columbia. The "Spirit Bear" is a local genetic variant of the Black Bear. The individual we saw was very easy to approach. The salmon were late that year and hunger was the only thing on that bear's mind. We simply stood still on the rapids and he slowly passed within a metre or two, looking in every pool and eddy for the signs of his next meal.

While at anchor in Khutze Inlet, B.C., I had time to do a detailed landscape drawing. This is a bit challenging with a ballpoint pen. You'll see that thin, white lines become tree trunks.

1000ft Waterfall Khutze Inlet B.C.
Sept 14/99

X : TO PRINT OR NOT TO PRINT

*Q*uestion: Who gets to view an original work of art? The owner, of course, and those he or she cares to share it with. But not many others. If the original resides in a gallery or a museum, more people may be able to see it, but only those who are able to visit the institution.

Today's technology meets some of these issues more than halfway with digitized images, electronic transmission and sophisticated printing facilities as close as the local Staples store. Three or four decades ago, however, popular access to the works of Canadian artists, other than the Group of Seven, was much more restricted. Enter the limited edition print—and another debate.

I have been roundly criticized for my decision to make prints of my work, to sign them and to sell them. The high priests of art have issued yet another decree: Real artists sell only originals. (This was an addendum to their earlier rules: Real artists do not paint wildlife, and Real artists cannot be commercially successful.)

As a school kid, I remember every classroom had reproductions of the works of the Group of Seven done by silkscreen method. They were quite large and suitable for framing. The technique displayed the idea and composition and colour but had a flatness and lack of subtlety in the detail and surface. That is the thing about silkscreens and serigraphs. Nevertheless, they made the work of the Group of Seven available without the public having to buy the originals or visit museums. These prints are not signed and numbered, yet half a century later, they are very collectible items.

The next innovation in reproduction technology was photomechanical offset reproduction. This was perfected in the mid-twentieth century using cameras, large film and flatbed presses. Touch colours were added to the usual four colours, and the reproductions were printed on high-quality, archival rag paper.

During the late nineteenth century, original printmaking by artists such as Whistler began to flourish in the form of etching or stone lithography. This enabled the images to be shared and the market to expand. Some artists started signing and numbering their original prints to limit their quantity and therefore make them more collectible.

Therein lies the rub. A few publishers started signing and numbering mere photomechanical reproductions. The artists had not worked on the plates as they had with etchings and stone lithos; machines had done that part. The fact that these reproductions were signed and numbered infuriated certain elements of the art world, especially the original printmakers. My response was this: Rembrandt and Durer did not sign and number their prints. This practice began around 1900 for two reasons—market and quality control. Since technicians regularly did the actual printing, the artist wanted to see each print before he signed it. And since the numbers were limited, the price could be higher. In the 1980s, some artists, including me, began signing and numbering their reproductions.

Now, in the twenty-first century, the issue seems quite quaint. Digital reproduction technology is ubiquitous. The market for flatbed

prints has gone flat, but high-quality giclée prints have almost taken over. These new giclée prints—when done with care on canvas and close in size to the original—are almost indistinguishable from the original artwork. Some may not like the idea of these realistic reproductions, but I do. They allow my work to be seen as I painted it—by a wider audience.

The irony is that when I was first approached about making prints, my answer was a firm no. In 1975, Bob Lewin, the president of Mill Pond Press, based in Venice, Florida, called to say that he wanted to represent me. I thanked him but neither Birgit nor I felt any need to have prints made of my work. We were earning a decent living; Birgit and I were teaching, and I was selling my originals. Plus, undertaking to do prints would surely consume more time.

But Lewin was persistent, and he tried several tacks. Would I fly to Florida, on the company tab? That would take three days of my time, I explained. What if he came to Toronto? I explained that that would eat up three hours of my time. What if we met over lunch, Bob asked. I said no to that too. Finally, he said he would fly up from Florida, rent a car in Toronto and come to our home in Rockwood—and there would be no need to feed him lunch. At first, I declined that offer too. But when he said that all he wanted was to demonstrate the quality of Mill Pond's work in making prints, I finally relented. I did it more as a favour than anything else.

That decision changed my life. Since then, more than 600 of my original paintings have also become limited edition prints.

MY GEOGRAPHER'S TRAINING INCLINES ME to put great store in connections, and 1975 was a year of momentous connections. I met Roger Tory Peterson for the first time, as well as Lars-Eric Lindblad. That year I was part of a show at the Royal Ontario Museum, along with Roger, who was already in Bob Lewin's stable as a wildlife artist.

"Who should I get?" Bob asked Roger that year.

"Get Bateman," Roger replied. And that led to Bob's pursuit of me.

Bob Lewin had a profound effect on my professional career, just as Tom Beckett did. Bob was a colourful guy with a colourful past. A warm, friendly aw-shucks fellow, he was a sharp businessman under the surface. Bob was a little rotund, which came from not exercising very much and eating fudge just about every day of his life. After the Second World War, in which he served as a U.S. Army photographer, he became involved in the printing business, based in New York.

One of his clients was Tender Leaf Tea, which offered cards depicting wildlife in every box. Those were the days when "Free Inside" were marketing buzzwords. Soap manufacturers put silverware or dishcloths in boxes of their products as enticements to shoppers. The idea was to keep on buying that product until you had a complete collection of whatever was being given away. Roger Tory Peterson, Peter Scott, Keith Shackleton and Arthur B. Singer were all producing art for Mill Pond, which Bob reprinted on Tender Leaf Tea cards.

Bob also had a small company that produced elite jigsaw puzzles of the work of artists such as Jackson Pollock and Arthur B. Singer. These were enormously challenging puzzles that they sold as conversation pieces in high-end stores such as Neiman Marcus.

Mill Pond's motto was "Quality is the difference," and Bob took it seriously. He once flew to London overnight to check the accuracy of a sketch of hands by Leonardo da Vinci. This was a challenging puzzle, since most of it was plain paper with smudges. He arrived at the back door of the National Gallery on Trafalgar Square, viewed the original, critically marked up the proof before the gallery opened to the public, and then flew right back to New York. Eventually, Bob and his wife established yet another business, Mill Pond Press, in Venice, Florida, and his limited edition print business came into being.

Up to this point, I'd had little experience with prints and could not see their future. Tom Beckett had done only one print of my work, a painting called *Canada Geese on the Eramosa River*. But he had not used 100 percent rag paper, which the best art paper is made from,

and sales were moderate. The Tryon Gallery in Britain had done four or five subjects of my work, creating 400 limited edition prints of each, which I signed, but I had not pursued the idea further.

Around this time, Tom Beckett and I had dinner with Paul Duval, an eminent Canadian art critic who had written several books on the Group of Seven and would later write a book about wildlife artist Glen Loates. We picked Paul's brain on the artistic implications of limited edition prints. What he said, in a nutshell, was this: Artists have been making copies of their work since the late nineteenth century. There's nothing morally wrong with signing and numbering prints. But if you do decide to do it, you will be rejected by the art establishment for being commercial. The thought came to me: I have already been rejected by the art establishment—for painting wildlife. So what have I got to lose? I have always enjoyed sharing, and here was a chance to share my ideas.

Bob Lewin himself had tried selling prints of work by artists such as Roger Tory Peterson in the late 1960s and early 1970s, with limited success. But now, working out of a rather sad-sack office in Venice with just a few employees, he saw brighter days ahead for limited edition prints. This was in part because he was doing a better job of printing.

"You'll be proud to be associated with Mill Pond," he told us when we met that first time in Rockwood.

Let's set down some definitions. What is a *print*? A print is made by putting ink on a surface and transferring the ink to paper by means of etching, stone lithograph, serigraph, a photomechanical process, wood block, potato print and/or some other technique.

Some prints are *reproductions*: An original work of art is copied, either in the same size or a different one. Reproductions are usually done by the photomechanical process; that is, the original art is photographed, colour separations are made, paper is fed onto a flat-bed press and the colours are printed one at a time—usually yellow,

magenta, cyan, and black. In the case of my reproductions, many touch colours of specially mixed inks are added as well.

An *original print* is one for which there is no earlier version of the work, no previous iteration in any medium, just the plate or stone or screen or woodblock—even the potato or the piece of linoleum on which the art was made. I do both original prints and many more reproduction prints.

It's far more difficult to do an original print than it is to do an original painting. With the latter, it's just me and the canvas. With an original print, I make the ultimate decisions, but I likely work with a master printer. "Make the blue bluer," I might say, or "Run down the red." The buck stops with the artist. My job is to mix the colours, choosing from a palette of up to twenty different ones, and the printer's job is to be true to those colours.

With original prints, the mechanical plate needs to be freshly dampened. From print to print, each one varies slightly, so that every one, I would argue, is an original piece of art. The original print method can have happy, accidental effects. An area of black, for example, may be softly lighter in one print and more densely black in another.

Sometimes my original prints derive not from a metal plate but from stone—as in lithography. This is a very old method that dates back to 1798, when its inventor, one Alois Senefelder, made a plate of porous Bavarian limestone (*lithos* means stone in Greek, hence the word *lithograph*). Lithography works on the principle that oil and water don't mix. Simply stated, the artist creates an image on highly polished stone using a grease pencil, after which ink is spread on the stone. When paper is then applied, under great pressure, to the stone, the image is captured—in reverse. Then the stone is cleaned and the artist adds another colour, and another. These days, the artist draws not on stone but on sensitized aluminum plates, or mylar, and the image is transferred to a sensitized aluminum plate that absorbs the water and greasy ink differently. Photomechanical lithography, as it's called, is much more mechanized.

I SIGNED ON WITH MILL POND PRESS, at first in a very modest and tentative way. I remember flying to Florida to sign one set of a few hundred prints. For that inaugural run, they had decided to reproduce my painting of two lion cubs perched on a cliff overlooking the Serengeti. The limited edition print market had not yet begun to move, but my work became part of the wave as it grew; then in the 1980s, the market for limited edition prints started to soar.

The first print runs were 950-strong, more than double what the Tryon Gallery in London had made. There were some 2,000 art dealers in the United States, more than a hundred in Canada, and it seemed they all wanted Bateman prints. On a few occasions, naturalist organizations such as the Canadian Nature Federation asked for independent runs. Meanwhile, some individuals were buying two and three copies of an image and treating them as investments. They would wait until the print run sold out and then sell the pieces for double what they'd paid.

Squabbles broke out between Mill Pond Press and dealers. "Ten people want that print," an outraged dealer would tell Bob, "and you're giving me only one?"

Speculators arrived on the scene. One businessman in London, Ontario, heard that a Bateman print of a wolf was coming down the pipe. He bought three prints, sight unseen. He then sold his VISA slip (constituting proof of ownership of the prints) for twice what his original had cost. This was all before he had seen the print.

"We can't satisfy demand," Bob complained to me. In some cases, he wanted to go as high as 10,000 prints. Ads began appearing in newspapers and magazines. "Bateman prints for sale," the classifieds would read. I looked on with both amusement and horror. Of course I was criticized for approving these massive print runs, but I did wonder why. The only possible downside, I told myself, was that it would depress the market for the originals. But that did not happen.

Natures' Scene, the Canadian distributor of my Mill Pond prints, would always counsel its dealers, "This is art. Buy a Robert Bateman

[print] because you love it, not as an investment. Frame it and honour the art."

I AM A BEAR FOR DETAIL when it comes to the natural world, but business and financial matters pass me by. Anything with numbers in it and I tune out. Luckily, Birgit enjoys doing our finances. I possess no entrepreneurial instincts, and am blissfully unaware of my income, or what paintings sell for or which have sold. Let this story illustrate it. On a trip to Mill Pond—this was long after they had vacated the old doctor's office where they had started and moved to bigger digs they had built—I walked in the front door and spotted a familiar painting. *High Kingdom—Snow Leopard.* The original.

"Nice to see that old friend," I said. "Who owns that?" I asked Bob.

"I think you do," he said.

"Oh," I said. "That's nice."

AS THE SIZE OF THE PRINT EDITIONS INCREASED, the thought occurred to me that this was almost a licence to print money. All of the expenses were up front and the unit costs fell rapidly. This seemed wrong to me, so I insisted that for large runs a percentage of profits be donated to nature preservation. Bob Lewin agreed, and thus the sale of my prints raised millions of dollars for worthy causes throughout the years. For example, Mill Pond Press gave $1 million to Peter Scott's Wildfowl and Wetlands Trust, based on profits from my prints.

In its heyday, Mill Pond's stable comprised dozens of artists. Today, the company no longer exists, and my prints are being done by Natures' Scene, my longtime distributors in Canada. In the early 1990s, a great leap forward in photography meant that anyone with a decent camera could shoot an image from a book and get a quite acceptable reproduction, even when enlarged. At this time, Mill Pond dropped artists, or the artists began making and selling their own prints. The

market for prints in the United States had declined dramatically by the middle of that decade, and while the print market continues at a low level, Mill Pond went into a freefall and never recovered.

WHEN LARGE-FORMAT BOOKS OF MY ART were published in the 1980s, certain entrepreneurs saw this as an opportunity to cash in on my reputation. They would buy a few hundred copies of the books, cut out the popular animals—the Cardinals, the Eagles, the wolves—then cut mats and mass-produce Bateman mini-prints. Thousands of them were made. I recently stayed at a lodge while giving art classes and discovered some images of mine hanging on a wall, clearly extracted from books. It's not illegal to cut up the books one buys, and there was nothing I could do about it. Eventually, librarians put my books in their reference sections in an attempt to protect them. Still, readers would come in and, when no one was looking, get out a razor blade and help themselves to the work of their choice.

I have seen my images, matted and shrink-wrapped, inside bins in galleries and shops, even at the Art Gallery of Ontario, which I'm sure didn't realize the reproductions were unsanctioned. I could joke and say that my work really was in the AGO, but all that unauthorized and sometimes illegal reproduction of my art only fuelled the notion that I was a "commercial" artist. And I had nothing to do with it. The abundance of this unsanctioned "Bateman art" is unfortunate, but it is not illegal, apparently.

One year, in suburban Toronto, we started seeing copies of my paintings that were not cut from books but clearly copied. Cutting up books is one thing, but making new reproductions without permission is an infraction of the copyright law. There were two giveaways: the size was either smaller or larger than the book reproduction, and when you looked on the back, there was no book text. The retailers we questioned would not reveal who the wholesaler was, so we called in the RCMP, and within short order a man was arrested and charged

before settling out of court. The arrest came just in time. Mr. Big, as I came to call him, was on the verge of selling thousands of framed Batemans, photocopied without my permission, to Sears.

Recent technological progress has had two results: the razor-blading of my books has stopped, and the once-flourishing sales of my limited edition prints have diminished.

No doubt some printmakers were relieved to see the Bateman market diminish. Some believed—mistakenly, I would say—that I posed a threat to them. I can understand how they might feel aggrieved after labouring over an etching for months and placing it in a local gallery with a $400 sticker, while meanwhile, around the corner, Bateman prints with $600 price tags were selling, and selling well.

Occasionally, one of these disgruntled artists got a chance to punch me in the nose, at least figuratively. One year, when I was still living in Ontario and limited edition prints were a hot issue, a producer at CTV's *Canada A.M.* (then co-hosted by Pamela Wallin and Norm Perry) called. He said, "You're about to be torn apart on national TV. Do you want to be present?" Indeed I did.

My opponent was a young woman who did etching. She didn't make a living at it, but she was a serious artist. We were both very civil. Still, she was firm on this point: She accepted that I was a skilled artist, but the reproductions did a disservice to my art. Gallery dealers were trying to fool people, she argued.

I had brought in as Exhibit A my painting *Queen Anne's Lace and American Goldfinch.* I had both the original and a limited edition print. And I said something like this: "I'm proud of both the original and the print. I'll bet you can't tell them apart. The important thing is the idea, the thought contained in the work. On closer inspection, you will see that the print has a wide paper border, with a number on it and my signature. That tells you it's a reproduction. I think there is no confusion. The print is good quality, and I spent a long time

getting it right. If you look at the image and see a painted signature as part of the painting, that tells you it's a reproduction. All my reproductions have two signatures, one painted and reproduced, and the other signed by me."

I always signed limited edition prints in pencil, for two reasons. The signature in 100 percent carbon lasts forever, and because it's done in pencil, it can't be reproduced when run through a printing process. And it has to be hand-done to prove that the artist has seen and approved that particular print.

The topic of limited edition prints came up again during a province-wide art teachers' convention in British Columbia in the mid-1980s. I was invited to be a guest speaker. Great, I thought. These are my people.

It transpired that a member of "the furor crowd" (as I then called those who opposed the idea of prints) was outraged that I would be speaking. He thought I was "a bad influence" on art. This fellow was circulating a petition aimed at stopping me from speaking before the conference. That tactic didn't work, but I had a suggestion for the organizers of the event: How about a panel on the question of prints?

Next day, in a small room at the school, before a few dozen onlookers, I sat down with a printmaker and a professor from the University of British Columbia, who acted as intermediary. I heard no argument from the other side that seemed persuasive. I gave the same arguments that I always did: that it's okay to do reproductions; indeed, it's okay *not* to sign and number them. Rembrandt, I reminded these art teachers, didn't sign his etchings; he would simply print and sell. Durer didn't sign and number his stone lithographs. The signing and numbering started only early in the twentieth century, and the point was really about the artist establishing control over the quality of the reproductions. Any printer could run off several hundred shabby copies and sell them, with nothing going to the artist but a blow to his or her reputation. I, too, wanted control over the quality of the art being sold under my name.

THE MARKET FOR PRINTS TODAY is nowhere near what it was. Natures' Scene has replaced Mill Pond Press, and they continue to make prints of my work. And dealers continue to sell my prints, and I continue to be attacked for it. So let me make the case.

I am like an author who has written what he hopes is a worthwhile book, and who wants as many people as possible to read it. Or like a musician such as Glenn Gould, whose work is available only through reproductions. I know that some opportunists have used the print market to their own advantage; they buy up, sometimes sight unseen as described, large quantities of prints by popular artists. They wait for the prints to become rare, for demand to heat up, and then they take their profits. These entrepreneurs naturally run the risk that the demand simply won't materialize, in which case they are stuck with their inventory. But when the demand is there, they do very well.

I see all this as the law of supply and demand playing itself out. If the publisher prints in excess of the demand, then it risks overwhelming the market. But if the demand is there, and the supply is increased, what's wrong with that?

I do insist that each print be absolutely faithful to the original and of the highest quality. Mill Pond Press' Richard Lewin, son of founder Bob Lewin, conceded in the 1980s that of all the artists in their stable, I was the most exacting. One preliminary run of 1,000 copies of *Queen Anne's Lace and American Goldfinch* was put in the recycling bin when I noticed that the bird's beak was marginally too drab and not clean enough. In my long history with Mill Pond, I probably rejected prints a dozen times.

I DO A TOUR OF ART DEALERS IN CANADA in the fall. Depending on the state of the economy, the mall may be half-empty, when the malls are half empty, but I am heartened to meet people who bring me something to be signed—a book of mine, a poster, a print. If I had a choice between an original oil painting done by an unknown artist and a

reproduction by Wyeth or Degas, I'd pick the reproduction. It's about the idea contained in that piece of art, and the mastery of its execution. There's nothing sacred about an original in and of itself.

I WAS TOLD THIS STORY. It's about an American who once spent a day at the National Gallery of Canada in Ottawa. He approached a security guard and said, "I have been all through the gallery twice. I have seen the contemporary art, the historic art, the work of the Group of Seven, the nineteenth-century room. But would you please tell me where the Robert Bateman room is? There must be one here."

"Oh, we would never show Robert Bateman in the National Gallery," the guard apparently replied.

"Why not?" the surprised tourist asked.

"Because he's a commercial artist."

Although I sell my paintings, as does every other artist, I have never been a commercial artist. I paint to please myself, not as a commercial assignment.

I concocted a culinary metaphor to describe how many in the art elite in Canada view me. They see my work as just so many Rice Krispie squares, while they actually prefer caviar on a bed of dry toast, all topped with some bitter lemon. Again, a question of taste.

Most people, including me, would like to see art connected to their own lives somehow. Most modern art doesn't do it, and postmodern art is even more puzzling. On a recent trip to New York City, Birgit and I visited the Museum of Modern Art. In the recent acquisition room, one piece consisted of a bit of broken venetian blind on the floor. Another was a plate-sized spot of spray paint on the floor. Both were part of the museum's permanent collection, acquired with donors' funds. To me, these pieces don't compare with Andrew Wyeth's *Christina's World* or Picasso's *Les Demoiselles d'Avignon*. Both are in that same museum. In my opinion, postmodern art contains less than meets the eye. It is a bit sad.

XI : THE POWER OF PLACE

Next to family, place is the most important thing in the world to me. I have formed deep attachments to the several places I have designed and built, in no small part because I infused each with the elements that sustain me.

Water, first and foremost. The dream house, as I called it, at Mount Nemo in Southern Ontario wasn't close to a river or lake, but it did have a stream, and I built ponds by the house. The house at Rockwood, also in Ontario, overlooked the Eramosa River. The house at Fulford Harbour, at the south end of Saltspring Island, was perched right on the ocean, with a view to the west and the setting sun. The cottages we built, first in Haliburton and then on Hornby Island, on the B.C. coast, are both on the water.

The final building project, where we now live, was and is the house at Ford Lake, in the middle of Saltspring Island. It, too, faces west over a body of fresh water some 274 metres long and approximately the same wide. There's a green canoe parked by the dock we built to extend past

the reeds on the shore, and all summer long I jump off that dock and go for a swim. There's a certain dead cedar I swim to off to the south, and I'll go there and back, using flippers to move me along, with a snorkel and mask affording me a view of the fish and the plants below.

I got hooked on snorkelling during my trip with Bristol in 1958. We were in Malaysia and rented equipment. I have hardly been able to swim anywhere since without donning snorkel, mask and fins. I was drawn to the underwater world, and I was quite prepared to endure what some might call the "yuck factor." I remember swimming in a swamp near Dorset, northwest of the family cottage at Boshkung Lake. The water was just two or three feet deep, and the muck was likely three times that depth. But the colours I saw that day were mesmerizing. Have you ever swum underwater and looked up at the bottom of lily pads? I remember seeing bright green, vermillion, magenta and chartreuse. It was one of the most dazzlingly colourful waterscapes I had ever seen. Well worth the muck and the fat, blood-bloated leech that fell from my inner thigh when I emerged.

I've snorkelled in Meat Cove, a clear turquoise bay in Cape Breton. I put on a wet suit and swam out to an island in the bay before snorkelling. I remember seeing kelp as wide as ironing boards waving gently in the current. The beams of sunlight penetrating the depths were breathtaking. It was like seeing a stained glass window in motion. I never tire of underwater vistas, and I never tire of looking for new ones.

I AM OFTEN ASKED, "Where would you still like to travel?" And I tell my questioner that I have drawn up no bucket list of destinations. Birgit and I still like to travel, but we have been blessed to see so much of the world already. We've been to Antarctica and India five times each and Africa more than ten times. I could be happy staying home at Ford Lake for the rest of my days. There's drama enough in my own backyard.

When I turned eighty, and eighty-four after that, I did not find myself obsessing over becoming an octogenarian. I actually feel half my age. If I'm obsessed with anything, I'm obsessed with time; not time passing, but time wisely spent.

From the house at Ford Lake, I can sit in a rocking chair and take in the lake, along with the marsh that is tended to by Ducks Unlimited for watershed protection, not for hunting. In several places, vertical lines of trees come right down to the shoreline, flanked by cropped meadows and overlooked by heavily forested Mount Maxwell. A mountain on a minor scale, by B.C. standards, but a mountain nonetheless.

My view in the foreground takes in several red cedar snags, the favourite perch of Bald Eagles that drift in most days from the northeast, following the shoreline and landing precisely in the same spot in the same tree. One warm day in February, I watched one eagle through binoculars as he sat and then slowly turned his head to the sun. There

he stayed, basking, for about ten minutes. That day, I had driven north into Ganges and spotted a young man on the sidewalk, adopting a prayerful yoga pose. He, like the eagle, had turned toward the sun. Eagle and man, on this day at least, were linked in their gratitude. In those same trees, we have seen Red-tailed Hawks, Peregrine Falcons, Merlins, Osprey, Pileated Woodpeckers, and countless Red-winged Blackbirds and many other perching birds.

THE FIRST HOUSE I DESIGNED, in north Burlington, in Southern Ontario, offered lovely vistas, and while there was a little stream on the property, there was no lake or river within sight. I built reflecting ponds outside that were thematically linked to a large planter inside in the dining room. I put a lot of thought into this: inside the planter were rocks and ferns and a small pool, the same sorts of rocks and ferns I had placed in the ponds outside so that they mirrored each other. One had the feeling that the outside ponds extended into the house, an effect enhanced by a curved bridge that stood at the edge of the reflecting pond.

I designed that house, and a Dutch-born carpenter built it. The red bricks of the wide fireplace had come from an old United Church being torn down in Rosemont, near Alliston. One brick contained the imprint of a cat's paw, so the feline had stepped into wet clay. The beam that formed the mantel had come from the barn of my neighbour at the time, the Canadian comedian and country music star Gordie Tapp.

When it came time to pull up stakes in 1985, I expressed the hope that an artist would buy the house and the ten acres that went with it, and that's exactly what happened. I had met a watercolourist named Brigitte Schreyer and her husband, Klaus. The two were driving past the house, saw the For Sale sign and inquired.

They were immediately smitten. Klaus, a designer, liked the Japanese and African elements in the house, as well as what he took

to be its chalet feel. Directly on one wall was the sketch of an eagle, a precursor to a larger painting of mine called *Vigilance*. Whenever the Schreyers painted the wall, they left the sketch untouched.

The house that Birgit and I first lived in was on the Eramosa River in Rockwood, Ontario. We added a studio and a family room, with generous windows to better take in the river. A big deck outside likewise enabled river views. One of my fondest memories of that house is the time a friend played her cello on the deck the morning after one of our musical reunions.

BOSHKUNG LAKE IN HALIBURTON COUNTY is crucial to who I am, and that's why I have been going back to it at least every other year for almost eighty years. Several weeks in summer are set aside so the Bateman family, our children and grandchildren, can all gather there. Some people have getaway places where they seek solace. My instinct is not isolation but to share what I have, to draw near to me the people I feel closest to. Escaping is not part of my lexicon; adventure is, exploration is, and certainly the Lodge (as I call our Boshkung cottage) is. Hopefully along with family and some friends.

In 1981, I was working on the actual painting *Dipper by the Waterfall*. I had known this waterfall since I was a boy. I stood up to stretch my legs and discovered there was a path leading inland from the Buck Slides River. The footpath led to a beaver pond at the bottom of a 30-foot cliff, peppered with cedars and pines growing right out of cracks and ledges in the pink and grey gneiss (An old German word pronounced "nice," *gneiss* means bright or sparkling. Such ancient rock is common in Haliburton, and indeed all over the Canadian Shield). Atop the cliff, I discovered, was a thick carpet of the most vibrant green moss. The pond was fed by a small second creek that was likewise fed by the Boshkung River. No matter where you stood, even out of sight of the creeks, you could hear the rush of water, and it got louder as you got closer to the creeks. It was so lovely, so peaceful and

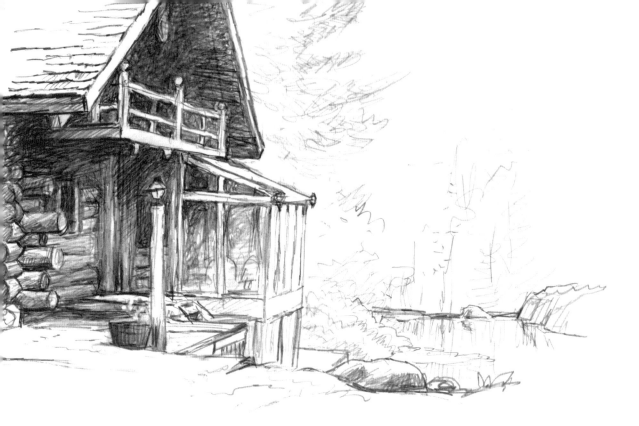

The cottage at Buck Slides.

so private. The water was warm in summer, and the falls removed all possibility of noisy powerboats and jet skis.

I noticed there was a For Sale sign. I said to myself, "Good heavens! You can't sell Buck Slides. God owns Buck Slides." We made inquiries with a real estate agent, who told us that an old fellow was selling the 5-acre property, which had been on the market for a while. We struck a deal. That year, I encountered a former student at a book signing, and we fell to talking about the property I had just bought in Haliburton County and my plans to build a cottage there.

"Do you remember Tom Kinn?" the former student asked me. I did indeed. Big guy, interesting fellow and another former student of mine. "He might just be," this alumnus said, "one of the best log house builders in Canada." A log house was just what we had in mind: a big round-log, two-storey place with a studio/loft facing that bold cliff and a stone fireplace that ran from floor to cathedral ceiling.

I did contact Tom Kinn, and in 1983 he built a most splendid place, with wide stone steps leading down to a deck, inviting swimmers to dive into the beaver pond. Incredibly, Tom had selected every log (the taper had to be just so) when it was still a tree, on a First Nations reserve near Huntsville. After securing a deal to harvest the timber, he and his crews then cut the trees, removed the bark, dried the wood in a kiln and set to work. The design of the entire project was a point of pride for Tom, and he was somewhat disappointed when we later added a bedroom wing at the back of the place to accommodate the growing Bateman clan, as well as a sunroom at the front. The additions meant cutting into those precious white pine timbers. We came to call the place "the Lodge" in order to distinguish it from the Bateman "cottage" on Boshkung, now in my brother Ross' hands—in earthly terms, at least. Also, a lodge is the name for a beaver's home, and we were on a beaver pond.

Since purchasing the property, we have raised the water level of the pond and reinforced the dam with stone and cement, under my instructions. A side river comes into the pond with a little waterfall, creating and sustaining the pond. The lodge sits on one side of the slope overlooking the pond, with steps leading to a very generous dock, almost a deck. The water in the pond is deep enough to dive in, and across the pond is that great cliff, with ferns and lichens, forming an almost theatrical backdrop. The pond always contains the warmer top water from Lake Kushog upstream, and is held at the same height by our little stone dam. The pond is about the size of two Olympic swimming pools. It is always quiet and calm, except for the sound of laughter when kids are playing.

I'm sure that God does, indeed, own Buck Slides, as well as the cottage on Boshkung Lake. Most years, the Bateman clan gathers there for several weeks in the summer and marks the tradition of tossing my daughter, Sarah Bateman, off the dock to celebrate her birthday.

We last gathered there in August of 2014. I was up on the deck outside my studio, working on a painting, when I thought, *This is*

bliss. My family was all around me (only one son-in-law and one grand-daughter were missing of the twenty-two in our clan), everyone either playing or occupied with chores, while I was moving ahead on a painting. We'd had a truckload of sand dropped off; Christopher and Robbie and their partners, Jenn and Madeleine, were hefting wheelbarrows of the stuff down to the water to fashion a beach and play space for the younger grandchildren. Even the little ones had shovels and helped move the sand.

Alan and Johnny were around the corner, obsessing over making a fire with sticks alone. I looked down at the pond, and there was my eleven-year-old grandson, James, swimming with his mask on, while several of his cousins occupied a raft-sized air mattress. With her dad beside her, eighteen-month-old Cleo commanded centre stage—now pretending to be asleep and then awake, then asleep again. The cousins played the game a long time, to Cleo's and their delight.

Just then, a bird in the forest made its distinctive cry—a long series of *wuk-wuk-wuk* calls. Birgit and I heard it at the same time. "Pileated Woodpecker!" she called up from the kitchen. "Got it," I replied.

Later I watched as Annie hauled up her minnow net to view her latest catches before depositing them in a white pail for the amusement of her younger cousins, Pierre, Grace and Sadie. Little Grace and Sadie spent a long time staring into that pail.

"Do the fish have red eyes?" I called down. I was curious to know their genus. If they had red eyes, they were rock bass.

Later that day, after I had gone snorkelling in the pond, I led half a dozen grandchildren on a hike over the cliff that faces the Lodge, and out to the several falls that frame the property. I don't expose the children unduly to danger, but I do believe in letting them take risks, so tree climbing is fine for those who are capable, as is leaping into the pond from the cliff where it lowers to a height of five feet next to the dam.

I carried with me a 5-foot-long hickory walking stick that a friend had carved for me. In fact, he carved two: one, my favourite, has a

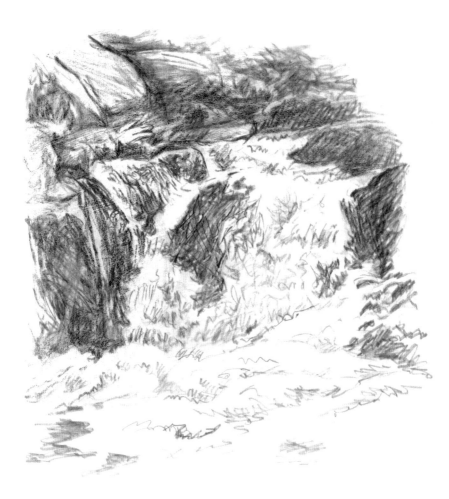

Peregrine Falcon on top and is modelled after my painting *Ready for Flight—Peregrine Falcon*; and the other, often loaned to friends who join me on these walks, is crowned with a salmon.

Several times on that walk, I turned to face the kids to make a point about the plants at my feet. One lesson was about the Indian pipe plant—also known as the ghost plant, for its pale white colour—which I see often on these walks. I also pointed out deer and grouse scat, and told a story about a mischievous friend who once led his pals on a similar walk. It was at a convention of mammologists in

Michigan. One of the hosts had gone out on the trail the day before and placed here and there little round molasses candies, which looked identical to deer droppings. Next day, he led a hike to that same spot and told everyone to gather round. Making a show of placing in his palm several "droppings," he said, "We call these deer berries in Michigan. They are really good." He then horrified the others by starting to eat them . . . the candy lookalikes.

Later that evening, the temperature dipped enough that Johnny made a fire. Our own children and their partners and the older grandchildren settled into the facing couches or in chairs here and there, while someone cracked open bags of poutine-flavoured potato chips and sweet-and-salty popcorn. Meanwhile, Ross would come over and we'd put our backs to the Rumford fireplace and warm up as we told tales.

A few days later, I made good on another promise: I began teaching Annie and James, then eleven and nine, and both keen to putter about the pond in the canoe, the J-stroke. As I've said, it seems I was born to teach, and I will go on teaching until the day I die.

Many years ago, when Robbie was eight and Christopher eleven, it dawned on Birgit that everyone was old enough to cook. She made up teams of two or three from different family members. Today, we rotate the cooking and cleaning up, with one family responsible for both on a given evening (breakfast and lunch are prepared individually). They even do the shopping, while Birgit and I pay the bills.

We serve ourselves from oversized soup tureens and retire to the sunroom/dining room or the picnic tables outside, or we eat from our laps on the couches by the fireplace. Sleeping arrangements involve a family of four occupying one bedroom or setting up a tent outside. It speaks to our tightness as a family that we can happily coexist in such cramped confines for weeks at a time.

We've also been there in winter, when a heavy cover of snow lies on the place and on the land and trees all around it. One year, a friend who was using the cottage took a photograph of the Lodge, with the

lights inside hinting at the warmth coming from the fireplace. A certain maker of Canadian rye was taken with the image and used it in its advertising. A framed version of the whisky ad still sits at the bottom of the stairs leading up to my studio, where I painstakingly sketched that magnificent cliff, the same one featured in half a dozen of my paintings. *At the Cliff—Bobcat*, for example, is set at a cleft in the rock higher up in the cliff, while *Winter Reflection—Wolf* is set at the base of the cliff. *Giant Panda* and *Dipper by a Waterfall* feature different points of the falls at Buck Slides.

A TRIP WEST IN 1976 TO SEE BIRGIT'S FAMILY and have Christopher christened got us thinking about living by the ocean. And in 1979, another trip to see her family, this time for Robbie's christening, as well as to visit Bristol Foster, further set the hook. Bristol had grown up in Toronto, but the B.C. coast was by then in his blood.

"Why are you living in purgatory," Bristol would say, "when you could be living in paradise?"

We would come west, and we would find a place on the ocean, but a tradition formed: every other summer we would spend a few weeks back at the cottage we had built at Boshkung Lake. The latter place affords a connection between my family and that of my two brothers; the cottage on Hornby Island enables the same connection with Birgit's family and cousins on both sides. These are meeting places for the Bateman clan, and it seems to matter to us all that the water is close.

Water lured us to a house on Reginald Hill Road, at Fulford Harbour on Saltspring Island. Hank Schubart, an architect who had studied with Frank Lloyd Wright, had moved to the island from California in the mid-1960s. Although he did not have a university degree, he was a professor of architecture in the 1960s. The father of five boys, Hank strongly opposed the Vietnam War and the draft, so he went north to Canada. He designed and built this place on the

ocean, with its stunning views to the south and west. There were many things to admire about the house and the 2.5-acre property: There seemed no barrier between the interior of the house and the waters of the harbour, the opening in the channel leading out to sea, and the opposite shore.

"Just take a look," Hank said about the house. It took about three seconds to convince Birgit and me that this was where we wanted to be. From inside the house, one had the sense of wide-open views. But from the ferry, the place looked tucked away and almost hidden.

The house at Fulford Harbour.

Hank had built the house as a weekend getaway for Hollywood actress Eileen Brennan (she earned an Academy Award nomination for Best Supporting Actress for her role as a sadistic commanding officer in *Private Benjamin* and played the girlfriend of Paul Newman's character in *The Sting*.) But Eileen had hardly used the place.

Much against the best advice, I had a mature Douglas Fir planted close to the house, which made us feel like we were living in a tree house. The tree was fifty feet tall, with an enormous root ball, but I had the means and I certainly had the desire. I had handpicked that tree and noted which side faced north. The Japanese say that the tree knows which way it faces, so we were careful to orient it exactly as it had been. A crew dug out the tree, wrapped the root ball in burlap and loaded it onto a flatbed truck, which briefly stopped traffic in Ganges. Getting it to our property was half the battle. Getting it down a steep bank to its new home required building a temporary wooden railway linking the driveway with the hole that had been dug. We also installed a big concrete wall to retain all the good soil we had trucked in to ensure the tree's health. I wanted that tree house feel, and I got it. We planted lots of trees on the property. And because trees on the island grow a foot a year, they did well. The Douglas Fir settled in and is flourishing.

To attract Bald Eagles, I had two tall dead cedars set in cement at water's edge. An eagle landed on one of the new perches almost immediately after the trees were installed. We could view the spot from our bed.

On a sunny day, the house on Reginald Hill sparkles. We added solar, wind and water power, not enough to get us off the grid, but sufficient to make the house feel green. And we liked living in the village, where everybody knew everybody else. One day, a mighty storm came up from the south and roared through the harbour, yanking our rowboat from its moorings. When the storm was over, my first thought was to don a wetsuit, get in the canoe and stick close to shore as I made my search, paddling with the wind. But before I could do this, the

phone rang. Someone from the ferry was calling to ask, "Did you lose a
boat last night?" They had found it floating in the harbour, made some
inquiries and easily located me as the owner. They said, "You will find
it in the ferry parking lot." There are no secrets in a village.

But after twenty years, we began looking around for another place.
For one thing, we wanted to downsize. The house was too big, too
rambling, with its six bedrooms and five bathrooms. The studio had
never offered a proper northern light, and it was too small. I couldn't
step back far enough to look at my paintings. Although the ocean
view was compelling, we loved the pastoral setting of the island prop-
erty at Ford Lake that we had owned since the mid-1980s, and we
were excited by the idea of living there. A move was in the works.

I would miss the otters at Fulford Harbour. Were I to come back
as an animal, I would come back as an otter. I felt such a powerful
kinship with them, and they had given me so many hours of joy as I
observed them playing and eating on the shore. But these sleek crea-
tures, which I loved to watch cavort on the rocks in front of the house,

found lodgings underneath the house, and their scent—like that of crab meat gone off—began to come up through the floorboards. So I had built, at great expense, a natural home for the otters down by the water (a Saltspring Islander formerly employed by the Vancouver Aquarium and an authority on the creatures had weighed in on the design), and eventually they left our house for this new den. Still, it required walling off below the house, and took two years' time, before this occurred.

Meanwhile, we kept going back to Ford Lake in the summer just to swim. The ocean was too cold and always required a wet suit, and I preferred fresh water to salt water for swimming. I liked the fact that the property came with an extraordinary history. The story is laid out in a book called *Never Fly Over an Eagle's Nest*. In 1903, Oland Garner was one of four brothers who fled South Carolina after running afoul of the Ku Klux Klan. But Oland wasn't about to leave without Lona, the woman he loved. Aware that the approach of the Klan was imminent, and with a gun to strengthen his argument, he stormed into her house in the middle of the night and told her parents that if they tried to stop them, he would kill everyone, including himself. He used the same compelling argument down the road with a preacher, who married them on the spot. Oland and Lona headed west to San Francisco, then north to Victoria, where he found employment with the father of Emily Carr, and later helped the painter build her house in that city. Eventually, Oland and Lona landed on Saltspring Island and the property at Ford Lake.

At first, they lived in a 12-foot x 12-foot square-timbered cedar cabin, which still stands and is attached to the old farmhouse I can see from my studio window. A 4-foot x 2-foot window overlooked the lake, with a much smaller window at the back. A loft served as sleeping quarters. It's hard to imagine that two adults ever called this home.

By the time Birgit and I bought the land, the place had come up a bit in standing. There was an apple orchard, a modest cedar-shake

farmhouse and a series of writer's cabins scattered up and down the property. Some genteel ladies had previously owned the place, and they had had hopes of turning it into a writers' retreat. In our hands, it became more of a Bateman clan retreat.

In 2003, we started the building process with the help of our son-in-law, Rob Barnard, a gifted house designer. Rob, Birgit and I planned the house with certain priorities in mind. One for me was the sight and sound of water. When a visitor approaches the gate, with its over-head trellis, the first sound that he or she hears is water cascading into a stone bowl just inside the gate, on the right. I had seen larger versions of such bowls in Japan.

There are discoveries to be made while descending the steps—sculptures, rock gardens, plants and trees. After the visitor follows the path, turns the corner of the house and leaves behind the sound of water landing in that bowl, another body of water comes into view, this time on the left. A 10-foot-square fishpond features water dropping down a rock face from a height of several feet.

The pond serves two purposes. First, it takes up the song of cascading water heard by the gate, but in a higher note now, as the water falls in a fine spray off a wide expanse of rock. Second, the pond is a beauty spot, an "Aha" moment for the visitor as he or she turns the corner and sees—and hears—it. British gardening expert Beverley Nichols (he wrote the 1932 bestseller *Down the Garden Path*) has suggested that even in a small garden, the space should be divided in such a way that anyone walking in it must turn a corner. The thought of what's around the corner should heighten the sense of mystery and surprise.

When folks first visit our house, I explain that I am anti-antebellum—that neoclassical- and Greek-revival style of architecture that one sees in former plantations in the southern United States and at the White House. What distinguishes that style is its ostentatious display, the pillars at the grand entrance begging to be admired, all the opulence seen at first glance. I much prefer a more discreet

presentation, one that quietly pays homage to some of the places we have lived or visited in our life, from Japan to Germany to Africa. The ponds full of koi suggest the Japanese influence; the small troughs are modelled on those used for watering animals in rural Germany; and the main door of the house is patterned after one I saw in a village in Africa.

It feels like the house has been here a while, and I find that comforting. This feeling comes, in part, from the moss on the stone decking and cement roof tiles. I like the solidity and elegance of the house, how the northern light pours in, and the quiet that prevails. Birgit and I both appreciate that we can grow fruits and vegetables here, something we couldn't do at Fulford Harbour.

I never tire of walking around the house, never tire of the island and its cast of eccentrics. (I suppose I could include myself in that category.) Saltspring is such an intriguing mix: the superannuated hippies who came here decades ago and whose ponytails are now turning grey; the retired oil barons who arrived from Alberta in the mid-1980s; the artists who have found refuge here and who strive to make a living by woodcraft and sculpture; the health practitioners who offer counsel on wellness and yoga and meditation. The discovery of Saltspring Island began with English eccentrics after the Second World War. And many writers since have sought the quiet here.

A song by a local musician, Shiloh Zybergold, implies that you can tell your social status on the island by your area code. The tony part of the island, the song claims, is the wealthier north end; the hippies, farmers and starving artists, at least according to the song's lyrics, live in the south. That is true, but there are lots of exceptions. There is another joke told on Saltspring Island, and it speaks to the interconnectedness of its inhabitants and their on-again, off-again relationships. "What's the most confusing day of the year?" the joke asks. The answer: "Father's Day on Saltspring Island."

Saltspring is the largest and most populous of the Gulf Islands, and some 12,000 people live on its 466 square kilometres. We live

a mere seven kilometres from our daughter, Sarah; her husband, Rob; and their daughters, Ruby and Jade. Our son John and his wife, Jocelyn, and their children, Annie and James, live nearby. Drive the island and you are likely to see signs advertising a silent retreat, wellness sessions or meditation classes. Even the ferry to Victoria, the *Skeena Queen*, has an official posting that bids passengers "Peace, love and joy." Lots of folks on the island never lock their doors. The only crime, an islander friend likes to say, is growing pot.

Since 1985, the Bateman clan has kept a certain family tradition: A few days before Christmas, those Batemans who are on the island join a community gathering in the parking lot in front of the general store in Fulford Harbour and sing Christmas carols, led by Valdy, the well-known folk singer and island resident.

Ruby at two weeks old.

Ruby.
Dec 10/95

Should I live to an age when walkers or canes or wheelchairs become necessary, the house will be able to accommodate them. The master bedroom, kitchen and studio are all on the same floor.

We did all we could to make our home not only esthetically pleasing but also safe and healthy. We cut cedar and Douglas Fir as log timbers for the structure, and alder to make the kitchen cabinets. We used no plywood, and all the paints were milk paints. We used formaldehyde-free insulation, and installed a geothermal system to heat and cool the house. We chose a building site where readings of magnetic radiation were virtually non-existent. And workers remarked on how they left the construction site feeling quite fresh at the end of the day compared with other sites.

More than anything, we wanted to achieve a house that was cozy—what the Germans call *gemütlich*. An Indian plum tree decided on its own to grow by the woodpile that visitors drive past as they come to the house, and we put a simple bench there so I could sit and welcome our guests. By the front gate, we planted trees I cherished while growing up in Ontario: one red maple and one sugar maple. Those trees honour the province I was born in, and three other trees here pay homage to British Columbia—a Big-leaf Maple, a Douglas Fir and a Vine Maple. The mossy rocks and clean pebbles at the foot of those trees were likewise placed there with a purpose, and I am reminded as I pass them that I could have been happy as a landscape architect.

A VITAL CONSIDERATION IN EVERY HOME we've lived in is the view from where I sit in the studio—a room, you might say, with a view. The prospects are planned to be so enticing that I cannot help but find them irresistible. But even while my eyes are savouring the scene, my mind is working on the painting at the easel.

Here in the Ford Lake studio, I cast my eyes first on the photos of grandchildren around the window frame, and then to the

world beyond. Close outside the windows are the bird feeders. A hanging feeder filled with sunflower seeds serves Chestnut-backed Chickadees, Purple Finches, House Finches and Pine Siskins. The covered tray feeder has millet for juncos and Steller's Jays. The suet logs draw Red-breasted Nuthatches, more Chickadees, Hairy and Downy Woodpeckers; once in a while a Pileated Woodpecker honours us with its presence. Overhanging these is our old Russet apple tree, and behind that several heritage Delicious apple trees.

Me in the studio looking out at the farmhouse built in 1930. A Steller's Jay and Chickadees are at the feeders.

In the middle distance sits the old farmhouse. That house was built the year I was born, and a number of our children have lived there with their spouses over the years. Son Johnny and his wife, Jocelyn, were there for the birth of Annie, who arrived with the help of a midwife twelve years ago. Annie can proudly point to the exact spot of her birth on the floor. The farmhouse's upstairs window recalls a painting our son Alan did of his wife, Holly, back in the 1980s. That was the window of their bedroom during the year they lived on Saltspring before moving to Nova Scotia. Our youngest son, Rob, and his wife, Madeleine, also lived in the farmhouse for almost a year. The fancy Victorian railing around the porch was rescued by my uncle Frank's son, Doug, from a heritage house in Oshawa that was being torn down. He thought the Bateman boys might like those rails. And he was right.

The backdrop to the whole affair is a dark green wall of forest. Could there be a finer reflection of all that this place represents—family, history, the wild? I like wilderness, but I love the bucolic, where the traditional hand of man has a gentle interface with nature.

THE JAPANESE ARE THE MASTERS OF PLEASING PLACES, and there are several touches here that pay homage to shrines in Japan, especially the ones at Ise, among the most important of the Shinto shrines. Ise is a sacred place steeped in history. Its shrines are simple and elegant, and every twenty years they are torn down and rebuilt, a custom that has been maintained almost continuously for more than 1,200 years. When a shrine is torn down, the previous site is strewn with large white pebbles. We have placed pebbles in our ponds at Ford Lake to echo that custom.

We have been at the shrine and heard American visitors worry aloud that at some point the builders won't have the massive beams required. "Won't you run out of wood and have to get trees from Alaska?" they ask. The answer: "We have planned ahead." For

instance, the wood used to rebuild the shrines in 2013 was planted some 400 hundred years ago. This is the true meaning of planning and sustainability.

We have installed several lanterns of my design, much like those at Ise. Power to the lanterns at our house runs underground; the wires are hidden inside the cedar posts on which the lanterns sit. What strikes the first-time visitor to the house is how shrine-like the lanterns are, with their bold ridge board, board and batten sides and generous overhang.

The Japanese treasure rocks and trees, and I possess that same affinity. The Isuzu River flows through the Ise shrine, which has been designed to soothe the eye and the ear. Islands have been created on the water, affording pilgrims viewing platforms that are themselves the most beautiful tableaus, and the pleasing sounds of running water. We incorporated some of those elements into our garden at Ford Lake.

Visitors access the house via wide concrete steps that lead down from the driveway, and as they walk they will see on either side trees growing in what looks like a continuation of the mountainside rock and moss, with a profusion of ferns, oxalis, shore pine and salal.

The trellises that partly shade the outside staircase are modelled on arbours we have seen on our travels. Mad King Ludwig built a palace at Linderhof, which we visited when we were living in Germany. And one of the things I took away from it was the king's fondness for vine-covered arbours. The one at Ford Lake offers both shade and pleasing fragrance. Honeysuckle grows on the trellis and lily of the valley grows nearby.

Though I don't like to think of the house at Ford Lake as a museum, the collection inside is mostly tribal art from many cultures. There are statues and carvings, textiles and pottery, some pieces quite old, and gathered from all over the world. The path outside likewise has a few pieces of art at turning points. At the foot of the stairs beyond the trellis is a welcoming cedar carving, a totem pole of a beaver set against the wall of the house. We bought the piece in the

early 1980s, even before moving to British Columbia. A coast Nisga'a carver named Norman Tait had brought the piece to the Museum of Vancouver, where I had just had a show. Norman was hoping to sell the piece, and right away I could see its quality.

Just to the right of the front door of the house is a bronze frog sculpture with a turquoise patina done by the Haida artist Robert Davidson, and below it is a ceremonial potlatch bowl based on a frog, also Haida. Both were gifts from Birgit. In the bowl are four green

glass balls, once used by Japanese fishermen to float their net. We found them while beachcombing on the west coast of Vancouver Island.

Finally, there is the door itself. Made of a single piece of mahogany, it is patterned after a door I saw in Awka, in southeastern Nigeria, in the mid-1960s, when I was teaching there. I had written home to my mother to get the dimensions of the front door of the house on Chaplin Crescent, for that was the size of door I wanted. The carver rendered a pattern of diamonds and ovals similar to one he had carved for a chief. So I had the door for my first dream house before I had the house. The diamond and oval theme runs through the Ford Lake house and several others. I call it the Bateman theme. Luckily, Birgit loves it as much as I do. Three times I have had this particular mahogany door installed in houses I had built—in Burlington, Fulford Harbour and Ford Lake. Unless someone has other plans, this house is its final resting place.

Yellow-eyed
Penguin -
Enderby Island
Dec, 16

In 2002, we joined Victor Emanuel Nature Tours on our one and only trip to the deep south of Antarctica in order to see colonies of Emperor Penguins. Our destination was Cape Washington on Coulman Island. At midnight of December 4, Birgit and I lay just a few feet from the Emperor chicks, with a glowing sky of midnight sun behind them. At one minute after, I rolled over in the snow, kissed Birgit's cheek and wished her a happy birthday.

Emperor Penguin Colony
Coulman Island Dec. 7

XII : THE ARTIST AS ACTIVIST

we won't wait any longer
we are stronger than before.

did not seek fame, but it came my way, and I have tried to use it wisely in defence of the natural world.

Certainly I am a political animal, but one of indeterminate stripe; you can colour me Tory blue, but my political hero is a red liberal, Franklin Delano Roosevelt. I have no party affiliation because I want to be able to reach politicians of all parties. I am an unapologetic monarchist, a conservative thinker who, as you might imagine, is opposed to fracking and salmon farming and any plan to let oil tankers ply the B.C. coast. But I'm not easily pigeonholed.

In 1973, Ontario premier William Davis—perhaps the best premier the province has ever had—appointed me to the fledgling Niagara Escarpment Commission.

I remember going to many, many meetings, where I seemed to be able to concentrate better on what was being said while sketching on the side. Sometimes my subject was the faces of people in the room, but on one occasion in 1983, it was a Norway spruce twig that I had brought into

the meeting. I still have that detailed ballpoint pen sketch that was three hours in the making.

I stayed on the commission until 1985, when we moved west. But I didn't always vote the way people thought I would. I saw myself as an advocate for the birds and the mammals, and if I thought—as it happened one time—that an absentee German landlord was good for a big parcel of land (certainly better than a subdivision), I would back the absentee landlord. I was guided by one consideration: What is in the best interests of nature? What's best for the Pileated Woodpecker?

In March of 1988, two members of the Western Canada Wilderness Committee—a non-profit group aiming to protect Canada's biological diversity—heard a disturbing rumour about the Carmanah watershed on the west coast of Vancouver Island, home to a magnificent stand of Sitka spruce, Canada's tallest trees. The two forged a path into the valley and saw for themselves the beauty of this stand of trees, one of the last areas of old-growth forest left on the island. They also discovered, to their horror, that the place was slated for immediate logging. Without public consultation, the provincial government had given Macmillan Bloedel permission to clear-cut the forest.

The committee launched a public education campaign, which included bushwhacking a path into the valley and taking scientists and politicians to the site. This led to a battle with the logging company. While that fight continued, more than a hundred B.C. artists including Jack Shadbolt, Toni Onley and yours truly hiked into the site. The idea was to create work for a book that would raise money for the battle to save the valley, and raise public awareness at the same time. And indeed, a book was published: *Carmanah: Artistic Visions of an Ancient Rainforest.*

What I remember most vividly about that walk to the site was passing through vast areas that had already been clear-cut. I was

shocked by the waste, and by the logging company's apparent ignorance, laziness and greed. And when we reached the Carmanah Valley itself, I was equally taken aback, this time by the magnificence of the forest. We stood in a cathedral of cedar and fir and spruce rising up from the mossy forest floor. Some of these ancient trees were more than 1,000 years old and 300 feet high. I knew that taking out these giants would change drainage patterns and increase runoff and erosion. The whole watershed was vulnerable.

The painting I did for the book was a diptych called *Carmanah Contrasts*. The larger, bottom piece depicted what a clear-cut actually looks like. I presented a grey and ghostly picture of death and desolation, save for one tiny skunk cabbage, a green plant that had probably grown there all its life but would soon die because the stream that had given it life was gone. The upper part of the painting portrayed the lush and green Carmanah forest floor as it was when I was there. Many of the artists on this mission were drawn to the height of the trees. I was drawn to the forest floor—its complex and delicate ecology, its mosses and plants. I inserted a human being (me) and a Pileated Woodpecker to give the viewer a sense of scale. The man is absolutely dwarfed by the trees.

Artists are not necessarily good at public relations, but the Sierra Club and the Western Canadian Wilderness Committee arranged for media to fly in by helicopter. TV crews landed on a logging road and interviewed some of us. When they asked me what I thought, this was my reply: "I understand that they're doing this logging for two reasons: to make money and to create jobs. Both worthy causes that help the world go round. I have a suggestion. There is a cathedral in the middle of Paris, on the Seine, called Notre Dame. The proposal would be to demolish it and sell all the sculptures and stained-glass windows, and then build condominiums in its place. This would be guaranteed to make plenty of money and provide plenty of jobs, at least for a while."

Then I stared into the camera and added, "It's the same thing."

I wish it were always this easy—that artists painted, that citizens took notice, that a sacred forest was saved when the province responded to pressure by buying back the tree farm licenses from MacMillan Bloedel, thereby paving the way for the creation of Carmanah Pacific Provincial Park in 1990. Those monumental Sitka spruce still stand, "protected" today as part of the expanded Carmanah Walbran Provincial Park.

Several years later, in the summer of 1993, I was part of another protest, this one aimed at stopping clear-cut logging at Clayoquot Sound, also on the west coast of Vancouver Island. The strategy was to set up a blockade and stop logging trucks at the Kennedy Lake Bridge. Birgit and I arrived in the evening, and I gave a little talk. Then we were up at dawn the following morning to stand in protest as the logging trucks appeared. A sketch from that day captures the scene: protestors holding aloft a sign that read "Unjust Injunction" and a man flashing a "V" for victory sign while being hauled away

by the RCMP. Most mass protests do little to affect change, but the protest at Clayoquot drew about 11,000 people that summer and it did go some way towards obtaining partial protection of the Sound and its forests.

On March 24, 2008, on the nineteenth anniversary of the Exxon Valdez's catastrophic oil spill off the coast of Alaska, when some 42 million litres of crude oil contaminated more than 2,000 kilometres of coastline, I participated in an online protest to voice my opposition to the possibility of oil tankers plying the Douglas Channel and other parts of the B.C. coast should the Enbridge pipeline go through. I argued then and still maintain that if Alberta oil is transferred to Kitimat, on the B.C. coast, an accidental oil spill is inevitable. Not a Pretty Picture was the name of the largely symbolic protest, which was filmed and put out on the Internet. To dramatize the point, I painted on canvas a giclée proof of *Orca Procession*—the original acrylic was produced in 1985—with thick black poster paint. The scene I had captured with *Orca Procession* was visible from a campsite I occupied at the time, on the south end of the Queen Charlotte Islands, just south of Alaska. Of all the temperate seashores of the world, this area offers the greatest variety of plants and animals. The painting depicts that rugged coastline's typical mist and low clouds, and an island full of Glaucous-winged Gulls, but the real subject is the pod of Orcas moving past the island in majestic formation. For the film, I had *Orca Procession* set up on my easel and I began by taking the dark poster black paint and drawing an X over the painting. I kept laying on the black paint until every inch of canvas was obliterated, the last casualty being my signature in the painting's lower right corner.

Other art of mine was done to provoke. I have painted shot Bald Eagles, clear-cut forests, grebes covered in oil, and sea birds and animals caught in fishermen's drift nets. What an awful invention is the

drift net; I have spoken against it many times. These things can be miles in length and are sometimes made of monofilament, making them barely visible and horribly durable. And they don't just catch fish; diving sea birds, seals and sea lions, porpoises and whales get caught up in them too. Sometimes the drift nets lose their marker buoys; sometimes rival fishermen cut them off. In these cases, the nets become ghosts, trapping so many creatures over a span of decades before falling to the bottom of the ocean with the weight of their victims. Once the carcasses have rotted or been picked clean, the nets rise again and resume their ruinous work.

I consider *Drift Net—Pacific White-sided Dolphin* and *Laysan Albatross* to be among my most important works. I actually attached a piece of real drift net across the canvas. It is not a pleasant scene to contemplate but, like *Coyote in Winter Sage*, it registers a necessary protest. No one will make a print of that driftnet painting, but I include it in many of my lectures. I want to show that Planet Earth has a spiritual and emotional value and that we humans must recognize it.

THE IDEA OF CREATING A LEGACY initiative around my art dates back to the year 2000, when I turned seventy. What was I to do with all the paintings still in our possession? Sell them off? Give them to our children, who have no space left on their walls? What rose to the surface were my old instincts as a teacher and proselytizer. I had a notion that if some of my best works were gathered under one roof, the collection might inspire and revitalize an interest in nature, an affection for the creatures I had spent a lifetime painting.

The first nudge towards this idea came from friends in Burlington, where I had long lived and taught. A public art gallery had been established there in 1978, and I continued to travel back to the city for shows and talks long after we had moved west in 1985. On one such visit, someone broached the idea: What about a Bateman gallery? Or maybe a Bateman wing in the existing gallery?

Several other possible venues were considered. There was a plan for a new wing at the National Museum of Wildlife Art in Jackson Hole, Wyoming. But the roadblock in both Burlington and Jackson Hole was that museum association rules forbade the hanging of reproduction prints as part of the collection. We own only a limited number of my originals, and would need prints, especially giclées, which are close facsimiles, to show the large scope of my work. There was a proposal for San Francisco, with the Presidio—a national park—as a possible site, as well as one for Royal Roads University, with its beautiful campus in the forest, west of Victoria. None of these enterprises quite got off the ground for a variety of reasons.

Finally, architect Richard Iredale, who was then working for the Harbour Commission in Victoria and had done some designs for the Royal Roads proposal, told us about the old Canadian Pacific Railway Steamship Terminal on Belleville Street in Victoria. This imposing visual delight, right on the water, was being upgraded, and the owners were looking for an anchor tenant.

The Terminal Building, in Victoria, which is now the home of the Robert Bateman Centre.

The two-and-a-half-storey terminal building, built in 1924, is a white neoclassical structure made of stone and concrete. Its architect, Francis Rattenbury, had designed the B.C. Legislative Building and the Empress Hotel, both of which are within sight, as is the Inner Harbour. A five-minute walk from there is the Royal British Columbia Museum, the best museum in the world for visitors, in my opinion.

I remember one day having tea at the Empress Hotel with Walter and Suzanne Scott, who have a significant collection of my work at their home in Omaha. I took Walter to a window and pointed at the terminal building.

"Now you're talking," he said. Walter and Suzanne were old friends and generous philanthropists. They were keen to advance the idea of a gallery to house my work and that would serve an educational function.

But before the physical institution could take shape, the Bateman Foundation had to be created to gather and maintain the art, to hire staff, to pay the bills. Had we decided to go with a university as a home for the art, there was always the risk the works might be sold some time in the future. With the formation of the foundation, which would one day own the art, that possibility was eliminated.

On May 24, 2013—my eighty-third birthday—the doors of the Robert Bateman Centre opened to the public. The centre houses ten galleries, which gather 160 of my paintings, including more than one hundred originals. The collection spans seven decades of my work. That first weekend, some 3,000 people visited the centre. In 2014, the number of annual visitors was 30,000, and I'm happy to note that a dynamic school program and teachers' guide will be unveiled in 2015.

Thanks to patrons such as Loretta Rogers, David and Diane Reesor, and Walter and Suzanne Scott, we were able to establish a gallery dedicated to my work. Paul Gilbert, a designer who was my student all through high school in Burlington, became our first executive director. He created the gallery from scratch.

One of the wonderful features of the gallery is that the visitor can park himself or herself in front of any of the works on view and link a cell phone or iPad with a device next to it. Up will come my mug and a two-minute tale of that painting and how it came to be. The paintings that depict birds have an extra feature; if you simply wave your hand in front of the plaque beneath or beside it, you'll get a short sample of that bird's call.

At the time of the grand opening, I was interviewed by *Maclean's* magazine, and I told their reporter how awkward it felt to have a museum in one's name. Rather than dwell on the centre's name, I prefer to focus on its aim: to help visitors understand the incredible variety, wonder—and vulnerability—of the nature that surrounds us.

It is the role of the Bateman Foundation to encourage all of us, including those in positions of power, to forge a rejuvenated relationship with nature through partnerships, research, collaboration and education. We are currently working with many like-minded organizations, among them the Canadian Wildlife Federation and the Jane Goodall Foundation, to achieve the same goals.

IN HIS BOOK *BIOPHILIA*, ecology guru E.O. Wilson argues that humans are hard-wired to love living things. I agree with him. For all the damage that has been done by our shopping-mad, consumer-driven economies, for all the narcissism of a population that seems bent on amusing itself to death, for all the catastrophes that some environmentalists predict, I still believe there is hope that future generations will grasp the truth that my generation has been too selfish to acknowledge.

The young are the keepers of the future, but we have a present responsibility to equip them for the task. I've spoken with the Cowichan elders on Vancouver Island on this matter, and I agree with their stance. "What kind of world are we leaving for our children?" they ask. "And what kind of children are we leaving for our world?"

I urge parents to let their children play outside, as I played outside when I was a child. The danger lies inside, not outside. Helicopter parents are not doing their children any favours by discouraging exploration, or by fostering a fear of risk in natural spaces. Please, can we stop building playgrounds designed by lawyers? And can we allow children to discover and explore wild and natural places without Orwellian supervision?

The benefits of exposure to nature were at one time self-evident, yet today we need to relearn them. I often cite Richard Louv's book *Last Child in the Woods* on the phenomenon of nature-deficit disorder and the risks that come with cutting those bonds with the natural world that have defined us as humans for all of our existence—until now. I speak about the practice of Japanese city dwellers, who take hour-long walks in the woods. The treatment is called "forest therapy" or "forest bathing," and it's been shown to reduce stress and blood pressure, boost the immune system and improve efficiency at work.

When Birgit and I were teachers, we would take students on four-day canoe trips. We observed the same process. Nature has a calming influence. The one or two boys who started out behaving like yahoos were caring humans by the end, helping the weaker ones over portages and carrying their gear. I heard somewhere that children today can recognize some 1,000 corporate logos but on average know only about ten species of birds and trees. How did we allow this to happen?

All my life I have been a conservationist, dedicated to preserving the great wealth that God bestowed on us—the forests and savannahs, the oceans and mountains, the lakes and rivers. Regrettably, all these precious resources are under siege, and all because of our obsession with economic growth. Fracking (drilling into the ground and injecting fluids at high pressure to release natural gas and oil) and the tar sands (an area in Northern Alberta where synthetic crude oil is extracted from the earth) point to the fact that we are now scraping the bottom of nature's barrel. We have an obese lifestyle, and there is a slender version to come. Market forces, and not my preaching, will

JACKDAW
MAY 7/92.

usher it in. I suspect that my grandchildren, when they reach my age, will have a lifestyle more like that of my grandparents than the profligate lifestyle of today. Life will be slimmer. And I pray this transition can be done gracefully and not catastrophically.

In the meantime, here is something we can all do: go on hikes and bring children with you. Nature is gloriously free. If Dad can be convinced to leave behind his sports channel, Mom her Facebook page and the kids their video games, the trees of the forest will spritz aromatics, and the immune systems of those hikers will rejoice. The smart phone–free zone has its own rewards, and we need to be reminded of them.

A drawing of a Jackdaw from the Artists for Nature Foundation trip to Poland, 1992.

WHINCHAT

Poland.

BLUE TITS

My first trip with the Artists for Nature Foundation was to the Biebrza Marshes in eastern Poland. "Progress" in the twentieth century had passed it by, so it was a living snapshot of a bygone era. Water wells were like old-time wishing wells. Storks nested on many of the buildings—a good indication that pesticides had not been used.

EPILOGUE

A gravel driveway, with its grassy median, curves past the farmhouse at Ford Lake. Birgit and I will follow it for our after-lunch hike. I could say after-lunch *walk,* but to me *hike* means uneven ground, and that is what we will traverse.

We go past the farmhouse and turn up the lane. There is a long, weathered wooden gate hanging from an old cedar post, put there for some purpose long forgotten. We pass a shed—remarkable for its moss-encrusted roof and its uprights of stout, hand-hewn cedar—that we think once held food for sheep. These assorted gates and the relics of page wire fences winding through the woods are a mystery. It is a pleasant thing to live in a map of little mysteries. We can theorize, but we will likely never know, and it really doesn't matter.

The lane then swings into an unused forest road, covered with more moss than grass and marked with one narrow, brown trail made by our daily footfalls over almost a decade. Tall trunks of Douglas Fir and Grand Fir allow for

clear visibility beneath the evergreen canopy. The forest floor is evergreen as well because it is carpeted with knee-high sword fern. On mild, damp Saltspring Island, the forest-scape is constant no matter the season. We come to an old wooden gate. Each April, we look forward to a spring treat at this spot—a tiny gathering of the same white trilliums that carpet hardwood forest floors in Ontario. Here they are a memento.

The gate marks the edge of our property, but we do not hesitate to enter. I like the line in the Robert Frost poem, "Whose woods these are I think I know . . ." We do, of course, know whose woods we are about to enter. About 150 acres of forest, meadow and giant beaver pond all around us are held in trust by Ducks Unlimited. They are congenial neighbours; we share the motto "Conservation Today, Wetlands for Tomorrow." Beside Birgit and me, humans are rarely seen here. A local farmer takes two crops of hay off the meadow every year. And on one or two hikes of the year, the woods ring with the joyous shouts of junior high schoolkids taking outdoor education classes. The classes were started by our daughter, Sarah, who engages some of the many retired scientists on our island as volunteer educators.

On another walk, in the field by the big maple, we once spotted some fifty Robins, and we stopped to let that extraordinary sight register. A few moments later, we came across the carcass of a young deer that, for whatever reason, died on a spot not far off the path. The earth was slowly reclaiming him. Another day, the path took us over a thatching ant colony. Rather than risk stepping on the creatures, we took a route to one side. Live and let live.

Passing through the gate, Birgit and I move under the boughs of a large Western Hemlock, not that common of a tree. When John and Jocelyn lived here, they saw in its branches a pygmy owl that has not been seen since. I think about a painting I can picture in my head: a self-portrait of me in the distance, backlit, beyond the Hemlock, at the gate. I hope that I can fit it in between my other commitments and demands . . . maybe if I live long enough. I have done two paintings

based on our walks. One is Birgit in a fresh snow scene. The other is a fall scene of the whole family under the big maple. There could be many other paintings. We will see.

Next, we pass what we call "Coon Corner." We recycle and have a compost bin for the garden. But that leaves the potentially smelly stuff, such as fats, proteins and carbohydrates, that we do not want to put in the garbage or dispose of near the house for fear they would attract rats. There is no local system to have these things picked up. We are sure that raccoons would appreciate our modest offering, but we suspect the Ravens get it first. At any rate, our gift is always gone within twenty-four hours, and sometimes sooner. We regularly hear the Ravens calling, or perhaps talking to one another. We are both good at imitating them by putting our tongues at the back of our palates and doing a kind of soprano gargle.

We listen for other birds, but I am of an age when my ears can't pick up the highest notes, so I have lost the high-frequency sounds of

Golden-crowned Kinglets. Birgit will stop and say, "Listen!" There will be a flock of them in the canopy high overhead, but their pitch has been too high for me for several years now. Still, I can clearly hear the Robins when they mob a Barred Owl, which happens with regularity.

Next, we cross a brook that flows out of the forest, as does a little waterfall, over some alder roots before entering a crystal-clear pool about the size of a dinner table. The sounds of nature soothe, and a gently babbling brook is hard to beat. Birgit always stops to spot the baby fingered-sized fishes. We think they are young cutthroat trout but are not sure.

It is very early spring on the island, and under the moist soil around the pool our first flowers, skunk cabbage, are preparing to poke up their yellow spears. Although they do not have the sweet smell of normal flowers, I would rather call them swamp lanterns than skunk cabbage. They have smooth yellow flowers bigger than a man's hand, and succulent leaves that may grow to half the size of a Plains Indian war shield.

We have that to look forward to, as we do each seasonal change in nature. Whenever I cross that stream, I think of the painting I did for Birgit at Christmas in 2009. We had had a skiffle of snow, and Birgit was carrying an umbrella. I had stopped to take a picture, and she was already ahead of me and wistfully looking at the ground. As in so many of my paintings, it was that unpredictable "Aha!" moment that I sought to capture—a very quiet and unspectacular moment, but full of meaning and the memory of so many hikes together. Behind her in the painting is the misty silhouette of the big maple.

On this hike, that tree will be our destination. It is for us a kind of trophy tree in that it is often the turn-around point when we take guests for a pre-dinner stroll. Standing on the edge of the meadow, the tree is a very large big-leaf maple. The leaves are huge, the size of large dinner plates. At this time of year, the soggy brown leaves are on the ground and the tree is surrounded by a giant circular carpet of them. A few months ago, the carpet was crispy and made crunching

noises when you walked on it. On a frosty day, these leaves were a joy to behold, especially if the sun glowed through them without melting the rim of frost.

You can tell by the spreading branches almost all the way down the trunk that the tree grew up in an open meadow well over one hundred years ago. The bark is scorched black by some long-forgotten grass fire, but most of the trunk is encrusted with a rich coat of moss. Even in winter, the almost-bare branches are festooned with masses of lichens of many species, a sure sign of pure, unpolluted air. Birgit has photographed the tree through the seasons as a kind of movable feast for the eye.

A hug and a kiss mark our turn-around point, and we retrace our steps. Although the hike home follows the same route, the sights are quite different, as is the light. Rain, shine or snow, every foray is unique, and every day special because we hike in nature's endlessly variable paradise. I am rejuvenated.

Soon I will go once again into the studio, take up my brush and do as I have done almost every day of my life. I will paint.

Howland.

ACKNOWLEDGEMENTS

There are many individuals I'd like to thank, as they were instrumental in helping shape this book into the volume you now hold in your hands as well as in shaping my life.

Kevin Hanson, president of Simon & Schuster, for envisioning this project and helping to bring it to fruition.

Larry Scanlan, for his patience in listening to my stories, his incredible eye for detail and for prompting me to abandon a chronological approach to my memoir in favour of a more narrative approach.

Nita Pronovost, my editor, for being an unusual pleasure to work with and for her eternal positive energy. Sarah St. Pierre, for her ongoing editorial assistance behind the scenes.

Alex Fischer, for acting as a liaison between the world and me. She is gifted with a phenomenal memory of people and events and is more of an expert in aspects of my career than any other person. The fact that she is still with us after twenty-four years is a tribute to her diplomacy and

patience. She has a great sense of humour and her wit is appreciated by all. She is the keeper at the gate of my days, skillfully handling numerous requests—more than I could possibly fit into my life.

Kate Brotchie, for being far more methodical and careful than I will ever be in paying attention to detail and recording things properly. This makes her an excellent archivist of my art, my presentations and my writing. She has a background in geography and teaching parallel to mine. Kate's efforts in searching for images and scanning them for this book were of particular help.

Steve Jarman, my brilliant Jack-of-all-trades, for being thoughtfully proactive and monitoring all the mechanical intricacies of a busy studio, household and property. He is proficient in everything from archival art photography and electronics to every sub-trade imaginable.

Casey Jarman, for keeping an eye on things around our property. One of Steve's brothers, he works for us part-time and is ready to help us at a moment's notice.

There are a number of "old" friends in my life who have for decades been part of who I am. These include Al Gordon, forester, Dr. Don Smith, biologist, and Erik Thorn, artist and naturalist, amongst many others. I have kept in touch with them through the years and treasure their friendships.

However, the most important friend from the 1950s to today is Bristol Foster. The 1955 trip to the Arctic was led by him. The fourteen-month "Rover Boys" trip around the world was really his trip. Birgit and I moved to B.C. because of his influence, which in turn is why we are living on Saltspring Island. I feel close to many members of his family and our family considers him a sort of honourary Bateman because we have shared so many experiences and adventures.

In the "blood relatives" category, I owe a lot to Mom and Dad for giving us a perfect environment on the Belt Line Ravine in Toronto allowing us to grow up as "Three Little Savages." My brothers, Jack and Ross, have always been close to me. We are generally kindred spirits, but their ideas are sometimes good foils for my opinions. Ross,

in particular, made a fair commitment of time into the early years documented in this book, including our family history.

Perhaps this book would not exist, if it were not for Al Cummings, who formed a small team of five, including Birgit and me, to assemble *The Art of Robert Bateman*, published in 1981. Madison Press, the company he founded, published five coffee table books and five children's books with the help of Hugh Brewster and Sandra Hall.

This along with my print publishing career begun by Robert Lewin of Mill Pond Press in Florida and continued with the Coles family of Natures' Scene in Ontario, have been responsible for any exposure I might have as a celebrity. I would never have promoted sales of books and prints of my own accord.

Starting in the 1980s, Tom Beckett, the owner of the Beckett Gallery in Hamilton, was a talented and successful promoter of sales of my originals.

Many of the stories in this book emanate from group trips. These have been a kind of magic carpet for Birgit and me. We get invited to go along as resource people (possibly the Bateman name helps with sales of the trips). This started with Lars-Eric Lindblad, the father of adventure travel and continues to this day with his son, Sven-Olof Lindblad, head of Lindblad Expeditions. Victor Emanuel of Victor Emanuel Nature Tours, a leader to many exotic places, has become a very close friend, as has Jim Allan, who created Ecosummer Tours of Vancouver in the 1980s. In addition, we have travelled with Matthew Swan of Adventure Canada and Catherine Evans of Tours of Exploration. It is an honour to know these creative, knowledgeable and likable individuals. They introduced us to many outstanding resource people and passengers with whom we shared adventures in all corners of the world.

Of course I may have left out someone whom I should have thanked. But in a way, the entire book is an acknowledgement.

Since this is a book about my life, family is elemental to my life. I will lump all of our five children under one deep and broad

appreciation. They all are individuals of course, but their personalities and gifts complement each other and complement my life. They seem to tolerate my patriarchal tendencies, but give me advice when needed. Without question Birgit is the most important person in my life, not only in the roles of wife and mother, but as a guide and frequent font of wisdom. This began when she was a fellow teacher and has continued throughout my career to present day. At times, her life seems overwhelmingly packed with tasks for our joint lives, but everything I do is better with her by my side. She is my life's companion.

Birgit Freybe Bateman

Robert Bateman was fascinated by the natural world around him from an early age. When he was just twelve years old, he signed up with the Junior Field Naturalists' Club at the Royal Ontario Museum where he spent his Saturdays attending talks, going on field expeditions and excelling in bird carving class. It was here where he learned to stuff small mice and bat specimens, which now occupy shelves and drawers in natural history museums in Canada, the United States and England.

An artist, as well as a scientist, Bateman took drawing classes from Carl Schaefer and was inspired by John Singer Sargent, the Group of Seven and a variety of artistic movements including Impressionist, abstract, expressionist and cubist. After several adventure trips around the world, he found his calling painting within the realist movement, and by the 1970s, his work started to receive major recognition. Robert Bateman's art has appeared in over twenty-five one man exhibitions across the globe, including the Smithsonian Institution in Washington, D.C.

and the Tryon Gallery in London. He opened a permanent exhibition, the Robert Bateman Centre, in Victoria, B.C., in 2013.

Robert Bateman is an Officer of the Order of Canada and a Member of the Order of British Columbia, and in 2013, he was awarded the Royal Canadian Geographical Society Gold Medal in recognition for his commitment to preserving the Canadian landscape. He has received thirteen honourary doctorates from universities across North America. A beloved teacher and renowned naturalist celebrated for his accessible realist style, Bateman is a Life Member of the Royal Canadian Academy of the Arts. He is the bestselling author of thirteen books. He continues to paint and lives with his wife, Birgit, in Saltspring Island, British Columbia.

John Evans

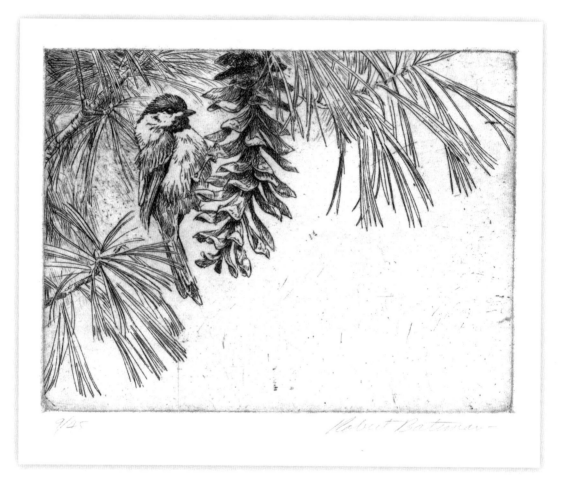

9/25 Robert Bateman

Chickadee in the Pine, *7" x 9", etching, 1985.*

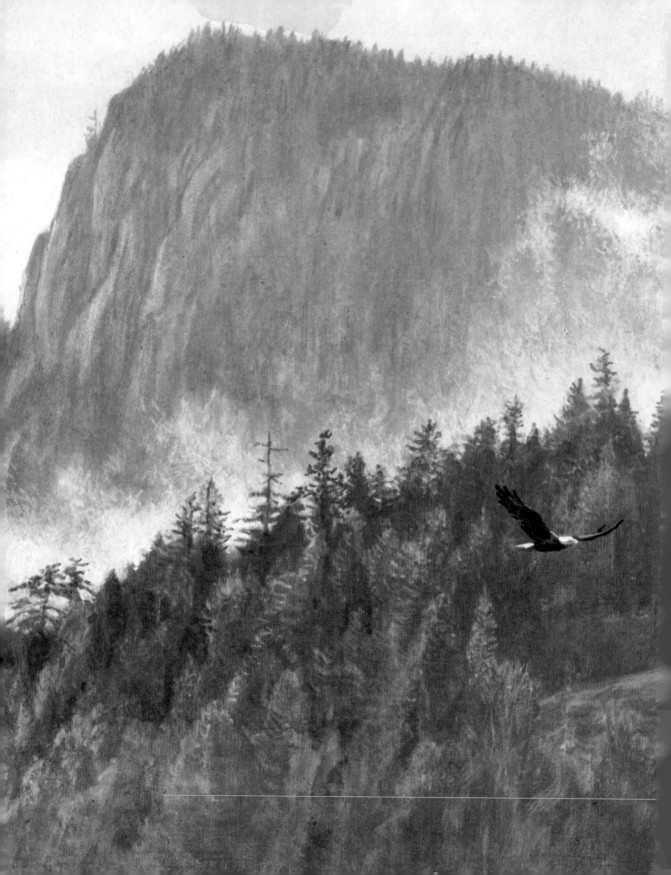